KU-001-311

066262
Aberdeen College Library

759.3 BEC

ABERDEEN COLLEGE
GALLOWGATE LIBRARY
01224 612138

Max
Beckmann

WITHDRAWN

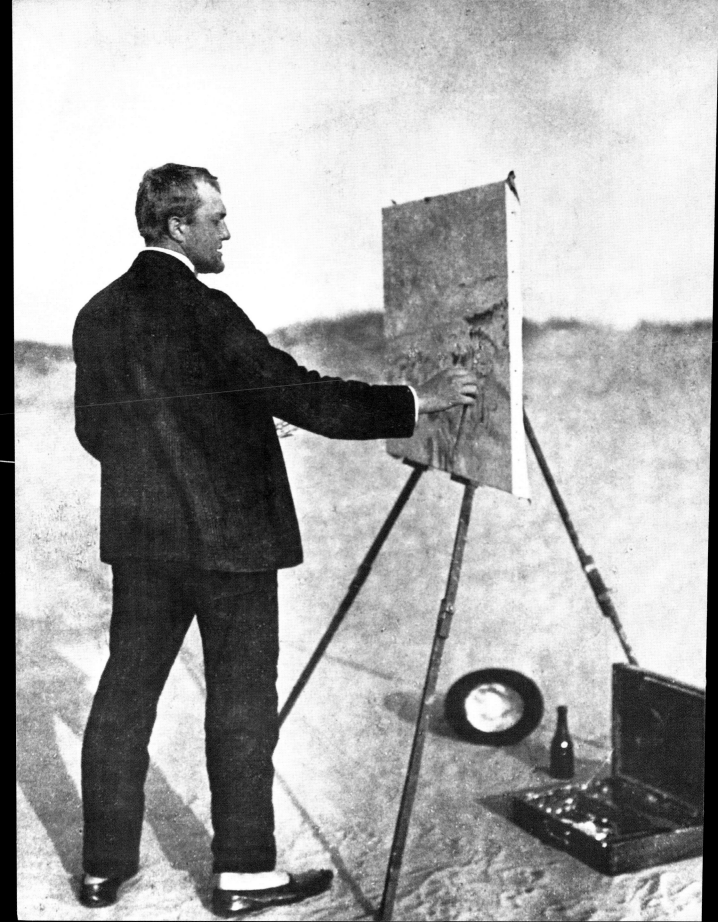

Reinhard Spieler

MAX BECKMANN

1884 – 1950

The Path to Myth

WITHDRAWN

ABERDEEN COLLEGE
GALLOWGATE LIBRARY
01224 612138

TASCHEN

KÖLN LONDON LOS ANGELES MADRID PARIS TOKYO

FRONT COVER:
Quappi in Blue in a Boat, 1926/1950
Quappi in Blau mit Boot
(see p. 162)
Photo: AKG, Berlin
© VG Bild-Kunst, Bonn 2002

BACK COVER:
Self-Portrait in Blue Jacket, 1950
Selbstbildnis in blauer Jacke
(see p. 193)
Photo: Artothek, Weilheim
© VG Bild-Kunst, Bonn 2002

PAGE 1:
Self-Portrait, 1922
Selbstbildnis
Woodcut, 22.2 x 15.5 cm
Hofmaier 226

PAGE 2:
Max Beckmann on the Baltic coast,
Working on *Sunny Sea*, 1907

© 2002 TASCHEN GmbH
Hohenzollernring 53, D–50672 Köln
www.taschen.com

Original edition: © 1995 Benedikt Taschen Verlag GmbH
© 2002 for the reproductions:
VG Bild-Kunst, Bonn: Beckmann, Ernst, Picasso, Utrillo
Layout and editing: Ingo F. Walther, Alling
Cover design: Angelika Taschen, Cologne
English translation: Charity Scott Stokes, London

Printed in Italy
ISBN 3–8228–2038–5

Contents

ABERDEEN COLLEGE
GALLOWGATE LIBRARY
01224 612138

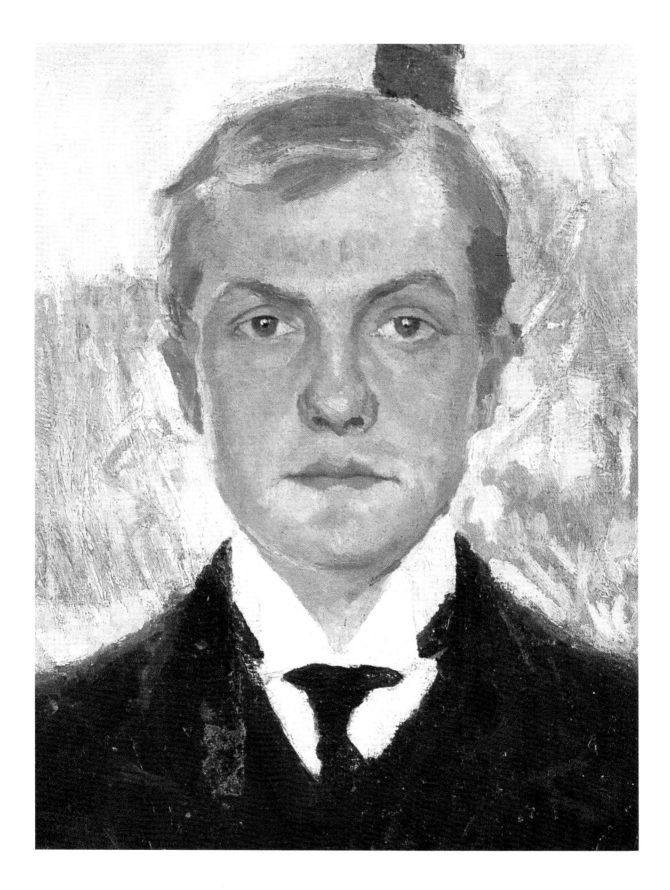

In Search of Self

"What are you and what am I? – These are questions that pursue and torment me, but which also perhaps help to make me an artist… The *Self* is indeed the greatest and obscurest secret in the world."[1]

It is fitting that the earliest Max Beckmann painting to have survived is a self-portrait. From the time of his earliest sketches to his last mature works, the self-portrait was a central theme. We encounter Beckmann in many different roles, in different moods, in different poses. We see him as medical attendant, as clown and as circus director. He appears in a dinner jacket, with a champagne glass or a cigarette in his hand, or in fancy dress or convict garb. He is the exiled seaman, the prisoner bound or unbound. Whether as soothsayer with crystal ball or as sculptor in a dressing-gown – there is seemingly no end to the roles he can assume. He appears alone or with his wife, at a party or on the stage, as a solitary contemplative or in dialogue with Christ. His penetrating gaze challenges the viewer. He is lost in thought, oblivious to the outside world. Tormented or horrified, aloof or engaging, he is at times close and at times remote; affirming or questioning, sensitive and introverted or self-assured and domineering. Fifty years' work produced some two hundred self-portraits embracing the full range of human experience.

Beckmann's self-portraits are more than autobiography, and it would be a mistake to see them in a narcissistic light. The theme of the self-portraits is a relentless attempt to scrutinise and define his own position: "All my life I have been trying to become some kind of *self*. I shall never give up the attempt and there is to be no whining for mercy and grace," wrote Beckmann in his diary on 4 May 1940. The same unswerving self-analysis is evident in the pictures and in the diaries, but it is not so much a scrutiny of his own existence as of the tragic entanglement of mankind, dependent on gods, sex and society. His own self is the medium for Beckmann's variations on the theme of human existence. True knowledge is gained via the route already known to antiquity – "Know thyself". In his 1938 London lecture *On my Painting*, Beckmann declared: "Prior to existence a soul yearns to become a self. It is this self that I seek, in life as in art".

This unceasing and relentless self-scrutiny is paralleled in art history only in the work of Rembrandt (1606–1669) and Vincent van Gogh (1853–1890), both of whom Beckmann greatly admired. First principle of their creativity was the will and the ability to see and know themselves, and the conti-

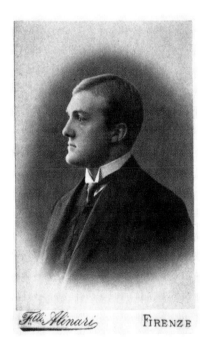

Max Beckmann, Florence 1906
Photo: Alinari

Self-Portrait in Florence (Detail)
Selbstbildnis in Florenz
Florence 1907
Oil on canvas, 98 x 90 cm
Göpel 66
Hamburg, Hamburger Kunsthalle,
Loan from private collection

1 Self-Portrait, 1899
Selbstbildnis
Oil on canvas, 25 x 19.5 cm. Göpel 1
Hanover, Sprengel Museum Hannover

2 Self-Portrait in Florence
Selbstbildnis in Florenz
Florence 1907
Oil on canvas, 98 x 90 cm. Göpel 66
Hamburg, Hamburger Kunsthalle,
Loan from private collection

3 Self-Portrait as Medical Orderly
Selbstbildnis als Krankenpfleger
Frankfurt am Main 1915
Oil on canvas, 55.5 x 38.5 cm. Göpel 187
Wuppertal, Von der Heydt-Museum

4 Self-Portrait with Red Scarf
Selbstbildnis mit rotem Schal
Frankfurt am Main 1917
Oil on canvas, 80 x 60 cm. Göpel 194
Stuttgart, Staatsgalerie Stuttgart

5 Self-Portrait with Champagne Glass
Selbstbildnis mit Sektglas
Frankfurt am Main 1919
Oil on canvas, 95 x 55.5 cm
Göpel 203. Private Collection

6 Self-Portrait in Front of a Red Curtain
Selbstbildnis vor rotem Vorhang
Frankfurt am Main 1923
Oil on canvas, 110 x 59.5 cm
Göpel 218. Private Collection

7 Self-Portrait in Tuxedo
Selbstbildnis im Smoking
Frankfurt am Main 1927
Oil on canvas, 141 x 96 cm. Göpel 274
Cambridge (MA), Busch Reisinger Museum,
Harvard University, Association Fund

8 Self-Portrait in Black Beret
Selbstbildnis mit schwarzer Kappe
Berlin 1934
Oil on canvas, 100 x 70 cm. Göpel 391
Cologne, Museum Ludwig

9 Self-Portrait in Grey Robe
Selbstbildnis mit grauem Schlafrock
Amsterdam 1941
Oil on canvas, 95.5 x 55.5 cm. Göpel 578
Munich, Bayerische Staatsgemäldesamm-
lungen, Staatsgalerie moderner Kunst,
Stiftung Günther Franke

10 Self-Portrait in Black
Selbstbildnis in Schwarz
Amsterdam 1944
Oil on canvas, 95 x 60 cm. Göpel 655
Munich, Bayerische Staatsgemäldesamm-
lungen, Staatsgalerie moderner Kunst

11 Self-Portrait in Blue Jacket
Selbstbildnis in blauer Jacke
New York 1950
Oil on canvas, 139.5 x 91.5 cm. Göpel 816
St. Louis, The Saint Louis Art Museum,
Bequest of Morton D. May

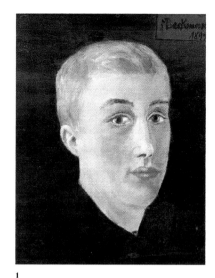 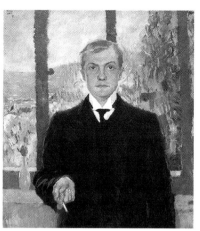

1 2

nuing appeal and influence of their fascinating self-portraits show that their message told of the human condition, transcending the individual and his time.

Beckmann's self-portraits yield detailed biographical material with which it is possible to trace his psychological development and the outer events of his life; they also enable the viewer to follow the development of his philosophy and his concept of art. He made relentless and uncompromising demands of himself in his self-analysis, and he made the same demands, of himself and others, with regard to art: "The purpose of art is knowledge – not diversion, pastime or transfiguration."[2] Beckmann's importance in the history of twentieth century art lies in the powerful link between his compelling search for truth and a "furore of sensuality", a declaration of absolute faith in the picture and in the force of form and colour.

In the captions the line following the description of technical details gives references to the standard catalogues and inventories of Max Beckmann's works (see Bibliography, p. 200). The following short titles are used:

BIELEFELD: Max Beckmann. Aquarelle und Zeichnungen. Ed. Ulrich Weisner and Klaus Gallwitz. Bielefeld, 1977
GÖPEL: Erhard and Barbara Göpel: Max Beckmann. Katalog der Gemälde. 2 Vols. Berne, 1976
HOFMAIER: James Hofmaier: Max Beckmann. Catalogue Raisonné of His Prints. 2 Vols. Berne, 1990
WIESE: Stephan von Wiese: Max Beckmanns zeichnerisches Werk 1903–1925. Düsseldorf, 1978

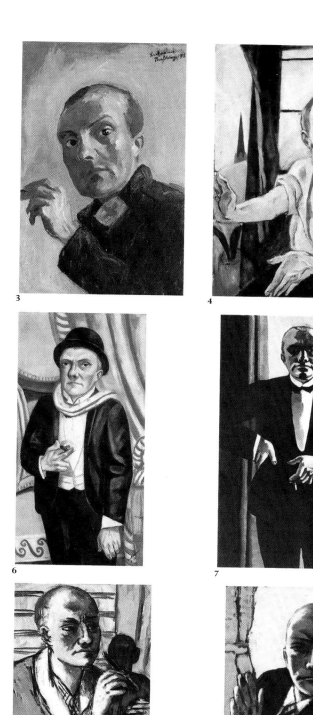

3

4

5

6

7

8

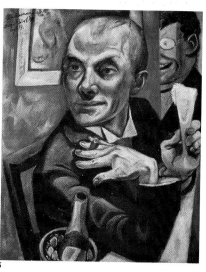

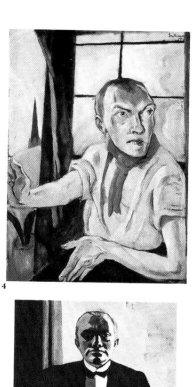

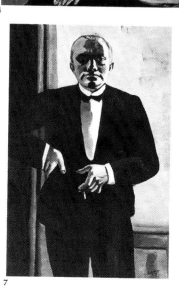

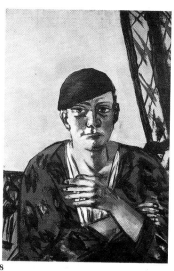

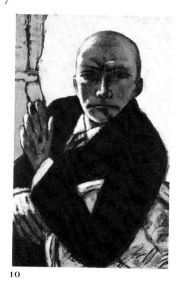

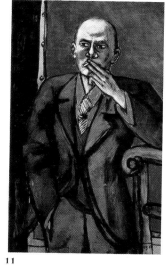

9

10

11

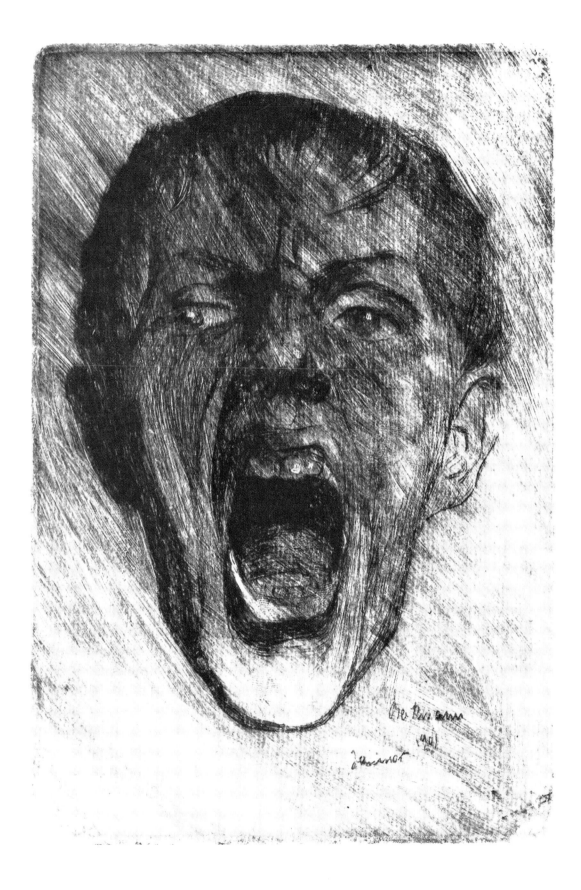

Orientation and Self-Assertion 1899–1915

From the beginning Beckmann's strong and distinctive personality charac-
terised his development as an artist. Even in the early works, the high ambition
in what he was attempting to do is evident. Although the first of the extant
pictures is a self-portrait painted when he was fifteen years old (p. 8), there is
none of the casual play with form and colour that one might expect from a
teenager, but rather, a conscious will to find expression charged with profound
significance.

In *Self-Portrait with Soap Bubbles* (p. 13), which was probably painted when he
was about sixteen years old and still at boarding-school, Beckmann devised an
extraordinarily complex picture of himself which remained valid in its essen-
tials throughout his life. Strangely stiff and earnest, almost as if he was bound
to the chair on which he sits, he is seen in profile before open countryside,
rapt in thoughts which seem to evaporate in the ascending soap bubbles. The
heavy brown earth tones and the contour of the horizon which is continued
in Beckmann's upper body line bind him to the lower area of the picture. Only
the head lifts in lighter colours towards the airy freedom of the escaping soap
bubbles.

Beckmann's theme here is clearly one that preoccupied him throughout his
life – the deeply felt dilemma of man split between earthbound matter and free
spirit. The ambivalence of both areas is already evident in this early picture:
there is a reassuring warmth in the brown tones of the lower area, but at the
same time the dark colours are weighty, almost oppressive. The rigid right
angles of the chair seem to impose a very uncomfortable sitting position on
Beckmann, to which he yields unwillingly. The legs of the chair and Beck-
mann's feet are cut off. The picture signals that even where "home" is supposed
to be there is nothing to hold on to, no point from which one can take one's
bearings, no genuine roots. The head rises towards the area of free spirit sym-
bolised by the immateriality of the soap bubbles. It is a dream of freedom,
transparently delicate in contrast to the lower area, but with the proverbial
threat that the bubbles may burst.

At the age of sixteen Beckmann became a student at the Weimar School of
Art. After the slight awkwardness of form in his early pictures he set out with
more assurance to find formal solutions to match his forceful will for ex-
pression. One of the first art school pieces, an etched *Self-Portrait* (p. 10), shows
more of what was to come. Unlike *Self-Portrait with Soap Bubbles* with its contem-
plative melancholy, the etching shows Beckmann screaming, with mouth

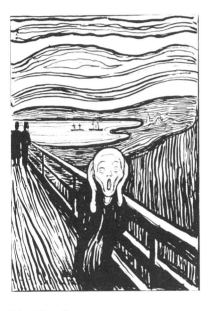

Edvard Munch
The Scream, 1895
Skrik
Lithograph, 35.5 x 25.4 cm

Self-Portrait, 1901
Selbstbildnis
Drypoint, 21.8 x 14.3 cm
Hofmaier 2. Private Collection

Old Botanical Garden
Alter Botanischer Garten
Berlin 1905
Oil on canvas, 94 x 60 cm
Göpel 21
Feldafing, Lothar-Günther Buchheim Collection

"After all kinds of experiments in style, I've now reached a point between Cézanne and van Gogh... I think you know me well enough to realise that when I say between Cézanne and v. G. I don't mean that I've cobbled together a style of my own from theirs, rather that my own path has led me logically towards the same discoveries, and now I intend to go further."
Max Beckmann 1905 in a letter to his painter friend Caesar Kunwald (see note 3)

Paul Cézanne
Maincy Bridge near Melun, c. 1879
Pont de Maincy près de Melun
Oil on canvas, 58.5 x 72.5 cm
Paris, Musée d'Orsay

wrenched open. His distorted face and the primal scream of fear and horror reveal an attempt to probe the self that he might become in an extreme situation. The scream becomes a radical act of self-assertion in the face of fear and horror, an attempt to escape from isolation, a declaration of war on life, as it was in the great work on the same theme (p. 11) created some years earlier by Edvard Munch (1863–1944).

Munch was one of several acknowledged contemporary masters from whom Beckmann initially took his lead in style and form. Munch's influence is particularly noticeable in the many sea scenes. A work by Paul Cézanne (1839–

1906) is the model for *Old Botanical Garden* (p. 12), and other landscapes show the influence of van Gogh and the Impressionists. "After all kinds of experiments in style, I've now reached a point between Cézanne and van Gogh... I think you know me well enough to realise that when I say between Cézanne and v. G. I don't mean that I've cobbled together a style of my own from theirs, rather that my own path has led me logically towards the same discoveries, and now I intend to go further", wrote Beckmann in 1905 to his friend and fellow painter Caesar Kunwald.[3]

While Beckmann was finding his way stylistically his favourite themes were landscape and, especially, seascape (p. 14). The pictures demonstrate his fascination with the apparently unending sea as a force of nature, the foretaste of eternity.

At the same time, since he was at art college he had to, of course, devote himself to studies to studies of nudes. The picture *Young Men by the Sea* (p. 15) painted in 1905 combines both themes. This first large-scale painting of nude figures in the open air takes up a tradition that occupied Cézanne in his

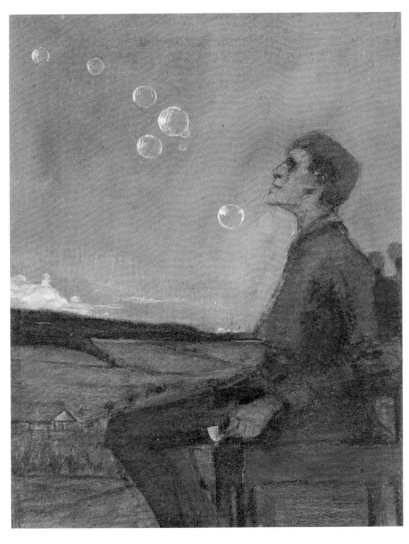

Self-Portrait with Soap Bubbles, c. 1900
Selbstbildnis mit Seifenblasen
Mixed media on pasteboard, 32 x 25.5 cm
Göpel 3. Private Collection

Shore Landscape, c. 1904
Strandlandschaft
Oil on wood, 50 x 69.5 cm
Göpel 16. Private Collection

Caspar David Friedrich
Monk by the Sea, c. 1808–1810
Der Mönch am Meer
Oil on canvas, 110 x 171.5 cm
Berlin, Staatliche Schlösser und Gärten,
Schloß Charlottenburg

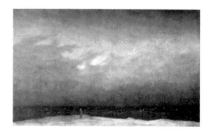

bathing scenes for most of his life. Unlike Cézanne, Beckmann does not seek
to demonstrate harmony between the human figure and nature and the inter-
relationship of all parts of the picture, but focuses rather on the contrast
between the monumental nude figures in the foreground, extending from top
to bottom and side to side of the canvas, and the unending expanse of the
seascape. Romanticism lingers in the apparrently infinite depth of space in
the picture. Yet Beckmann's nudes are not helpless playthings of eternity, as
is, for instance, the human figure in *Monk by the Sea* (p. 14) by Caspar David
Friedrich (1774–1840): Beckmann gives equal weight and balance to the pro-
fundity of space and the monumental human figure.

The monumental quality and the heightening of the human figure are remi-
niscent of the work of Ferdinand Hodler (1853–1918) (p. 15). Beckmann was
well aware of this: "As regards my style, here in Geneva I have discovered in
Hodler's work almost everything that I had laboured for myself in the hard
battle to shape the language I was going to use. Not a pleasant discovery, since
it means battling on. But I feel I still have the strength, a lot of strength, and I
think I can do it", he wrote from Geneva to his fellow painter Kunwald.[1]

The studies of nudes show that in Weimar Beckmann received sound train-
ing as a craftsman. His teacher Frithjof Smith (1859–1917) was neither a cre-
ative genius nor a great theoretician but he was able to provide Beckmann with
an excellent grounding in figure drawing and composition. Beckmann had an
exceptionally solid basis in composition and an assurance in structuring the
human figure on which he constructed his formal language – even in the later
more abstract works where form took precedence over subject matter.

However, this training was not enough. Beckmann's borrowings from
Cézanne, van Gogh, Munch and Hodler are evidence that he sought to keep
up with developments in the international modern movement. In 1903 he left
Weimar for Paris, the acknowledged centre of modern art at this time. This
first long stay in Paris lasted some six months, and one of his priorities was to
become self-reliant for the first time and to clarify his thoughts on his relation-

ship with Minna Tube, whom he had met and fallen in love with at the Weimar School of Art. It was also important to enjoy life in the great city: "Paris is beautiful… When I am not sitting in cafés or lying in bed I paint 5.5 x 4 metre pictures. In short, I do everything a genius should do", he wrote to his friend Kunwald, again, describing the advantages of living in Paris.[5]

Beckmann arrived in Paris just as the avant-garde was forming round Picasso (1881–1973) and the young group of Fauve artists, Matisse (1869–1954), Georges Braque (1882–1963), André Derain (1880–1954) and Maurice de Vlaminck (1876–1958). In the artists' café Closerie des Lilas he saw Munch. Those who had paved the way were still very much in evidence: Cézanne, the "Douanier" Henri Rousseau (1844–1910), Claude Monet (1840–1926), Edgar Degas (1834–1917) and Auguste Rodin (1840–1917) were still alive; Henri de Toulouse-Lautrec (1864–1901) had died two years earlier; Edouard Manet (1832–1883) and van Gogh were constantly referred to. Beckmann felt the need to orient himself towards the avant-garde and their forerunners, but this need was counterbalanced by his awareness of his own strength: "I believe that I will achieve everything that I want to achieve, everything. What I don't know is whether I shall be glad when I've done it," runs his diary entry for 14 August 1903 on the point of leaving for Paris.

One outcome of his encounter with French art was "a very powerful antipathy towards the abundant flood of Impressionist imitators in Paris at the time".[6] What displeased him was the formalism of the works that reproduced distinctive characteristics at the expense of any real involvement with life: "My heart responds more to raw vulgarity, to an art that does not live in a fairytale

Ferdinand Hodler
Spring, 1901
Der Frühling
Oil on canvas, 99 x 129 cm
Essen, Museum Folkwang

Young Men by the Sea
Junge Männer am Meer
Berlin 1905
Oil on canvas, 148 x 235 cm
Göpel 18
Weimar, Kunstsammlungen, Schloßmuseum

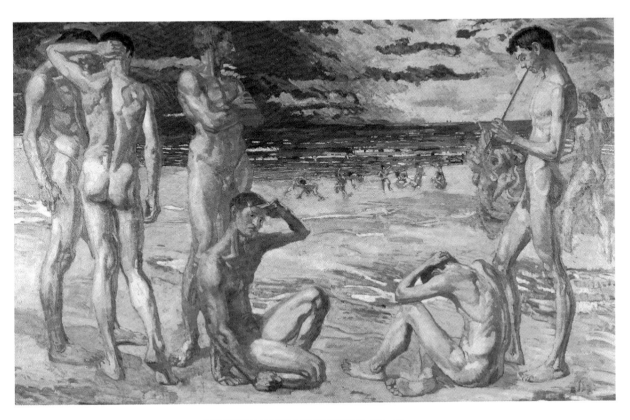

dreamland but instead grants access to life's dreadfulness, its baseness, its magnificence, its commonplace grotesque banality. An art that remains with us in the vital moments of real life."[7]

His art was open therefore to a shift in emphasis when he returned to Berlin. The focal point now was in human drama with its various manifestations. *Nude Study: Old Woman* (p. 16) reflects the tragedy of an entire life. The viewer is confronted with unadorned bare essentials in the shape of a shrunken old woman sitting on a chair, forlorn in an empty room. *Large Death Scene* (p. 17) also portrays a human drama. In this painting Beckmann re-works the agony of his mother's death from cancer in the summer of 1906. The desolate picture of death, pain and isolation transcends the autobiographical event. The dead woman lies deformed by spectral rigor mortis, a de-gendered rendering of death itself. The mourners are deformed by suffering almost as much as the woman is by death. A girl crouches by the bed, naked like the dead woman, with legs agape, making her look as if she had been torn apart. On the right a female figure gives way to histrionic gestures of grief, while the man on the left seems lost in thought, oblivious to the world around him. He sits undignified beside the dead woman, with bare torso and bare feet and trousers hanging down. Numbed by pain, he has lost control of himself and his appearance and is reduced to almost repulsive corporeality. There is no link between the mourners, each is stiffened in isolation. The colours convey the prevailing emotions: cold whites with green in the dead body, sordid greys; only in the background red is there any resonance of the inner turbulence of the mourners.

Just four weeks after his mother's death Beckmann married Minna Tube (p. 19) and in order to please him she gave up painting and embarked on a career as a singer. She enjoyed her greatest successes as a dramatic soprano, especially in Wagnerian roles, under the famous conductor Hans Knappertsbusch (1888–1965) during the years immediately following the first world war. For nearly ten years Beckmann signed his pictures HBSL – "Herr Beckmann seiner Liebsten" – "Mr. Beckmann to his Love". Shortly after the marriage his *Young Men by the Sea* received the Villa Romana Prize of the "Deutscher Künstlerbund" (German League of Artists), which included a scholarship to Florence.

In *Self-Portrait in Florence* (p. 8), painted during the stay in the city, there is evidence of Beckmann's growing self-confidence as an artist and in his new social role as a husband. With the lovely Tuscan countryside and Florence, city of art, as backcloth he presents himself as heir to a great artistic tradition and also as Florentine prizewinner. The central half-figure of Beckmann facing squarely to the front sets the scale. With firm self-assurance his gaze meets the viewer, while cigarette and black suit lend an air of nonchalant sophistication; this is no bohemian artist but a citizen of the world, ready to take his place in society. The bright white shirt collar gives added emphasis to the prevailing black of the jacket, so that even the non-colour takes on a delightful glow. The colourist sleight of hand, and the pose itself, may be interpreted as homage to Manet's *Déjeuner à l'atelier* (1868; Munich, Neue Pinakothek).

After returning to Berlin and moving into the newly built house in Hermsdorf, Beckmann continued to favour human drama as subject matter. Greater self-confidence allowed him now to venture beyond individual tragedy to large-scale pictures and subjects drawn from group scenes of historical, biblical

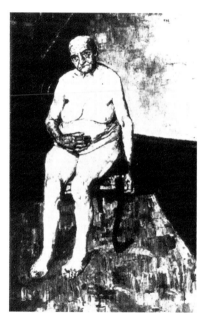

Nude Study: Old Woman
Akt der alten Frau
Berlin 1905
Oil on canvas, 155 x 97 cm
Göpel 47
(The painting was destroyed during an air-raid on Berlin in 1944/45)

or mythological drama. In this respect he continued in the tradition of great French Romantic works such as *The Raft of the Medusa* (p. 56) by Théodore Géricault (1791–1824), *The Massacre of Chios* (p. 20) and *The Death of Sardanapalus* (p. 102) by Eugène Delacroix (1798–1863). In the historical *Scene from the Destruction of Messina* (p. 20), where more than 80,000 people lost their lives in 1908, in *The Sinking of the Titanic* (photograph p. 23), and also in the biblical scenes *The Flood* (p. 20), *Resurrection* (p. 28) and *The Crucifixion* (p. 22), and in the mythological dramas such as *The Battle of the Amazons* (1911), *Judith and Holofernes* (1912) and *Samson and Delilah* (1912), Beckmann sought to express humanity's unending fight for survival, the tragedy of human existence. A photograph of 1912 (p. 23) presents him as an accomplished and skilful director of human drama: he sits in front of his huge painting *The Sinking of the Titanic* in which

Large Death Scene
Große Sterbeszene
Berlin 1906
Oil on canvas, 131 x 141 cm
Göpel 61
Munich, Bayerische Staatsgemäldesammlungen, Staatsgalerie moderner Kunst

"I only know one thing, which is that I pursue the idea that I was born with, already present – if only in embryonic form – in the Drama or the Death Scene, with all the powers I can muster, till I can do no more."
Max Beckmann in conversation with the publisher Reinhard Piper (c. 1919)

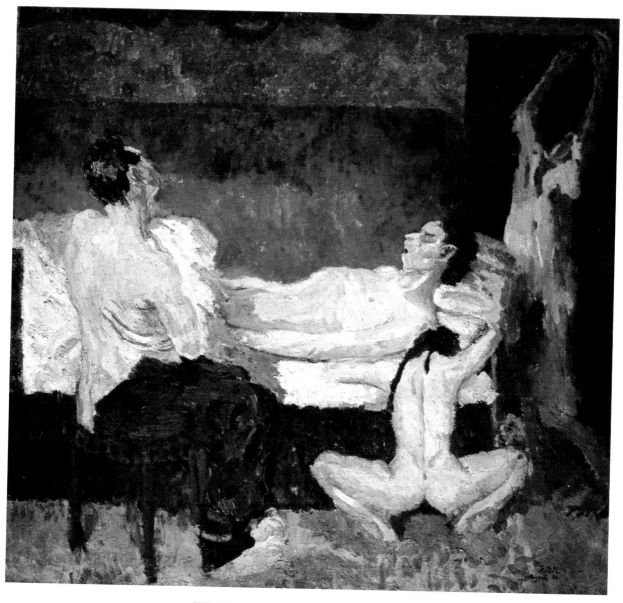

would-be survivors fight for their lives; he has one leg thrown casually over the other, his hands are in his pockets, but his penetrating gaze is focused fully on the viewer. As if he were the centrepiece of a triptych, he is flanked on the left by a female nude, a study for the *Resurrection*, and on the right by *Large Death Scene* which allude to the key reference points of the human struggle for survival: death and eternal life. With the drama of personal experience on the right and christian drama on the left, the gigantic central scene from contemporary history, set in its splendid frame, is presented as a classical masterpiece in the old style.

This style is located at a point somewhere between the painting of the academy and the free Impressionist manner, which Beckmann utilised not so much for the purpose of achieving light and colour, as the French Impressionists did, but more to heighten expression. He thus became one of the acknowledged contributors to the new and influential vogue of Berlin Secessionist painting centred around Max Liebermann (1847–1935) and Lovis Corinth (1858–1925), and in 1910 he was elected member of the Secession committee, the youngest to date.

The main artistic concern for Beckmann in these paintings (in addition to his thematic preoccupation with human drama) was the representation of space and spatial relations. The suggestive power of space and the plasticity of the figure could translate the gripping immediacy of life into painting, but they were not to be confused with banal illusionism: "Plasticity and the sense of space in painting do not necessarily mean creating a naturalistic effect. What matters is force of representation and personal style."[8] With this fundamental conviction of the importance of plasticity and depth Beckmann became a participant in the theoretical debate on modern art.

In his 1912 polemic *Gedanken über zeitgemäße und unzeitgemäße Kunst* (Reflections on fashionable and unfashionable art) he launched a strong attack on Franz Marc (1880–1916) and the new trends in painting which sharply emphasised the two-dimensional character of the picture. He rejected out of hand the modern attempt to define the picture in terms of its two-dimensionality and the aesthetics of form – as Picasso, Braque and Matisse were trying to do in France, as were also Wassily Kandinsky (1866–1944) and the "Blaue Reiter" group ("Blue Rider", see p. 81) in Germany, and Kasimir Malevich (1878–1935) in Russia. "The enervating weakness of this so-called new painting is that it does not distinguish the notion of wallpaper or poster from the notion of a picture. Certainly, I too am capable of entertaining pleasant feelings, perhaps even a sense of mystery if I am in the mood for it, when I look at beautiful wallpapers. Nor do I wish to deny that a man who designs wallpaper or posters draws on nature in so doing. But there is a very serious difference between these feelings and the feelings aroused by a picture... When these united hosts of art and craft enthusiasts have spent another ten years fabricating their framed pieces of Gauguin tapestry and Matisse textiles and tiny Picasso chessboards and posters of Siberio-Bavarian memorial tablets, they may suddenly wake up and be perplexed to find that there are genuinely new people out there who, goodness gracious, seem never to have been the slightest bit modern or fashionable."[9]

The reduction of the picture to its two-dimensionality and formal aesthetic content was for Beckmann "l'art pour l'art", art without life, and therefore artificial. He turned his back deliberately on the modern notion of the picture,

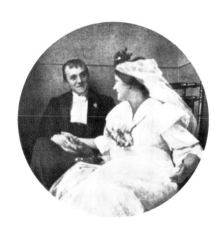

Wedding Photograph of Max Beckmann and Minna Beckmann-Tube, Berlin 1906

Double-Portrait of Max Beckmann and Minna Beckmann-Tube
Doppelbildnis Max Beckmann und Minna Beckmann-Tube
Berlin 1909
Oil on canvas, 142 x 109 cm
Göpel 109
Halle, Staatliche Galerie Moritzburg

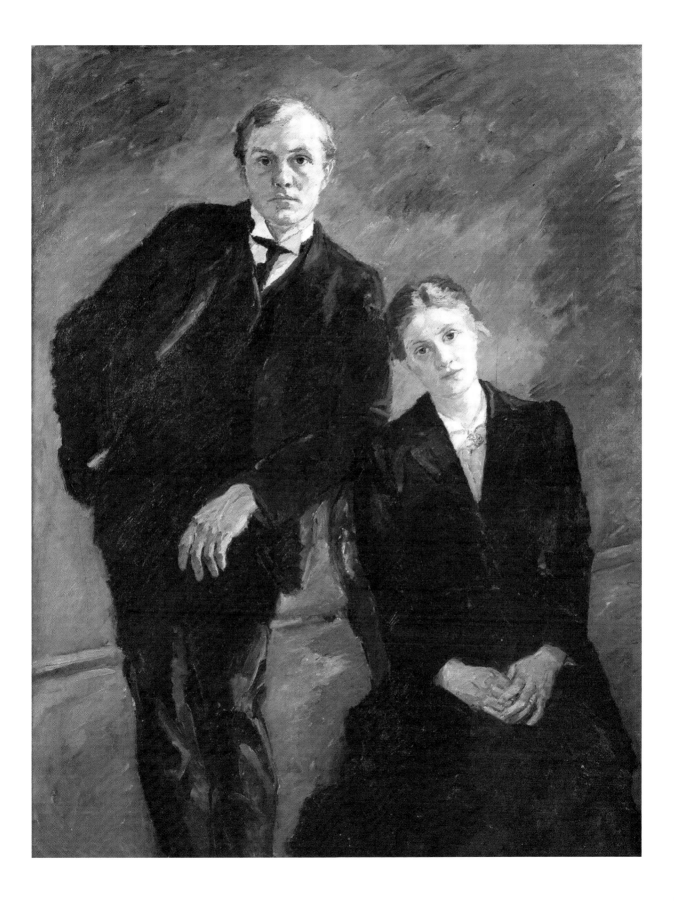

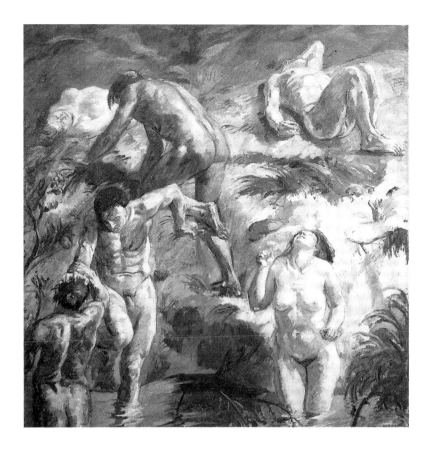

The Flood
Sintflut
Berlin 1908
Oil on canvas, 221 x 216 cm
Göpel 97. Private Collection

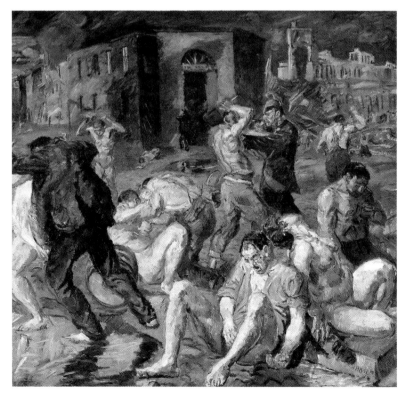

Scene from the Destruction of Messina
Szene aus dem Untergang von Messina
Berlin 1909
Oil on canvas, 253.5, x 262 cm. Göpel 106
St. Louis (MO), The Saint Louis Art Museum

Eugène Delacroix
The Massacre of Chios, 1824
Les massacres de Scio
Oil on canvas, 419 x 354 cm
Paris, Musée National du Louvre

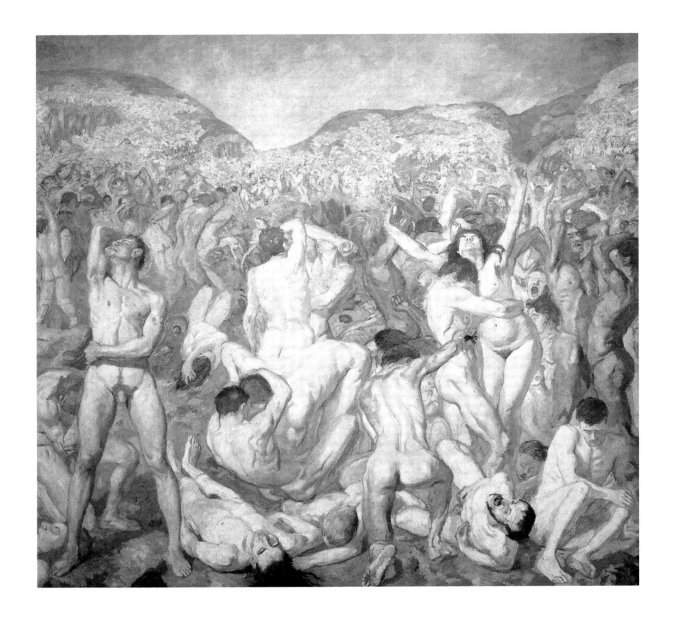

The Battle
Die Schlacht
Berlin 1907
Oil on canvas, 293 x 332 cm
Göpel 85
Leipzig, Museum der bildenden Künste
Permanent Loan, Mr. & Mrs. Peter Ludwig

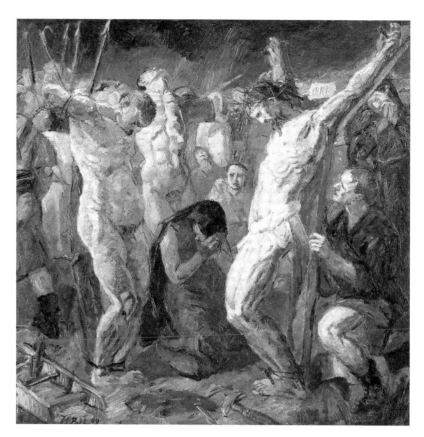

The Crucifixion
Kreuzigung Christi
Berlin 1909
Oil on canvas, 150 x 150 cm
Göpel 119
Munich, Bayerische Staatsgemäldesamm-
lungen, Staatsgalerie moderner Kunst,
Loan, Sammlung Georg Schäfer

Sketch for **The Crucifixion**
Berlin 1909
Black ink with brush and pen, 20.8 x 22.5 cm
Wiese 35. Private Collection

for the emancipation of art from life and the autonomy of art and art's techniques were the key aims and achievements of the avant-garde, with the first great milestone being the introduction of the notion of the abstract in the years round 1910. Beckmann's individual development caused him to follow a solitary path, like Cézanne, and this continues to be problematic for art historians since it prevents them from slotting him into the generally accepted scheme of modern art.[10]

Beckmann's early work is important more for complexity of content and forceful élan than for development of successful new forms of expression. The techniques that he used in the attempt to convey what was deeply felt often bear the mark of the academy, and historical paintings teeming with figures are liable to succumb at times to formulaic melodrama. Nevertheless, even in these early works the very presentation of the melodrama could be fired with something of the compelling power and life which make Beckmann's later works so distinctive – in a manner which may not always have been quite in accordance with his avowed theoretical aims.

Max Beckmann in his Berlin Studio in front of *The Sinking of the Titanic*, 1912/13

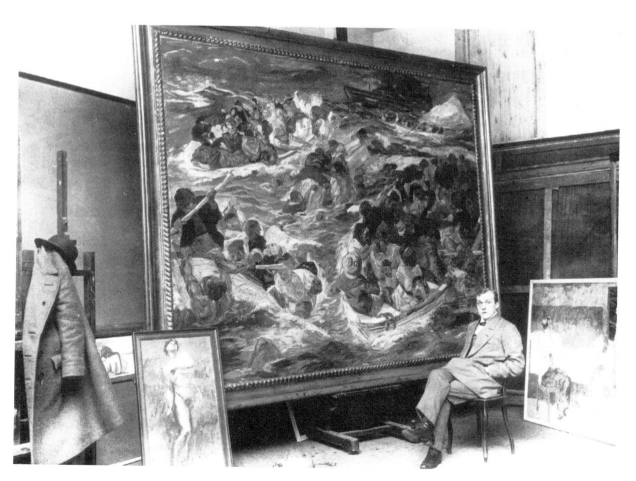

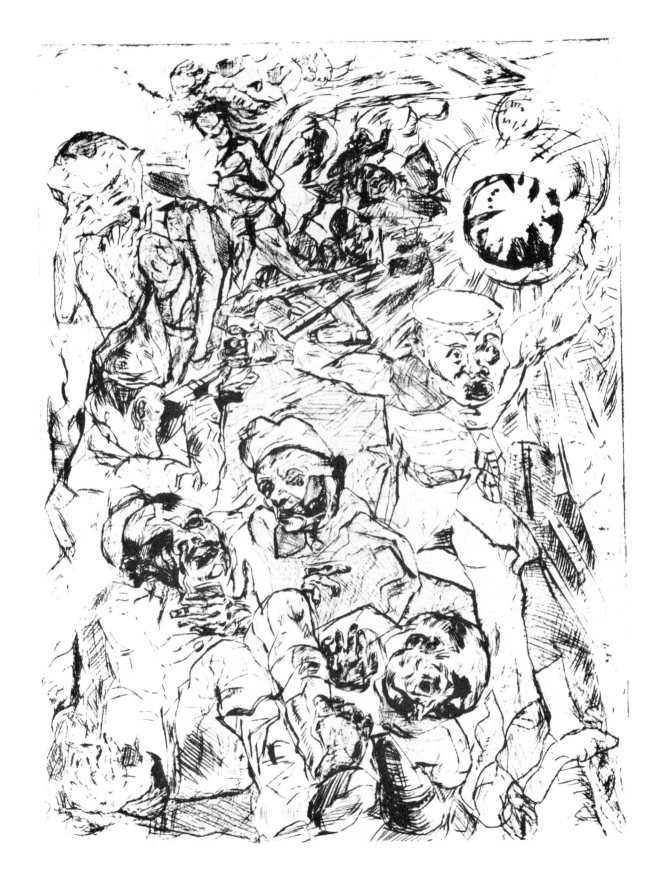

The War Years:
Drypoints and Drawings

The first world war wrought profound changes in Beckmann's personal outlook on life and heralded a new direction in his development as an artist. On the occasion of his first exhibition after the war in 1919, the art historian Paul Ferdinand Schmidt wrote: "His earlier work seems to have come to an abrupt end. Those who knew and admired the Beckmann of 1913 may well be appalled by so radical an alteration in style. There can hardly be any other example in recent German art of such a fundamental change in a painter's approach."[11]

When Germany declared war on France on 3 August 1914 Beckmann sketched the carnivalesque tumult on the streets of Berlin (p. 25). Yet beneath the superficial euphoria whipped up in the enthusiastic crowd he saw the anxiety, tension and fear in people's faces. Many other artists, including Ernst Barlach (1870–1938), August Macke (1887–1914), Franz Marc and even George Grosz (1893–1959) and Otto Dix (1891–1969) welcomed the onset of war and immediately volunteered for active service, while Beckmann foresaw the impending catastrophe and referred to the outbreak of war as "the greatest national disaster that could befall us."[12] Like most of his contemporaries, however, he did not evaluate the war on moral grounds; rather, he saw it as "an expression of life, like disease, love or lust"[13], in which people's innermost emotions and perceptions are revealed. Beckmann focused on extreme situations in order to see into the innermost parts of the human being, as he had done before in the *Self-Portrait* with screaming mouth (p. 10), in the *Large Death Scene* (p. 17) and in the historical drama paintings, *The Sinking of the Titanic* and *Scene from the Destruction of Messina* (p. 20). The horror of war was fascinating to him, almost to the point of self-destruction: "I pursue the ultimate in fear, illness and lust, love and hate, whether I really want to or not, and I am trying to do the same thing now with the war."[14] Describing his feelings to his wife he wrote: "There is a savage, almost evil voluptuousness in being suspended between life and death."[15]

After the first impressions of war, gained when he accompanied an aid convoy to East Prussia, Beckmann volunteered for paramedical service. The full horrors of war confronted him for the first time in the battles round Tannenberg and the Masurian Lakes, where his brother-in-law Martin Tube was killed. In 1915 he was transferred to the Belgian front where he worked first in a typhus unit and later in an operating theatre. Though there is scant documentation for this period, it is known that in the late summer Beckmann suffered

The Declaration of War
Die Kriegserklärung
Berlin 1914
Drypoint (2nd stage), 20 x 24.9 cm
Hofmaier 78. Private Collection

The Grenade, 1914
Die Granate
Drypoint (3rd stage),
38.6 x 28.9 cm
Hofmaier 80. Private Collection

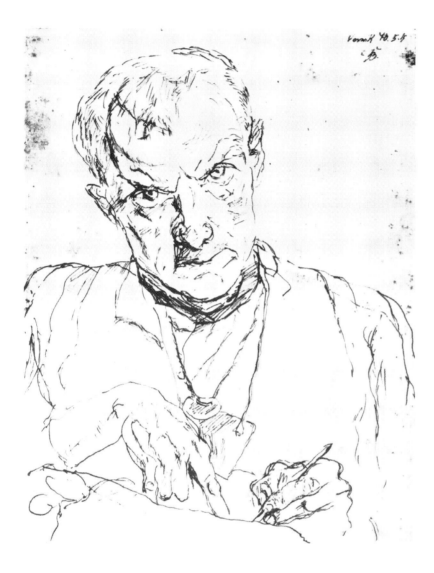

Self-Portrait while Drawing
Selbstbildnis beim Zeichnen
Vervik 1915
Reed pen on paper, 31.7 x 24.3 cm
Wiese 280
Stuttgart, Staatsgalerie Stuttgart,
Graphische Sammlung

a physical and mental breakdown. In 1916 he was on leave for specialist treat-
ment in Frankfurt am Main, and he settled there when he returned to civilian
life in 1917.

Some of the many war-time letters written to his wife Minna were published
in 1916. They reveal the terror and horror of the indescribable suffering he
witnessed, which he tried to face up to with a matter-of-factness sometimes
bordering on sarcasm: "The doctors showed me the most ghastly wounds in a
cool, polite manner. Stench of putrefaction everywhere in spite of good ven-
tilation and light rooms. I stuck it for about an hour-and-a-half, then had to
go outside. Not so grim out there, of course, in spite of all the ruined houses.
The worst has already been cleared away and all along the roadside and in the
potato fields there are long humps with wooden crosses and a few helmets on
them. The countryside is beautiful, I'm going to R."[16]

On the other hand Beckmann experienced, perhaps under the influence of
Friedrich Nietzsche (1844–1900), the fascination of the unparalleled intensity

of life in the presence of death and of the naked fight for survival: "In this short time I've experienced so much … My life here is savage and strange, I've never been so conscious of its contradictions".[17] "My will to live is stronger than ever, although I have seen terrible things and have died several deaths in sympathy. The more frequently one dies, the more intensively one lives."[18]

The relationship between Beckmann's experience of war and his creativity as an artist is equivocal. Sometimes the letters give the macabre impression that the war is taking place in order to provide substance and sensations for his art ("I saw fantastic things. Half-clothed men streaming with blood, being bandaged in white down below in the half-light. Huge pain. New ideas of the flagellation of Christ."[19]) Beckmann was aware of the craziness of this way of seeing almost to the point of obsession: "In real life, painting devours me. I can live only in dreams, poor wretch that I am."[20]

Yet paradoxically it is painting that enables him to survive all the horrors: "I have been drawing, that is the safeguard against danger and death", he wrote to his wife on 3 October 1914. As the grimness of his experiences intensified, so also did his need to liberate himself by giving them artistic form. It became essential to his existence, the necessary condition of his fight for survival: "I have never bowed down before God or anything of the sort in order to achieve success, but I would drag myself through every sewer in the world, through every kind of abasement and humiliation, in order to paint. I have to do it. Every living form and shape must be squeezed out of my head, then it will be a pleasure to be rid of this damned torture."[21]

At first sight there may seem to be a contradiction between this statement and Beckmann's wartime output: he painted only two pictures in 1915, two in 1916 (one incomplete), seven in 1917 and again two in 1918. *The Night* (p. 33), one of his most important pictures, was not completed until 1919. These years form the only major hiatus in nearly fifty extremely productive years of paint-

Left:
Reclining Male Nude
Liegender männlicher Akt
Vervik 1915
Graphite on paper, 30.5 x 23.6 cm
Wiese 296
Mannheim, Städtische Kunsthalle

Right:
The Morgue
Totenhaus
Frankfurt am Main 1922
(after a drypoint of 1915)
Woodcut, 37.2 x 47.4 cm
Hofmaier 252. Private Collection

"I drew nearly all of them, these dead. Perhaps they took it amiss; but, after all, they called on me there…"
Max Beckmann (1916)

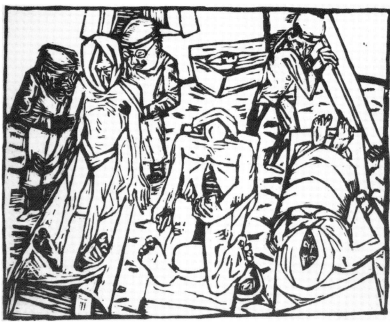

Resurrection
Auferstehung
Berlin 1909
Oil on canvas, 400 x 250 cm
Göpel 104
Stuttgart, Staatsgalerie Stuttgart

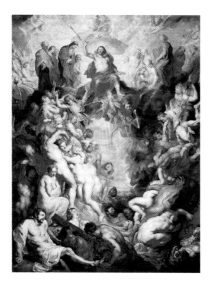

Peter Paul Rubens
The Great Day of Judgement, 1614/15
Oil on canvas, 606 x 460 cm
Munich, Bayerische Staatsgemäldesamm-
lungen, Alte Pinakothek

ing, during which time Beckmann produced no less than 835 pictures. A super-ficial explanation could be found in the difficult circumstances of the war years, but this cannot have been the only reason since Beckmann found it possible to hire models from time to time in spite of the difficulties. Moreover, while stationed in Belgium he worked under a Professor Kühn who was well disposed towards the arts and allowed him as much time as possible for paint-ing and drawing, and who also helped him, for example, to obtain a com-mission for a mural.

There is another reason why Beckmann did not paint during these years in spite of his apparently insatiable need to do so: namely, the difficulty, or sheer impossibility, of finding the right form. Up to that time he had been content to use an academic formal language, but given the radical nature of his experiences it was no longer an adequate means of expression. Though he had been able to exploit its potential for historical pathos, the academic forms were those of a latterday feudal society that had finally been destroyed in the collapse of Wilhelmine Germany. Beckmann's early history paintings were conceived according to the nineteenth-century perceptions of the world, with their distinctive aesthetic and allegorical preoccupations – and this world had been shattered by the vehement and cruel reality of war, which made it im-possible to cling to the old language and forms.

Beckmann's struggle for a new means of expression began logically with graphic work. The intimate medium of drawing offered the most immediate means of expressing intense emotions and perceptions, spontaneously and without the strictures of academic form or the polished perfection of the finished painting. Drawing allowed him to respond more directly to what he felt, using pen or pencil to chart the tremors within. But even drawing was difficult: "After the meal I tried to do a big drawing of a girl who lives opposite me. After struggling for hours ... I had to give up and tore the whole thing to bits."[22]

Before the war Beckmann had favoured a soft pencil, but now he turned to a hard, sharp reed pen. The thin but exact line of the reed pen, unlike the pencil, made no concessions to uncertainty; it transferred each nervous shiver relentlessly to paper, giving every stroke its own weight and precision. The *Self-Portrait while Drawing* (p.26) shows just how expressive medium and tech-nique can be. Beckmann's mood is characterised above all by the nervous incisiveness in the drawing of the line, razor-sharp and inexorable. The con-tours are hard and angular, heightening the expressivity of technique. The terrible experiences of war are engraved in the hardness of his features, the sunken cheeks, the deep eye-sockets and penetrating gaze. The squarely drawn outline of the head stands out, as does the right hand, which is con-torted and seems at once wizened and powerful.

The physical and psychological catastrophe that befell him in the war is documented still more relentlessly in the *Self-Portrait* of 1917 (p.40). Physically spent, with empty gaze and burnt-out spirit, Beckmann is a broken man who has lost the last vestige of illusion. Again it is above all the hard, nervous stroke, held only for a moment, that expresses his shattered state. At the end of the war, in the *Front View Self-Portrait, Gable in Background*, a drypoint of 1918 (p.40), he stands tight-lipped in horror before the inferno of a world in ruins: a Lot who may not look back at the destruction of Sodom, lest he become a pillar of salt.

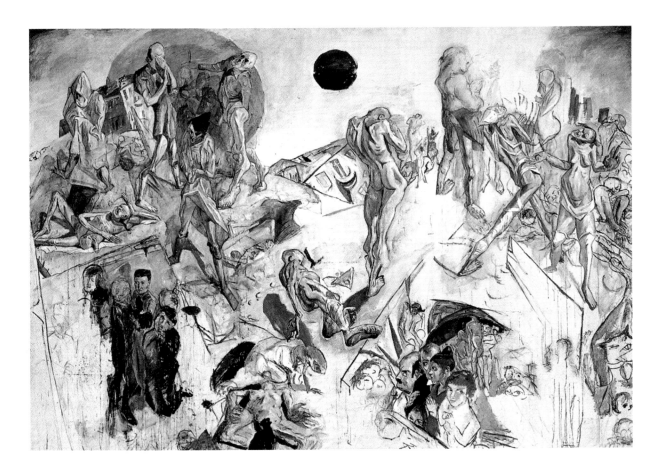

Another medium that Beckmann favoured during the war and in the early nineteen-twenties was drypoint intaglio. A sequence of portfolios and individual plates appeared in rapid succession in the time up to 1924, after which there was an abrupt end to the graphic work. The technique involved is similar to pen-and-ink drawing inasmuch as both permit a high degree of spontaneity and precision, the line scratched into the metal plate being, however, even sharper than that of the pen. The sharpness and hardness seemed to Beckmann to yield the most appropriate formal means of expressing his terrible experiences.

The Grenade (p. 24), a drypoint of 1914, is the key work for the break with earlier forms. It shows a grenade explosion such as Beckmann often experienced at the front. The traumatic experience is translated into a newly conceived form. The explosion of the grenade with its destructive frenzy is matched by the breaking asunder of fixed forms of composition, of central perspective, space and volume, figures and contours. Outline and interior line of bodies and shapes are interrupted by the jerky rhythm of the blast generated by lines that impact and end with equal abruptness. The scene of chaos and devastation is rendered not only by the few discernible faces and maimed bodies, but also by the dismemberment and fragmentation of the picture's visual structure as a whole. Only the grenade remains a fixed entity at the top right-hand edge of the picture, like a dark sun whose rays bring destruction, wreaking havoc throughout, leaving only fragments and ruins in its wake. It is

Resurrection (unfinished)
Auferstehung
Frankfurt am Main 1916–1918
Oil and charcoal on canvas, 345 x 497 cm
Göpel 190
Stuttgart, Staatsgalerie Stuttgart

Pablo Picasso
Les Demoiselles d'Avignon, 1907
Oil on canvas, 243.9 x 233.7 cm
New York, The Museum of Modern Art

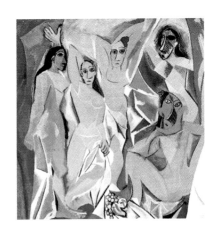

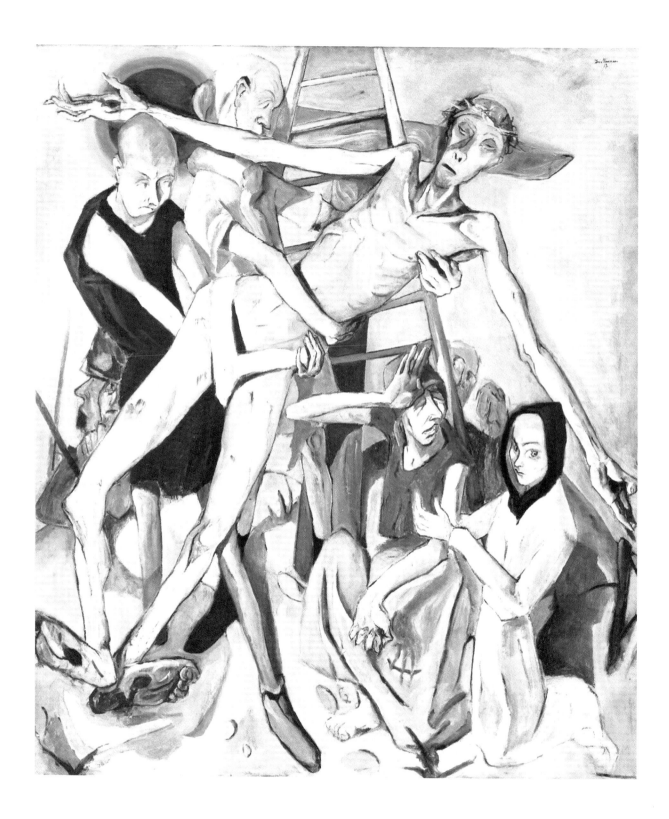

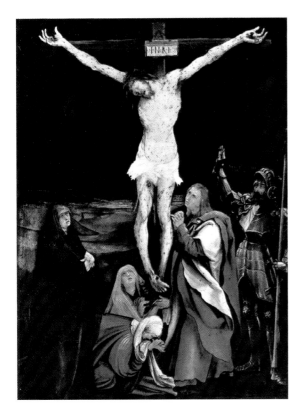

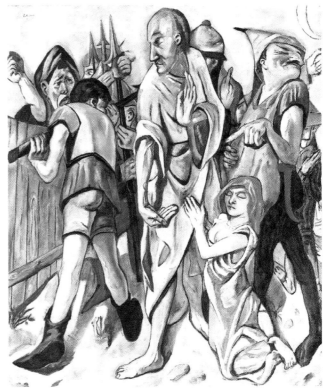

Matthias Grünewald
The Crucifixion, c. 1500–1508
Die Kreuzigung
Oil on wood, 73 x 52.5 cm
Basle, Kunstmuseum Basel

Right:
Christ and the Woman Taken in Adultery
Christus und die Sünderin
Frankfurt am Main 1917
Oil on canvas, 150 x 128 cm. Göpel 197
St. Louis (MO), The Saint Louis Art Museum,
Bequest of Curt Valentin

Deposition
Kreuzabnahme
Frankfurt am Main 1917
Oil on canvas, 151 x 129 cm. Göpel 192
New York, The Museum of Modern Art,
Bequest of Curt Valentin

"I certainly hope we are finished with much
of the past. Finished with... that false, sen-
timental, and swooning mysticism! I hope we
will achieve a transcendental objectivity out
of a deep love for nature and mankind. The
sort of things you can see in the art of Mäless-
kircher, Grünewald, Breughel, Cézanne and
Van Gogh."
Max Beckmann, *Ein Bekenntnis* (Creative Credo,
1918)

as if Beckmann were presenting in *Grenade* not only an episode in the war but
the violent explosion of his own previously held notions of artistic form and
convention.

Resurrection, begun in 1916 (p. 29), shows the application of Beckmann's
new style to painting. The picture remained unfinished, which is in itself
indicative of the difficulty of translating to canvas the techniques developed
for graphic work. It was designed on a monumental scale (345 x 497 cm) and
it remained in Beckmann's studio throughout his time in Frankfurt – a kind
of memorial. It is clear both that he attached great importance to the paint-
ing and that he accepted its unfinished state, whether as documentation of
his own inadequacy or indeed an adequate expression of his version of the
resurrection.

Seven years earlier he had already approached the subject (p. 28). No other
comparison could demonstrate so clearly the change that occurred during
these years. Composition and style of the earlier version owed much to *The
Great Day of Judgement* by Rubens (1577–1640) (p. 28). The high format assists
the upward movement towards the light of two "pillars" of naked bodies, as-
cending from the crowd below. In marked contrast to the Rubens composition,
and to other traditional presentations of the Last Judgement, in Beckmann's
picture Christ the Judge, centre-point of the resurrection, is missing. In his
stead there appears a generalised, not specifically religious, metaphor of lumi-
nosity in which the resurrected are ultimately dissolved. As in Christian ico-
nography, the resurrection is shown as a positive transition from the darkness
of this world to the light of salvation.

How different all this is in the *Resurrection* of 1916! The wide format immediately indicates that there is no upward movement here, but a continuance in the horizontal. In the place of transfiguring light a black sun looms over the events, a dark star of death bringing not salvation but annihilation. The comparison with *Grenade* is compelling, not only with regard to technique but also with regard to content and motif. Both pictures present a scene of destruction. In the earlier resurrection scene the crowd was gathered together down below, whereas in the later scene the people have been blasted apart into separate groups. The earlier naked bodies are liberated from social constraints – the crowd below is still decently dressed – but the later bodies are of beings appallingly mutilated, the wounded and the dead. They do not strive to rise, rather they burst in upon polite society, among whom may be discerned on the bottom right-hand side Beckmann himself with his wife, his son Peter and several friends and acquaintances, as in the earlier picture. Ruined houses, craters, contorted and maimed trunks deprive this apocalyptic

Left:
The Night (preparatory drawing)
Die Nacht
Frankfurt am Main 1917/18
Pencil on paper, 20 x 21.6 cm
Wiese 367. Private Collection

Middle:
Detail from **The Triumph of Death**
Fresco in the Camposanto in Pisa, before 1350

Right:
Detail from **The Night** (cf. ill. p. 33)

scene of any last glimmer of hope, and make it into an unequivocal "anti-resurrection", setting it apart from traditional portrayals and from his own painting of 1909. Perhaps it is for this reason that the picture remained unfinished: a lingering hesitation may have prevented Beckmann from finalising irreversibly the apotheosis of doom. So it remains a provisional version. The apocalypse is planned, the material lets us see the plan, but the reality is not, or not yet, quite there.

Beckmann explores his new aesthetic syntax even more thoroughly here than in *Grenade*, taking the details a step further. Overall spatial composition and central perspective are abandoned for fragmentary views, scales are distorted, one plane abuts jaggedly onto another, in confrontation with spatial elements (such as the central reclining figures drawn in perspective). Hard, sharp contours collide, sharp-edged and with expressively exaggerated lines; scarcely a single figure escapes deformation. These are techniques with which Picasso had shocked the art world ten years earlier, in his *Demoiselles d'Avignon* (1907, p. 29), but unlike Picasso, for whom such means became more and more independent of content and gained a life of their own in form, Beckmann used them only to heighten expressivity and content. In the preparatory studies for

the *Demoiselles* Picasso also emphasised the content and expression of the composition, whereas the final picture marked his swing to formalism. Instead of content – the picture presents five prostitutes in a brothel – the formal structure which draws space and plane into a single system becomes central, and leads Picasso ultimately to Cubism. Beckmann, on the other hand, sought new formal solutions not for their own sake but in order to enhance meaning and expressivity.

In 1917, after the interrupted *Resurrection* project, Beckmann undertook some important works which show his increasing assurance in the new mode. It is striking that he should choose predominantly Christian themes as a vehicle to express the bitter experiences of war. The *Deposition* (p. 30) and *Christ and the Woman Taken in Adultery* (p. 31), for instance, are strikingly re-interpreted as generalised metaphors of guilt, suffering and cruelty. Scarcely any other twentieth century artist has made these Christian themes so relevant to the age and so expressive.

The Night
Die Nacht
Frankfurt am Main 1918/19
Oil on canvas, 133 x 154 cm
Göpel 200
Düsseldorf, Kunstsammlung Nordrhein-Westfalen

"With my Night too, one should forget the things represented, and see the metaphysical. The metaphysical shall triumph.
One should see only the beauty, in the same way that a funeral march is beautiful."
Max Beckmann in conversation with Reinhard Piper (1919)

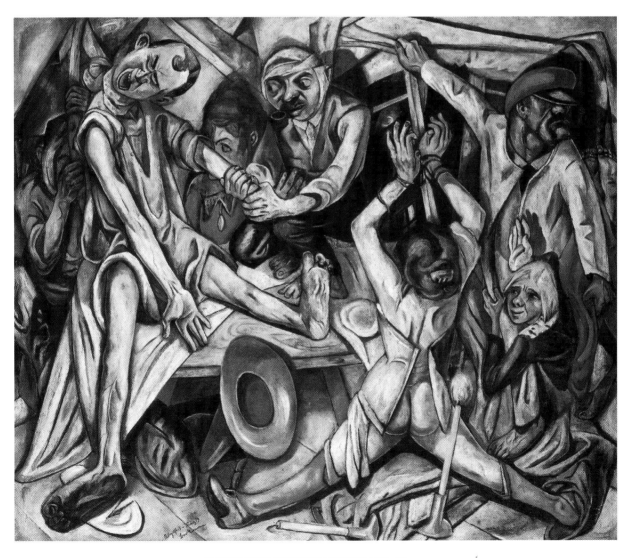

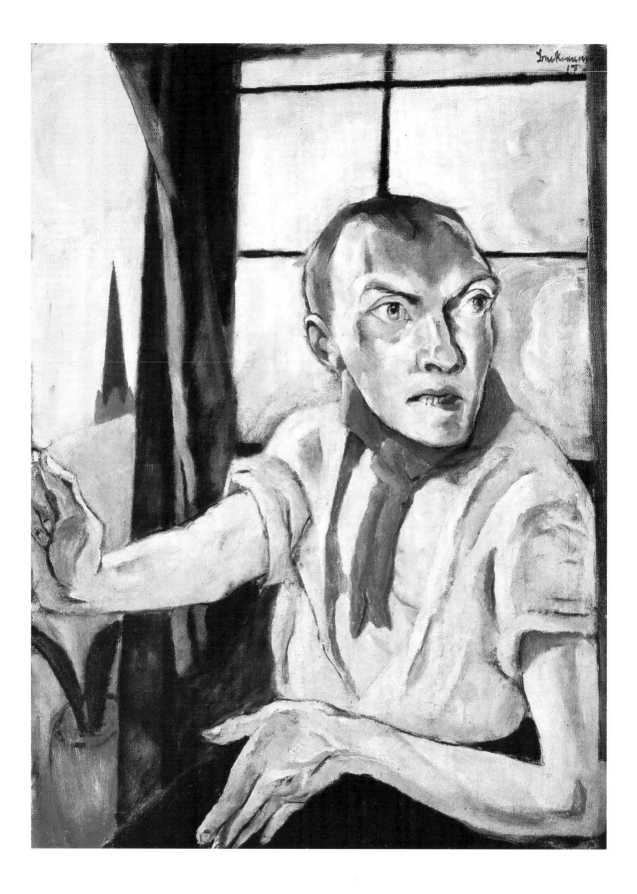

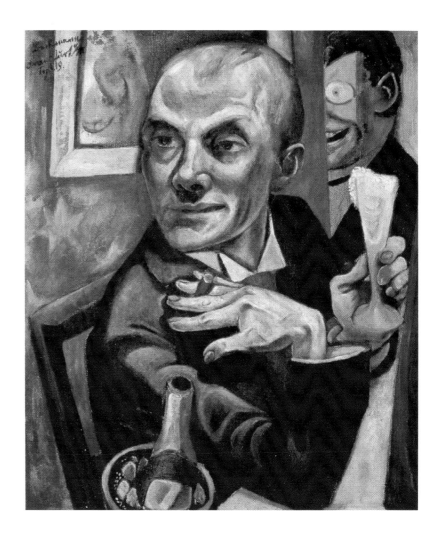

Self-Portrait with Champagne Glass
Selbstbildnis mit Sektglas
Frankfurt am Main 1919
Oil on canvas, 95 x 55.5 cm
Göpel 203. Private Collection

Self-Portrait with Red Scarf
Selbstbildnis mit rotem Schal
Frankfurt am Main 1917
Oil on canvas, 80 x 60 cm
Göpel 194
Stuttgart, Staatsgalerie Stuttgart

In his search for novel means of expression Beckmann recalls the late me-
diaeval masters: the horrifyingly emaciated and violated body of Christ in
the *Deposition* is reminiscent of the naturalism of fourteenth century *crucifxi
dolorosi*, and the coarse and brutal exaggeration of the figures suggests Mat-
thias Grünewald (c. 1480–1528) or Gabriel Mälesskircher (c. 1430–1495), to
whom Beckmann also makes explicit verbal reference (p. 31). There is no
trace of pathos-seeking in the works of this period. Unpretentiously and
mercilessly, the saviour himself becomes an object serving to demonstrate the
brutality and deformation suffered at the hands of the world and the people
in it. "There is nothing I hate more than sentimentality. The stronger my
determination grows to grasp the unutterable things of this world, the deeper
and more powerful the emotion burning inside me about our existence, the
tighter I keep my mouth shut and the harder I try to capture the terrible,
thrilling monster of life's vitality and to confine it, to beat it down and to
strangle it with crystal-clear, razor-sharp lines and planes". In these words of
1918 Beckmann formulated his new Creative Credo.[23]

These were the last of Beckmann's works with Christian themes for many
years. After the war he abandoned the field of traditional iconography entirely

Portrait of Max Reger
Bildnis Max Reger
Frankfurt am Main 1917
Oil on canvas, 100 x 70.5 cm
Göpel 191
Zurich, Kunsthaus Zürich

Photograph of Max Reger, 1915
Photo: Hoenisch

and created his own genres, deriving from the Christian metaphors of suffering a "profane passion". The most important work of this era, *The Night*, 1918/19 (p. 33), conveys the sum of his experiences during the war, projected onto postwar society in the city. The theatre of war has moved from the battlefield to the living-room: "Do you believe, you questioners, that you can already forget, that the war is over and done with? History? . . . This is not about things past. This is here and now," wrote Benno Reifenberg in 1921 with reference to *The Night*.[24]

An appalling scene of murder and torture is played out before the viewer's eyes, "a nightmare raised to metaphysical heights" (Reinhard Piper, 1879–1953). Three assassins transform a bourgeois attic idyll into a claustrophobic torture chamber: the first is hanging the father of the family from the rafters,

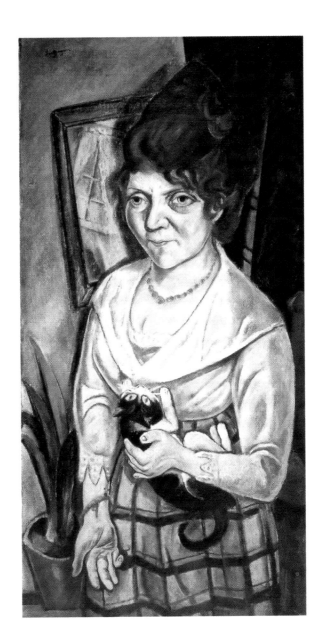

Portrait of Fridel Battenberg
Bildnis Fridel Battenberg
Frankfurt am Main 1920
Oil on canvas, 97 x 48.7 cm
Göpel 205
Hanover, Sprengel Museum Hannover

the second is breaking his arm. The third has grabbed the child and has his hand on the window, ready to throw it out. The woman's clothes have been half torn from her body; with bound hands and brutally parted legs she is about to be raped. Shrill tones seem to heighten the dreadfulness of the scene: the hanging man opens his mouth to scream, a dog howls his lament out of the left-hand side of the picture, but greater still is the impact of the gramophone's "mouth" in the centre with its drastically foreshortened perspective.

Yet strangely, like the black sun in *Resurrection* or the fire-ball in *Grenade*, the great round of the gramophone is the only point of repose in the hectic fragmentation of the picture. Only in its immediate vicinity does there seem to be some empty space, and it seems to absorb the sound rather than amplify it; the

infernal uproar is transformed into eerie silence, and in spite of its narrative violence the scene seems frozen still.

What at first glance appears to be unambiguously a scene of bloodthirsty ruffians destroying the bourgeois idyll, turns out on closer inspection to be much more problematic. Villains and victims, good and evil, are not so clearly distinguishable after all. The carefully arranged hair of the hanged man suggests a degree of bourgeois comfort and the broken plates are evidence of a recently consumed meal, whereas one of the perpetrators looks like a member of the starving proletariat and the one with the bandaged head may well be a victim, or veteran, of war. Paradoxically the child seeks refuge beneath the clothing of the murderer, of all places, and he in turn takes a harried, even persecuted look to see if there are witnesses around. There is no sign anywhere of any reason for the horrible events. Beckmann draws a topsy-turvy picture of a world peopled ultimately by victims only. Man has become a hell unto himself and, as the densely filled canvas shows, there is no place to escape.

Beckmann makes masterly use in this picture of techniques acquired in graphic work. With a few strokes he sketches a floor and at the same time suggests space. Space is suggested also by the extreme foreshortening of the hanging man's leg. But the upward view of boards and table precipitates this space upwards to such an extent that the people alongside, in front of and behind one another seem to have no scope for action. In addition to the spatial effect, the boards have an iconographic function: they suggest a stage. The scene becomes a scene from a play, transposed from reality to the level of timeless parable, as was indeed Beckmann's explicit intention: "With my *Night* too," he remarked to Piper in 1919, "one should forget the things represented, and see the metaphysical. The metaphysical shall triumph".[25] The preliminary drawings for the picture (p. 32) show how important the formal composition was to him, in addition to the iconographical. From the beginning the trapezoidal motif was central to the design of the picture. In the preliminary drawings this shape was formed by the legs of a man hanging head down; in the final version the motif is retained, but formed this time by the arms of a woman.

As in *Resurrection* the figures are drawn with amazing late Gothic expressiveness. Beckmann adopts the iconography of the *Man of Sorrow* and *Deposition* for the hanged man, and cites a figure from *The Triumph of Death* (p. 32), a fifteenth century fresco in the Camposanto cemetery in Pisa, for the murderer with the proletarian cap, on whom he bestows the features of Lenin. The dense grouping of the figures is reminiscent of fifteenth century Calvary scenes. Beckmann combines elements drawn from the Old Masters, especially from the expressive early German painters, with his own distinctive modern form of expression. By blending Christian topoi such as the deposition, the man of sorrows, and the torturing mercenaries with contemporary types drawn from the proletariat or victims of war, Beckmann achieves a form which transcends commentary on his own time: the corruption and cruelty of postwar society is raised to a general and timeless level of human experience, to eternal night, to humanity's hell on earth.

Beckmann's criticisms are not only levelled at other people, as they are in *The Night*. Relentlessly he perceives himself even more than others as a participant in the battlefield of social conflict. Comparison of *Self-Portrait with Red Scarf* (p. 34), painted during the war years, with *Self-Portrait with Champagne*

Portrait of Frau Tube
Bildnis Frau Tube
Frankfurt am Main 1918
Graphite on paper, 40.9 x 29.1 cm
Wiese 397
Frankfurt am Main, Städelsches Kunstinstitut
und Städtische Galerie

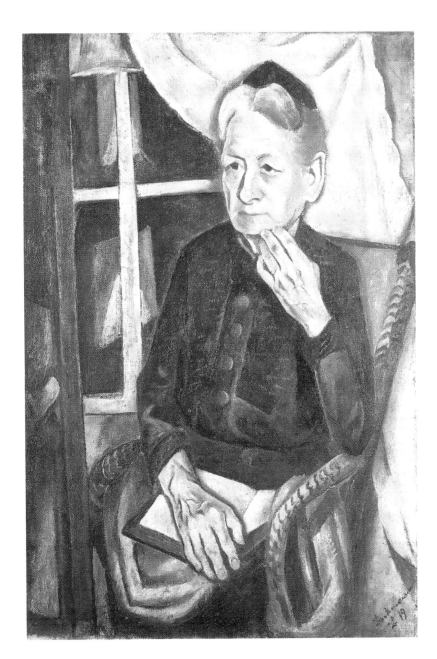

Portrait of Frau Tube
Bildnis Frau Tube
Berlin 1919
Oil on canvas, 90.5 x 59.5 cm
Göpel 201
Mannheim, Städtische Kunsthalle Mannheim

"First I always have to get inside a person's
head and become as familiar with it as with a
city in which one has lived for many years".
Max Beckmann (1915)

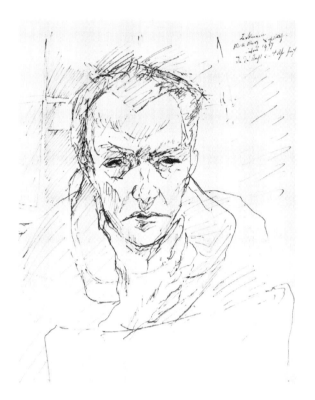
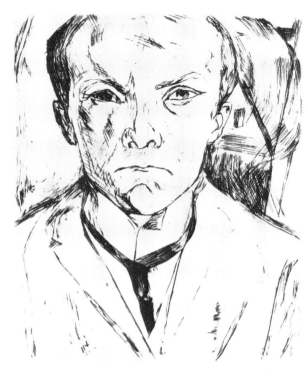

Left:
Self-Portrait, 1917
Selbstbildnis
Pen and black ink, 38.7 x 31.6 cm
Wiese 368
Chicago (IL), The Art Institute of Chicago,
Gift of Mr. and Mrs. Allan Frumkin

Right:
**Front View Self-Portrait, Gable in Back-
ground**, 1918
Selbstbildnis von vorn, im Hintergrund
Hausgiebel
Drypoint, 30.5 x 25.6 cm
Hofmaier 125

Glass (p. 35), painted in 1919, reveals the fatal development that Beckmann sees in a German society that has run off course, and in his own position within it: the *Self-Portrait with Red Scarf* shows a man hunted and harried, his physiognomy emaciated and hard-edged, his movements sudden and nervous, his face agleam with sparks of intensity and even insanity. The red scarf against the dull, pale colour of the body seems a defiant manifesto; the open-necked shirt, the clenched teeth and the resolute look are signs of revolt and protest. The protest finds direct expression in his art – and this art itself becomes protest: the extended right arm looks like a mechanical lever arm, translating directly onto the canvas the reality that the horrified gaze is forced to register.

Within the space of two years, resistance and the will to protest have yielded to destructive cynicism. In a tight black lounge suit, pressed between chair and table, Beckmann is now confined as a role-player in an unheeding society bent on entertainment. His hands no longer serve to record protest. Horribly twisted, as if broken, and yet full sized, they display their uselessness, degraded from their former use as the instruments of art to mere holders of decadent salon accessories: a champagne glass and a cigar. The mouth is distorted into a grin, showing his cynical self-loathing. Only his awareness of his own wretchedness distinguishes him from the idiotic would-be man-of-the-world in the background, who represents the salon society. The colours and the pattern of wallpaper suggest the transformation of the starry sky into a hell-fire; the perpendicular frame of the studio window has been replaced in this picture by disturbing diagonals which offer no support. Tormented and cynically tormenting, fully aware of the impossibility of keeping apart cause and effect,

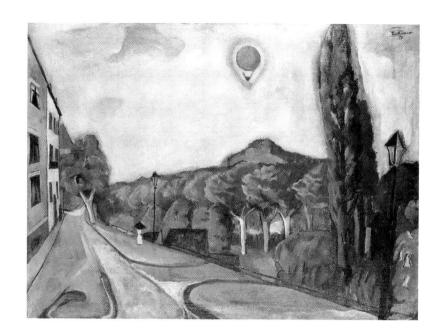

Landscape with Balloon
Landschaft mit Ballon
Frankfurt am Main 1917
Oil on canvas, 75.5 x 100.5 cm
Göpel 195
Cologne, Museum Ludwig

Landscape with Balloon
Landschaft mit Ballon
Plate 14 of *Faces*
Frankfurt am Main 1918
Drypoint (2nd Stage)
23.3 x 29.5 cm
Hofmaier 134. Private Collection

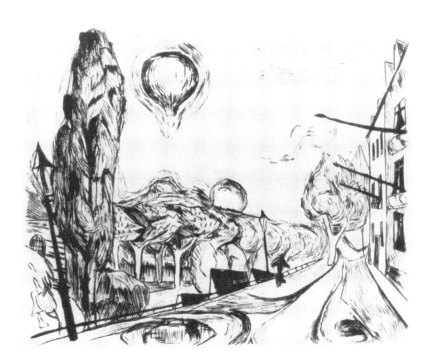

perpetrator and victim, Beckmann presents in this self-portrait a magnificent portrait of the postwar German society, whose schizophrenia was pilloried also by Dix, Grosz and others.

The other portraits originating from this period, though few in number, show that Beckmann judged himself more harshly than he did others. *Fridel Battenberg* (p. 37), wife of his friend and fellow-painter Ugi Battenberg, his mother-in-law *Minna Tube* (p. 39), and the composer *Max Reger* (p. 36) are all sharply characterised and by no means idealised, yet without the relentless cynicism that he applied to himself. "First I always have to get inside a person's head," he wrote to his wife Minna, when describing to her the difficulties of portrait-painting, "and become as familiar with it as with a city in which one has lived for many years."[26] Into no other face does he penetrate so deeply as he does his own.

Notwithstanding the pictures discussed in this chapter, Beckmann concentrated during the war years and the early 1920s primarily on graphic works. For him, as for most other artists at the time, financial considerations may have been a major motivation; paintings were difficult to sell during the economic crisis. Yet this was not for Beckmann the most compelling reason. As has already been suggested, the medium and techniques of graphic art with its harsh contrasts of black and white and its sharply incisive lines provided a new means of expression whose ultimate purpose was to convey oppositions, contradictions, devastation and destruction – in short, to capture the harshness and sharpness of perceived reality.

Direct comparison of Beckmann's media, for instance, of the painting and drypoint of *Landscape with Balloon* (p. 41), shows how his new expressiveness takes its orientation from graphic principles and is articulated with more urgency and intensity in graphic work. In spite of the extreme linear depth of the street, the painting seems more gentle, harmonious and round in the grouped trees, whereas the drypoint displays a more uncompromising sharpness of line. The more emphatic graphic technique is emphasised still further by the additional motif of the flagpoles, which seem to threaten the balloon with their spikes like lances or bayonets.

There was a further reason for Beckmann to turn increasingly to graphic work. Towards the end of the war, the attention of artists, Beckmann included, was drawn to the city itself as the new "theatre of war": "The war has now dragged to a miserable end. But it hasn't changed my ideas about life in the least, it has only confirmed them. We are on our way to very difficult times. But right now, perhaps more than before the war, I need to be with people. In the city. That is just where we belong these days. We must be a part of all the misery which is coming. We habe to surrender our heart and our nerves, we must abandon ourselves to the horrible cries of pain of a poor deluded people. Right now we have to get as close to the people as possible. It's the only course of action which might give some purpose to our superfluous and selfish existence – that we give people a picture of their fate. And we can only do that if we love humanity", declared Beckmann in his Creative Credo, published in a periodical in 1918.[27]

Print portfolios, favoured by other artists as well as by Beckmann, offered a better medium than did painting for conveying the turbulence of the city, the multiplicity of impressions and scenes, people and events; it was possible to create from a series of individual viewpoints a panoptic view of the variegated city world. His major portfolios created after the war are all concerned with life in the city: *Faces* (Gesichter, 1918, appeared 1919), *Hell* (Die Hölle, 1919),

Pages 43–49:
Hell
Die Hölle
Frankfurt am Main 1919
Lithograph series comprising 10 plates and title plate in portfolio
Portfolio format 88.5 x 64 cm;
plate format 87 x 61 cm
Hofmaier 139–149

Self-Portrait
Selbstbildnis
(Title plate of *Hell*)
38.5 x 30.3 cm
Hofmaier 139

"Hell. (Great Spectacle in 10 Plates by Beckmann.) We invite the honourable members of the audience to step closer with the pleasant prospect of not being bored for some 10 minutes. Anyone not satisfied gets money back."
(Text on the title plate)

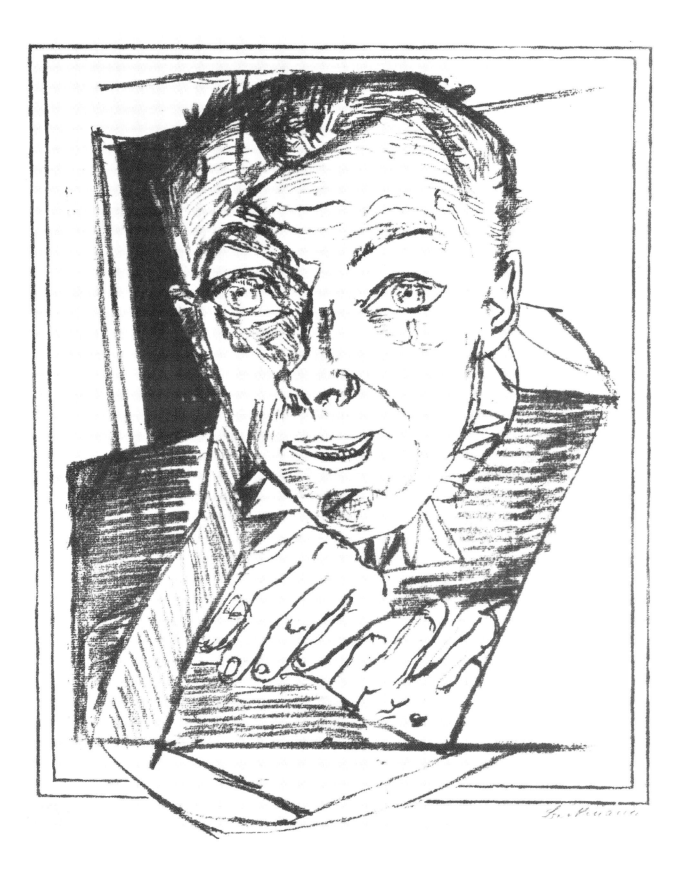

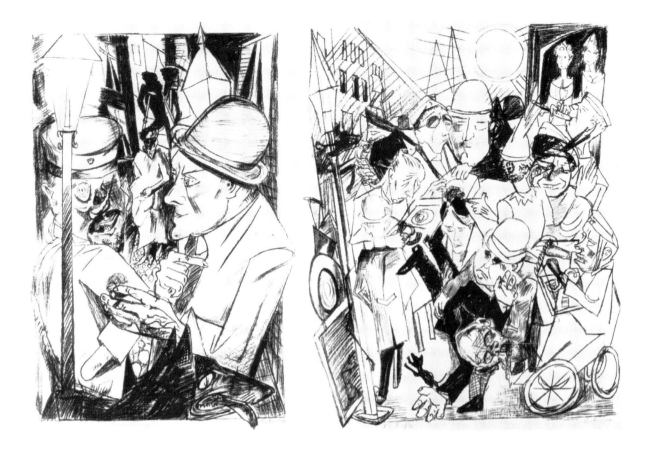

Left:
The Way Home
Der Nachhauseweg
(*Hell*, Plate 1)
73.3 x 48.8 cm
Hofmaier 140

Right:
The Street
Die Straße
(*Hell*, Plate 2)
67.3 x 53.5 cm
Hofmaier 141

City Night (Die Stadtnacht, 1920), *The Fair* (Der Jahrmarkt, 1921) and *Berlin Journey* (Die Berliner Reise, 1922).

The title of the first portfolio, *Faces*, is indicative of the ambivalence Beckmann felt with regard to his task as an artist in society. On the one hand, his task is to take individual faces, and with them individual destinies, from the anonymous mass of the city, to observe them and to render them visible for others – in short, to grasp the reality of the individual. On the other hand, there is contained in the German title *Gesichter* a reference to the ability to see, the gift of vision, the calling of the artist.

The 1919 portfolio *Hell* introduces ten different facets, all reproduced on these pages (pp. 43–49), of city life. Whereas *Faces* was a collection of prints from various times and contexts, *Hell* is the first of the portfolios with a planned sequence in which each print has its specific place. Although Beckmann pays detailed attention to current social and economic factors and even to the crucial political events of the day, such as the murder of Rosa Luxemburg (1870–1919), yet in their totality these prints create a timeless picture of human society. They show the insanity of a society in which each human being has become the other's hell, with an intensity unmatched by previous artists unless it be by Francisco de Goya in his *Desastres de la Guerra* (p. 45). It is the universal validity of the message that distinguishes Beckmann's cycle from the graphic works of other artists at the time, such as Grosz, whose message was more tightly bound to events and politics of the day.

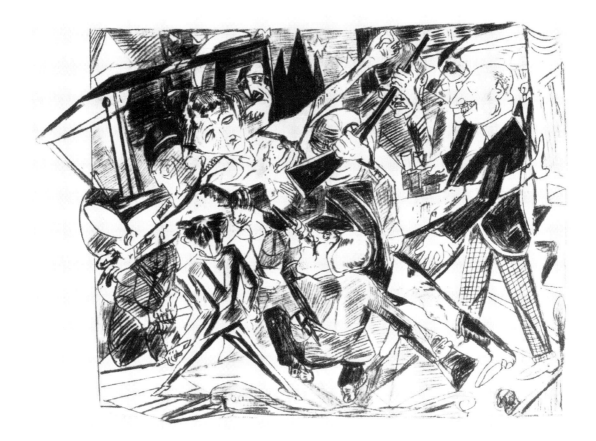

Martyrdom
Das Martyrium
(*Hell*, Plate 3)
54.5 x 75 cm
Hofmaier 142

Francisco de Goya
Por qué? (Why?), 1811/12
Plate 32 from the etching series "Desastres de
la Guerra" (The Horrors of War)
The series first appeared in 1863

The ten large-scale lithographs, comparable by virtue of their format to oil paintings, are preceded by a self-portrait title-leaf (p. 43). Just as the figure of St. John regularly precedes mediaeval representations of the individual visions of the Apocalypse, Beckmann presents himself in this portfolio as the man who has gazed into the unfathomable depths and has descended into hell. A ruff marks him as jester, but the wide open eyes attest the high seriousness of his mission, or vision. The black opening behind him marks the gate of hell through which he has just emerged, and he breaks through the frame in front of him, removing any barrier between the viewer and his impressions.

In the first print – *The Way Home* – Beckmann, the narrator, comes upon a grotesquely deformed figure in the lamplight, who points the way to hell. It is a war cripple, composed entirely of artificial limbs, eyes, mouth; at the bottom of the picture Cerberus, the hound of hell, bares his teeth. Again it is Beckmann here who breaks the frame, signifying that he is going on and that he does not recognise any demarcation. The next plate, *The Street*, reveals hell as a city scene peopled with cripples, prostitutes, fools and "respectable" citizens. A couple try to pull an injured man – or is he already dead? – out of the crowd, who show no sign whatsoever of offering help. Each person turns away as if he or she sees nothing, or even finds things cynically entertaining, like the woman at the right-hand edge of the picture. But the "saviour" himself hardly inspires trust, looking for all the world like a corrupt state prosecutor

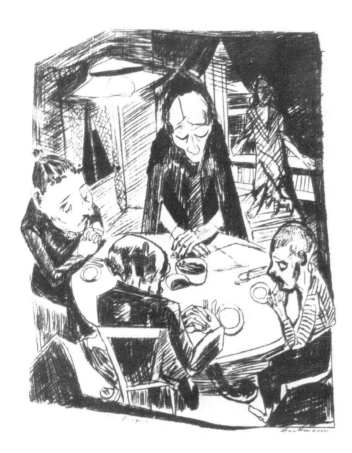

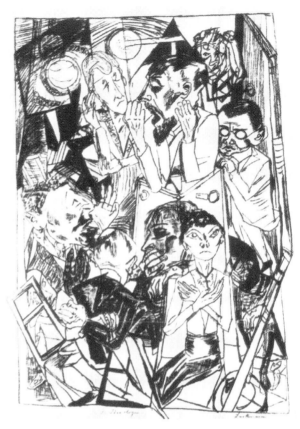

Left:
Hunger
Der Hunger
(*Hell*, Plate 4)
62 x 49.8 cm
Hofmaier 143

Right:
The Ideologues
Die Ideologen
(*Hell*, Plate 5)
71.3 x 50.6 cm
Hofmaier 144

anxious to get rid of the traces of a crime as quickly as possible. It may be that Beckmann is alluding here to the murder of the anarchist writer Gustav Landauer on 2 May 1919 in Munich.

Martyrdom is concerned with another political assassination, the murder of Rosa Luxemburg. As the title suggests, Beckmann elevates the death of the socialist leader to a higher level by expressing it in the form of a Christian rendering of the Passion, uniting in a single picture several of the stations of the Cross. The arms extended wide and the body of the woman form a cross; the scene can be interpreted in several different time settings. The people beating her with rifle-butts and dragging her along the street transpose the flagellation and the mocking of Christ to the Berlin Kurfürstendamm in 1919. The flagellation reading suggests that the cross is being raised up, but the scene could equally well be interpreted in terms of the deposition (see Beckmann's *Deposition* of 1917, p. 30). Deposition becomes lustful physical abuse: instead of being laid in the grave her body is dragged into a car to be carried off. In its fragmented structure, expressive figure drawing and brutal theme of torture the scene is akin to the painting *Night*, which Beckmann scaled down and re-drew for inclusion in the cycle, and to which he gave a central sixth place in the sequence. These two plates stand out in the cycle also by virtue of their wide, rather than high, format.

In *Hunger* and *The Ideologues*, which precede *Night* in the sequence, Beckmann confronts the two polar extremes of post-war society one with another. The

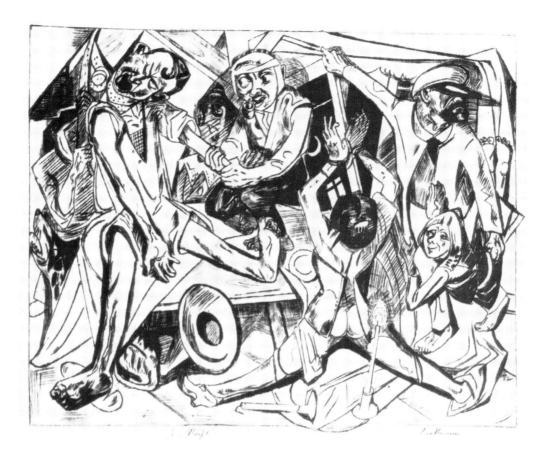

comfortless situation of a starving family – in this case there is no breaking through but rather a sinking inwards of the frame – is followed by the *Ideologues* representing the supposed spiritual and intellectual leaders of a new society. Their meeting is chaotically confused, complacency and vanity are just as much in evidence as is their inability to communicate. *Night*, the epitome of hell, sharing with *Martyrdom* the central position in the sequence, is followed by *Malepartus* (a name taken from a Frankfurt bar), in which the sensual ecstasy of a life of pleasure may be seen as counterpart to the "spiritual fatherhood" of a society that has veered out of control. The whole scene is in the grip of a whirlwind, everything is spinning around, the stiff contortions of the dancers make them hardly distinguishable from the cripples who are denied entry to the exclusive venue. The head of the man in the centre is shaped like a skull, exposing the whole macabre event as a dance of death. In the next plate the *Patriotic Song* has become the primitive and raucous bawling of drunken war veterans. Their frustrated appearance stands for the demoralised mood of Germany after the war. The once proud symbol of the state – the imperial Prussian eagle – looks like some shabby insect on the cup.

In the *Last Ones* the violence culminates in a sad climax. It is as if all the characters who have gone before – soldiers, cripples, householders, proletarians – are joining together in an orgy of violence. The composition builds up a powerful arc of tension, beginning at the bottom on the left with the chair, then curving up and over to the right, where all the forces of this violence seem

The Night
Die Nacht
(*Hell*, Plate 6)
55.6 x 70.3 cm
Hofmaier 145

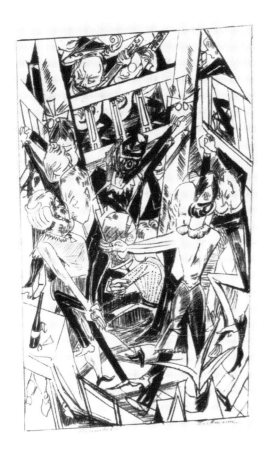

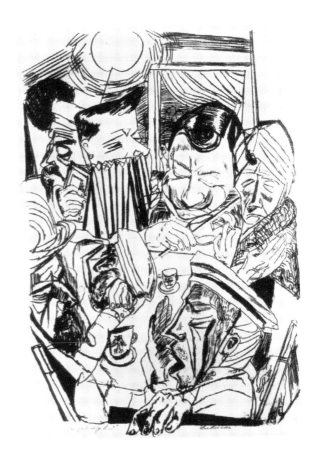

Left:
Malepartus
(*Hell*, Plate 7)
69 x 42.2 cm
Hofmaier 146

Right:
The Patriotic Song
Das patriotische Lied
(*Hell*, Plate 8)
77.5 x 54.5 cm
Hofmaier 147

to be gathered into the firing of the rifles out of the crowded narrowness of the room, and hurled out onto the street outside to be continued there as well. Yet what the composition has led us to see at first as a joining of forces turns out to be a ruthless fight of each person against the other, in which each one becomes loser and victim.

The last plate, *The Family*, is perhaps the most shattering in this kaleidoscope of terror. At the end of his path through hell Beckmann encounters his own family – there is a seamless join between this and the title-page in which he still seemed to be located outside the gates of hell. There is no longer any difference between his own reality and his vision of hell: hell is everywhere. Beckmann's reaction is one of anger and defiance. With his upward-pointing gesture he seems to be attributing to God the blame for the hopelessness of the situation, as he did that same year in a conversation with Piper: "My religion is pride before God, defiance towards God. Defiance because he has made us in such a way that we are incapable of loving each other. In my pictures I reproach God for everything that he has done wrong."[28]

His mother-in-law, on the other hand, incorporates in her gestures and lowered gaze just the opposite, namely humility before God. This last plate shows how vain and useless both reactions are in the face of reality. The window-cross in the background points to death, ever-present in the background; while in the foreground the child – a portrayal of Beckmann's son Peter – in spite of the polarity between childhood and death, brings death and

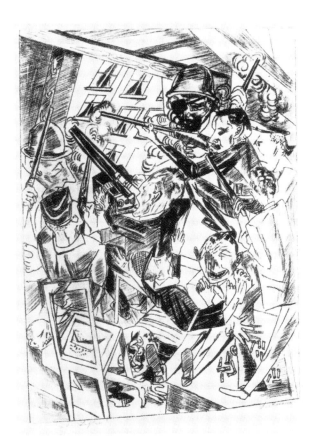

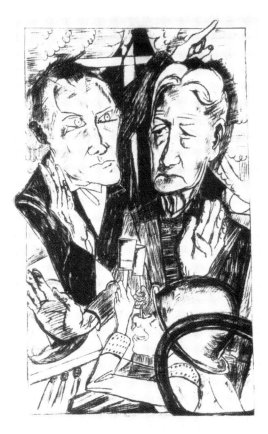

destruction into the world in the shape of the hand grenades that he has found and is proudly presenting to his father. So hell lies ultimately in the inability of mankind to effect change, in the restriction of choice to the choice between violence and death. The means of portrayal convey this message too: throughout the sequence it is fragmented chaos and interrupted rhythm of line that control the figures, rather than the other way round. The entire sequence conveys an impression of claustrophobia and hopeless constriction; mankind seems imprisoned and straitjacketed in a hell from which there can be no escape.

Left:
The Last Ones
Die Letzten
(*Hell*, Plate 9)
75.8 x 46 cm
Hofmaier 148

Right:
The Family
Die Familie
(*Hell*, Plate 10)
76 x 46.5 cm
Hofmaier 149

"My religion is pride before God, defiance towards God. Defiance because he has made us in such a way that we are incapable of loving each other. In my pictures I reproach God for everything that he has done wrong."
Max Beckmann in 1919 in conversation with Reinhard Piper

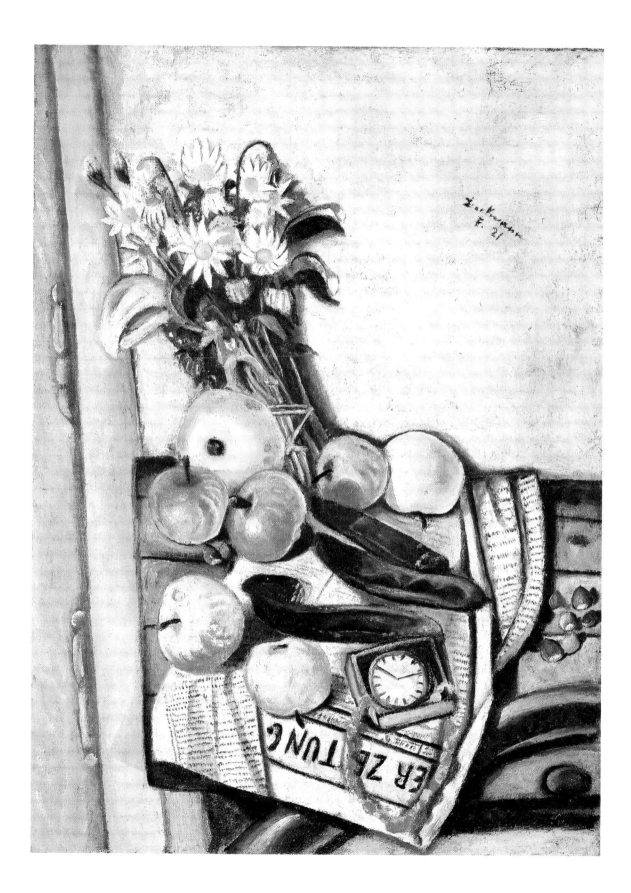

Consolidation of Form:
The Twenties in Frankfurt

After the inferno of war and the creative assimilation of the experiences of the immediate post-war period, there followed a further profound change in Beckmann's art. This time the change was less abrupt; it was a gradual development over a period of years. The revulsion Beckmann felt towards bourgeois society, gallery and salon, is understandable after the horror of war, and it is still evident in pictures such as *Self-Portrait with Champagne Glass*, but it gradually gave way to a more sober contemplation of the world and of his place in it. After protest and revolt, cynicism and self-loathing, there followed a gradual return to bourgeois "order".

There is external evidence of this in his more stable living conditions. After his breakdown his friends Ugi and Fridel Battenberg had offered a refuge in their home in Frankfurt am Main, and when they gave up the apartment Beckmann took it over. He kept the studio in the Schweizerstrasse throughout his time in Frankfurt until 1933, when he evaded the Nazis by moving to the anonymity of Berlin. The first exhibition of paintings in the new style, shown in Frankfurt in 1919, was very well received and it marked the beginning of his new rise to artistic and social acclaim. The first post-war purchases for museums were made: the *Deposition* (p. 30) was bought by Georg Swarzenski (1878–1957) for the Frankfurt Städel Art Institute and *Christ and the Woman Taken in Adultery* (p. 31) and *Portrait of Frau Tube* (p. 39) by Fritz Wichert for the Mannheim Kunsthalle.

Israel Ber Neumann, who had an important gallery in Berlin, published the *Hell* sequence of lithographs and became Beckmann's Berlin agent while Peter Zingler represented him in Frankfurt. This meant material security for the time being. Beckmann also emerged from social isolation and in the circle around his friend and patron Heinrich Simon, editor in chief of the internationally renowned *Frankfurter Zeitung*, he came into lively contact with the most prominent people in Frankfurt society. He got to know, among others, the actor Heinrich George (1893–1946), the head of the powerful firm I.G. Farben, Georg von Schnitzler, and his wife, Lilly, who was to give support during Beckmann's years of exile in Amsterdam, the writer Fritz von Unruh (1885–1970), the director of the Frankfurt Städel Art Institute, Georg Swarzenski (1878–1957), and members of the Frankfurt municipal council.

There was consolidation also in Beckmann's artistic development, both in choice of themes and in technique. From subject matter in which sombre

The Beckmanns' apartment on the Sachsenhäuser Berg, Frankfurt am Main, Steinhauserstrasse 7

Still Life with Marguerites
Stilleben mit Margeriten
Frankfurt am Main 1921
Oil on canvas, 49.5 x 35.5 cm
Göpel 212
Germany, Private Collection

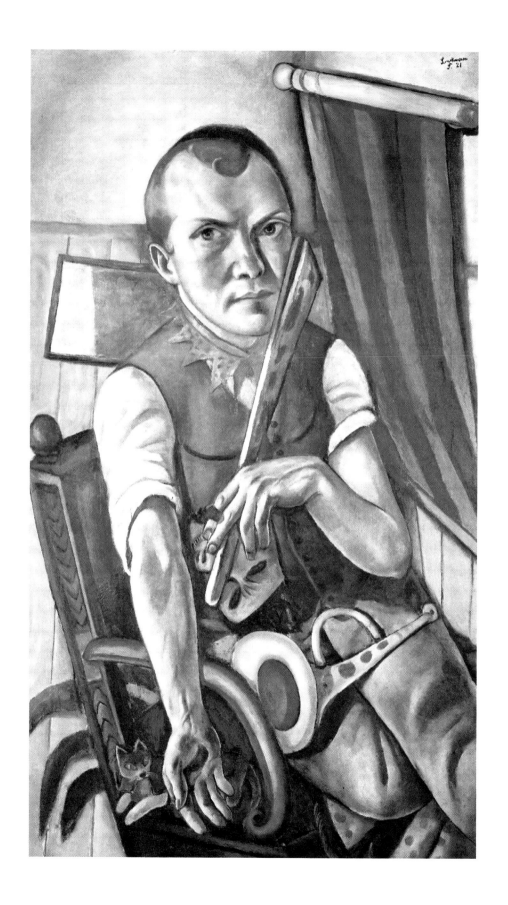

polemics and indictment are more central than objects, as in *The Night* (p. 33), Beckmann turned to focus more closely on the object. It is as if, after the fearful destructive fragmentation of body and spirit, he was now looking to things, to the concrete, to the object, for some lasting hold in life and in his work. Still life, landscape and portrait, all with a focus on actual objects and figures, loom large in the work of the twenties. "I paint portraits still lifes landscapes visions of cities rising from the sea, lovely women and grotesque freaks. People bathing and female nudes. In short a life. A life simply existing. No thoughts or ideas. Filled with colours and shapes derived from nature and from myself. – As beautiful as possible. That will be my work for the next ten years", wrote Beckmann on 9 August 1924 to the Berlin gallery owner Israel Ber Neumann.[29]

Beckmann was not alone in the importance he attached to "life simply existing" in the early twenties. The Neue Sachlichkeit (New Objectivity) did not only establish a style which ran counter to Expressionism, it also reflected the sober and disillusioned attitudes to life which were prevalent in the wake of the first world war. The collapse of the old order and the horrors of war gave way to a widely perceived inner emptiness, which found expression in many disturbing New Objectivity works, by artists as varied as Christian Schad (1894–1982), Georg Schrimpf (1889–1938), Alexander Kanoldt (1881–1939) and Anton Räderscheidt (1892–1973) in Germany, Giorgio de Chirico (1888–1978) and Felice Casorati (1886–1963) in Italy, and others in other European countries.

All these works display a focussing on the object which seems to emerge from a vacuum, for want of other values, and they all share a needling inner emptiness and frigidity as a result of this. Although Beckmann remained on the periphery and was never a typical exponent of New Objectivity, critics at times went so far as to see him as its leading spirit. Gustav Friedrich Hartlaub (1884–1963), to whom the common usage of the term "New Objectivity" as applied from the time of the great Mannheim exhibition of 1925 may be attributed, saw in Beckmann's works the possibility of reconciliation between the conservative classicist trend within New Objectivity and the contrasting "contemporary stridency born of the denial of art". In 1922 Hartlaub had already prophesied: "We await the redeemed Max Beckmann of the future".[30]

Once again it is a self-portrait, the 1921 *Self-Portrait as Clown* (p. 52), that indicates Beckmann's new position. The upright format contributes to the impression of greater mellowness, giving more support to the natural form of the human figure and allowing more scope for movement than the constricting narrowness of *Self-Portrait with Champagne Glass* two years earlier. In spite of the restlessness of the sitting position, the figure is no longer so contorted, and the earlier sharp contours of physiognomy have given way to a more rounded plasticity which allows the figure to regain a certain calm and natural simplicity. Beckmann holds out his right arm with the palm open, like Christ showing his stigmata, or like the hanged man in *The Night*, displaying his own unforgotten wounds. At the same time the parallel with Christ the Man of Sorrows is a manifestation of the incipient healing process. A similar argument is put forward by Joseph Beuys (1921–1986) in his challenging 1976 installation *Show Your Wound* (Munich, Städtische Galerie im Lenbachhaus). What matters is not to blot out life's memories but to be aware of one's past,

Still Life with Gramophone and Irises
Stilleben mit Grammophon und Schwertlilien
Frankfurt am Main 1924
Oil on canvas, 114.5, x 55 cm
Göpel 231. Private Collection

Self-Portrait as Clown
Selbstbildnis als Clown
Frankfurt am Main 1921
Oil on canvas, 100 x 59 cm
Göpel 211
Wuppertal, Von der Heydt-Museum

to recognise one's identity in these wounds, and to build upon this knowledge one's future existence.

Beckmann portrays himself in clown's garb, with ruff, mask, slapstick and carnival red, but the earnestness and awareness of facial expression show that this is no harlequin. He has the wherewithal to play the part of the clown in society, but it is he who will decide when to wear the mask. He is not forced into his role, as he was in *Self-Portrait with Champagne Glass*; he will decide himself whether to play the part or not. Nor is the role of the clown merely a negative one. Although the fool may be derided, the mask gives him the fool's licence to utter truths that cannot otherwise be uttered with impunity. In spite of the precariousness of the picture, the lack of spatial definition, the instability of the chair, the disturbing diagonal lines, and the unmistakable self-irony – the picture parodies the dynastic portrait, with rocking-chair in-

Page 54:
Dance in Baden-Baden
Tanz in Baden-Baden
Frankfurt am Main 1923
Oil on canvas, 100.5 x 65.5 cm
Göpel 223
Munich, Bayerische Staatsgemäldesamm-
lungen, Staatsgalerie moderner Kunst,
Stiftung Günther Franke

stead of throne, slapstick instead of sceptre, laughable red stripes in place of purple wall-hanging – Beckmann is showing that he has overcome his earlier self-devouring cynicism and has accepted his new role. He knows that he is no clown although he may play that part; his human dignity is not made ludicrous.

Beckmann's themes continue to derive from social analysis, but there is a definitely altered thrust. He turns from naked force to the double standards of the salon (*Dance in Baden-Baden*, p. 54), to the acutely problematic social phenomena of masquerade and role-play, isolation and lack of communication. Whereas a *horror vacui* had filled all the available space in the earlier canvases,

Before the Masquerade Ball
Vor dem Maskenball
Frankfurt am Main 1922
Oil on canvas, 80 x 130.5 cm
Göpel 216
Munich, Bayerische Staatsgemäldesamm-
lungen, Staatsgalerie moderner Kunst

Lido
Frankfurt am Main 1924
Oil on canvas, 72.5 x 90.5 cm
Göpel 234
St. Louis (MO), The Saint Louis Art Museum,
Bequest of Morton D. May

"I paint portraits still lifes landscapes visions of
cities rising from the sea, lovely women and
grotesque freaks. People bathing and female
nudes. In short a life. A life simply existing.
No thoughts or ideas. Filled with colours and
shapes derived from nature and from myself.
As beautiful as possible."
Beckmann in a letter to the gallery owner
I. B. Neumann (9 August 1924)

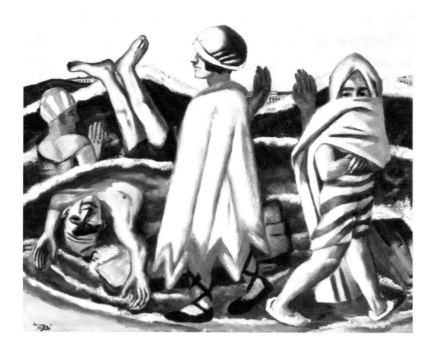

Arnold Böcklin
Play of Waves, 1883
Im Spiel der Wellen
Oil on canvas, 180.3 x 237.5 cm
Munich, Bayerische Staatsgemäldesamm-
lungen, Neue Pinakothek

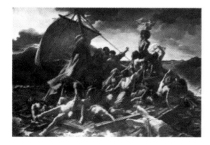

Théodore Géricault
The Raft of the Medusa, 1818/19
Oil on canvas, 491 x 716 cm
Paris, Musée National du Louvre

leaving the figures no room for manoeuvre, now space itself becomes palpable.
But this in turn is used to express a lack; space becomes a symbol of isolation
and emptiness.

In *Before the Masquerade Ball* (p. 55) space serves as backcloth for the theatre of
the world, a metaphor that Beckmann favoured in words as well as in pictures.
There is no trace of carnival spirit. Postures and facial expressions are frozen,
there is no communication in word or look. Each figure has its own space, but
this has become a vacuum. From the child to the old woman, all wait immobile
in their roles. The stage metaphor takes away the last vestiges of privacy that
might be expected in a family scene – for the figures are Beckmann himself, in
the centre, on the left his son Peter and wife Minna, on the right two friends
from Graz (where Minna was performing at the opera) and his mother-in-law.
Even family life has become a stage performance in which each character plays
the prescribed part.

The oppressive scene does not convey the embittered indictment of *The
Night* (p. 33), but it expresses isolation and resignation, and the impossibility
of escaping one's role and ending the farce. The masquerade is the central
motif not only in this picture, and it shows a reversal of his view of society.
Beyond the metaphor of role-play he recognises more and more clearly the
grotesqueness of human cohabitation, which he finds at once alluring and
alienating.

This grotesque quality of life is displayed again in the 1924 beach scene
Lido (p. 56). What seems at first glance a scene of jolly seaside pleasures turns
out to be a scurrilous and even threatening scenario. Arnold Böcklin (1827–
1901) presented his *Play of Waves* (p. 56) as a metaphor for sensuality and
Dionysian joys, and Beckmann used the same title, but for him it became a
token of mankind's helplessness, at the mercy of the waves. The man on the
left is so buffeted by the waves that torso and legs seem to belong to two

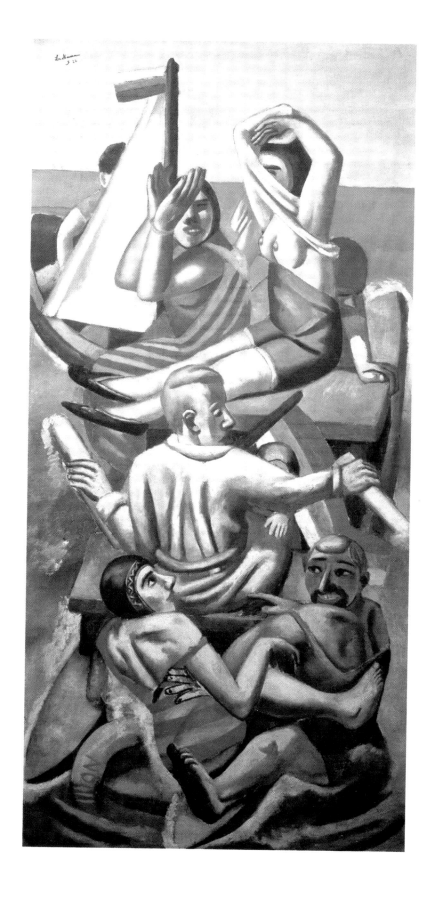

The Barque (Play of Waves)
Die Barke (Spiel der Wellen)
Frankfurt am Main 1926
Oil on canvas, 180.5 x 90 cm
Göpel 253
New York, Mr. Richard L. Feigen Collection

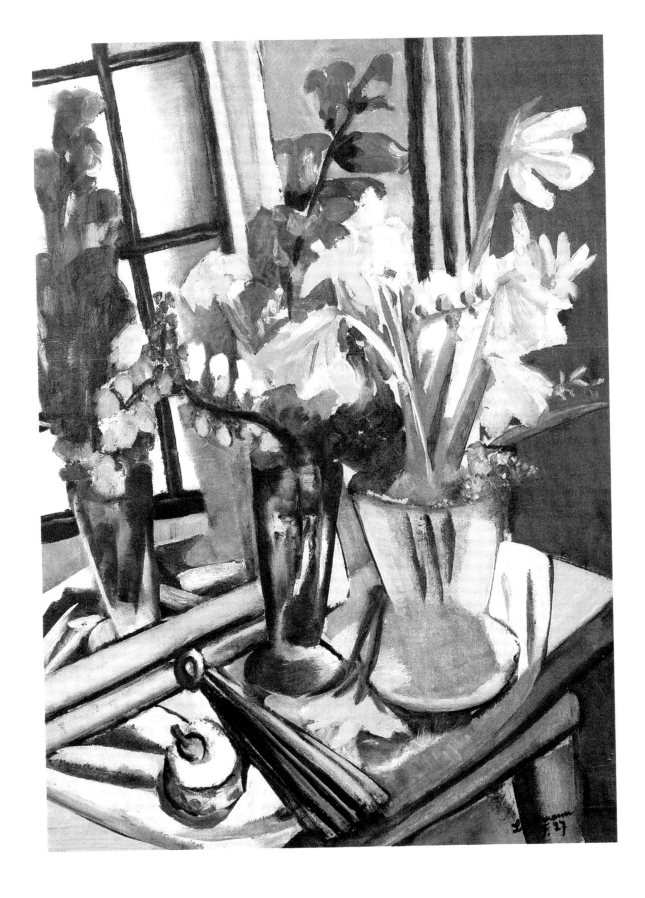

Right:
Still Life with Violet Dahlias
Stilleben mit violetten Dahlien
Frankfurt am Main 1926
Oil on canvas, 70 x 36 cm
Göpel 25
Private Collection

Page 58:
Still Life of Flowers with Mirror
Blumenstilleben mit Spiegel
Frankfurt am Main 1927
Oil on canvas, 80 x 60 cm
Göpel 271
Private Collection

different people. The legs suggest an (intentional) dive into the deep, but the tortured expression and helplessly flailing arms of the man whose upper body has regained the surface show that he has been thrown off course and hurled aground by the waves. At least he is not yet at the point of death, unlike the drowning man whose arms and vanishing head are still just visible between the two figures in the foreground. The turbulent sea is dark and threatening with its sombre colouring, the towering two-dimensional waves seem like walls. The sinister impression is heightened by two coffin-like wooden planks. The two figures in the foreground take no notice of the drama that is unfolding before their very eyes. Their apparent detachment and their ridiculous fancy dress make the scene all the more shocking. The picture shows the impact of the stream of life on human beings, and their self-alienation when confronted with life's caprices. For all its individual tragedy, however, the surrealism of the picture retains a grotesque humour and

Mirror on an Easel
Spiegel auf einer Staffelei
Frankfurt am Main 1926
Charcoal and black crayon on paper
50.2 x 64.1 cm
New York, The Museum of Modern Art,
Gift of Stanford Schwartz

comedy and is no longer dominated by the bleakness that prevailed, for instance, in *Before the Masquerade Ball.*

A similar view of life is depicted in *The Barque (Play of Waves)* (p. 57). There is an illuminating comparison to be made here with Théodore Géricault's *The Raft of the Medusa* of 1818/19 (p. 56) which Beckmann knew from his time in Paris and which he had alluded to once before. As in Géricault's picture, the viewer's attention is focused on a bevy of figures, but whereas Géricault's figures join together and rear up to form a pyramid, denoting the principle of hope for mankind confronted with the threat of doom – hope justified by the appearance of the tiny boat on the horizon – for Beckmann the entanglement of the figures has no further purpose or meaning. There is no external threat against which the figures can make common cause, the sea being almost alarmingly calm. Instead they are preoccupied with their own curious intertwinings and

The Nizza in Frankfurt am Main
Das Nizza in Frankfurt am Main
Frankfurt am Main 1921
Oil on canvas, 100.5 x 65.5 cm
Göpel 210
Basle, Öffentliche Kunstsammlung Basel,
Kunstmuseum

diversions. As in *Lido* (p.56) there is an ambivalent impression of seriousness and humour. At first the bright colours, the holiday atmosphere conjured up by the presence of the Italian flag and the grotesque disarray convey a jolly picture. Yet the company seems to have been smitten by an inner vacuousness dominated by sexuality and bondage. The uppermost figures weigh down, optically at least, on those below, who are in danger of sliding off into the dark sea. For all the efforts of the oarsman the boat seems to be getting nowhere, so that the grotesque little company drifts in aimless self-absorption on the sea.

However, Beckmann was no longer concerned only to refute, to negate and to accuse; he was also concerned with the intrinsic dignity of the object, and

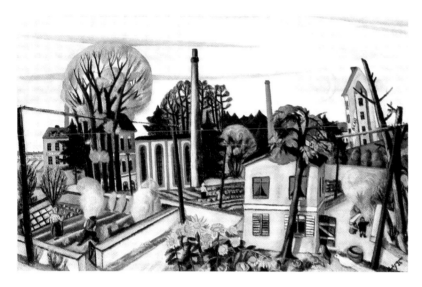

Landscape near Frankfurt am Main
Landschaft bei Frankfurt am Main
Frankfurt am Main 1922
Oil on canvas, 66 x 100.5 cm
Göpel 214
Waltham (MA), Rose Art Museum,
Brandeis University, Gift of Mr. and Mrs.
Harry N. Abrams

this is most clearly revealed in his increased attention to still life and landscape. From the early 1920s until he died he turned regularly to still life. These paintings are not widely known since public response has tended to focus more on his depiction of the human figure, but almost half his œuvre consists of urban scenes or landscapes (c. 260) or still lifes (c. 140).

For Beckmann, as for Cézanne, probably the greatest of the early Modern still life painters and one whom Beckmann venerated, the still life demanded close attention to the object and self-discipline. The still life was for the artist what the étude was for the musician: it required the artist to dismount from the "high horse" of figure painting and iconography and to turn instead to the prime concerns of composition, colour, plasticity and dimension. For Cézanne the still life was always in a sense an "act of penance", obliging him to discipline his unruly emotions, to attend to reality and to reflect upon painterly form.

The same could be said of Beckmann, who called in 1917 for an "objectivity of inner vision".[31] For Beckmann there is a further important point: in the still life he found liberty, freedom from the self-imposed constraints of form and expression, a place where he could celebrate and enjoy the form of painting for its own sake, something which Pablo Picasso and the Impressionists had done as a matter of course. The formal priority notwithstanding, Beckmann's

The Iron Footbridge
Der Eiserne Steg
Frankfurt am Main 1922
Oil on canvas, 120.5 x 84.5 cm
Göpel 215
Düsseldorf, Kunstsammlung Nordrhein-
Westfalen

Portrait of Frau H. M. (Naila)
Bildnis Frau H.M. (Naila)
Frankfurt am Main 1923
Woodcut, 59.7 x 34.3 cm
Hofmaier 282

still life œuvre, like Cézanne's, is very interesting from the point of view of iconography.

Still Life with Marguerites (p. 50) is a wonderful study of apples and flowers, but it is more than that: newspaper and clock introduce the themes of transience and the confines of time. Symbols of the vanity of the world were an important component of sixteenth and seventeenth century painting in the Netherlands, and with emblems of this sort Beckmann is alluding not only to the painterly form but also to the whole earlier history of the still life tradition, though the most obvious influence may be that of Cézanne.

It is not so much the history of painting as its specific manner and function

Portrait of Frau Dr. Heidel
Bildnis Frau Dr. Heidel
Frankfurt am Main 1922
Oil on canvas, 100 x 65 cm
Göpel 217
Hamburg, Hamburger Kunsthalle

that is the theme of another still life, Beckmann's charcoal and crayon *Mirror on an Easel* (p. 60). Easel and frame suggest that the mirror is a picture – a reflection, common since the Renaissance, on the nature of the picture as mirror. But painting is presented not only as a mirror picture: it also makes accessible the view out of a barred window which the mirror reflects. By means of this double refraction Beckmann's still life defines painting as a limited view of nature, wherein the grid structure expresses subjection to an abstract order; but the view offers nevertheless both literal and figurative reflection.

Ambivalence of picture and mirror is evident again in *Still Life with Gramophone and Irises* (p. 53). In this still life, as in numerous others, Beckmann gathers

Portrait of Elsbeth Goetz
Bildnis Elsbeth Goetz
Frankfurt am Main 1924
Oil on canvas, 95.5 x 35.5 cm
Göpel 229
Lübeck, Museum für Kunst und Kultur-
geschichte der Hansestadt Lübeck

Page 67:
"Locked up like children in a dark room we sit
there, god-fearing creatures, waiting for some-
one to open the door and lead us out to execu-
tion, to our death. When the belief that we
can make our own decisions is firm in us,
then, and only then, shall we achieve a greater
measure of responsibility for ourselves."
Max Beckmann, Der Künstler im Staat (The
Artist and the State, 1927)

together an assortment of objects and symbols familiar also from his figure
paintings, such as the striking flared centre-piece of the gramophone already
encountered in The Night. Some of the items, such as the mask on the chair, the
fan on the ground and the masked woman in picture or mirror, have connec-
tions with play-acting, impersonation or masquerade. The whole scene, with
flowers and the letter on the floor, is suggestive of the dressing-room of a star,
perhaps a singer (with mandolin and gramophone). The objects themselves
seem to be masquerading and challenging the audience to make connections,
to piece together the parts of a play.

Yet although the representation, for instance of the gramophone, and the
collocation of objects suggest symbolic meaning, there can be no definitive
iconographic interpretation. Connections between the items are established
"only" by composition, form and colour: the central round of the gramophone
amplifier corresponds with the roundness of the table, the mandolin, the vase
and the white shape at the right-hand edge of the picture; the base and the
upper edge of the composition are shaped in contrast by the right angles of
the gramophone stand and the picture. One possible sense of all this could be
that ultimately form and colour alone, in other words painting alone, can
create order and establish relationships amidst the unfathomable motley con-
fusion of things in this world.

The grotesque juxtaposition of things that do not sit easily together is also
a feature of Beckmann's landscape painting in the early twenties. The Land-
scape near Frankfurt am Main of 1922 (p. 62), juxtaposes bare trees and trees in
leaf, a factory with its chimneys, and isolated, curiously displaced houses,
people and animals. Each item is treated individually in a tenderly naïve
realist manner reminiscent of "Douanier" Henri Rousseau, whom Beckmann
once described as his "great old friend, Homer in the porter's lodge".[32] The
whole picture, however, results in an almost surreal rendering of a landscape
with its differing proportions, alternating view from above and below, and
abrupt juxtaposition of planarity and depth; each element remains in isola-
tion, leading a strange life of its own, as was the case in the bizarre still life
and society pictures.

A similar impression is created by The Iron Footbridge (p. 63), painted the
same year. The bridge's dull metallic glow and the realist plasticity of its
structure and of the houses in the background contrast glaringly with the
changing perspective and relative scale of the objects. On the one hand, the
realistic presentation of individual objects or parts of them, as with the crane,
creates a sense of authenticity at the level of the single item, but this is
disrupted by the total lack of homogeneity in the whole. The crane is set in
the landscape like a child's humming top, the people are like dolls – an
apparently naïvely playful picture that at first seems full of childish merri-
ment, but which then reveals nonetheless a grotesque and tragic isolation, an
insurmountable or even inimical disharmony between objects and people. It
is a tragi-comic melancholy lyricism not unlike that which Charlie Chaplin
also perceived in the modern world of the twenties and expressed in his films.
This affinity can be seen even more clearly in the Self-Portrait in Front of a Red
Curtain (p. 73).

Nowhere is the post-war change in Beckmann more striking than in his
portrayals of people. In contrast to his work during and immediately after the
war, a whole series of pictures was created during the twenties which focused

Double-Portrait of Frau Swarzenski and Carola Netter
Doppelbildnis Frau Swarzenski und Carola Netter
Frankfurt am Main 1923
Oil on canvas, 80.3 x 65 cm
Göpel 222
Frankfurt am Main, Städelsches Kunstinstitut
und Städtische Galerie

on a single figure, or on two. The earlier canvases had been crowded with people who scarcely left each other room to breathe, who could only be accommodated in the picture by means of dismemberment, deformation and overlapping, but now all the space was given to one or two figures who could therefore retain their bodily unity and individual dignity. A fitting rubric for the years 1922–1925 would be "The individual re-discovered". It was not only Beckmann who was re-discovering the individual: the pictures make it seem that the people portrayed – *Frau Dr. Heidel* (p. 65), *Elsbeth Goetz* (p. 66), *Minna Beckmann-Tube* (p. 68), *Frau Swarzenski and Carola Netter* (p. 67) – were themselves suddenly becoming aware of their individuality and their loneliness . "My god how lonely people are all together," observed Beckmann in 1925 in a letter to his second wife, Quappi.[33]

The figures in these portraits have a certain serenity but their facial expressions reveal an awareness of inner sorrow. Although Beckmann's technique gives the figures a relatively simple and idealised form, this is belied by the portrayal of psychological characteristics. He saw them as people in transition, suffering from a malaise that afflicted society as a whole: the old ideals that gave meaning to life were no longer there, but nothing had been found to replace them. There was an awareness of inner emptiness – no confidence or recognition of new aims, but at least awareness. "Locked up like children in a dark room we sit there, god-fearing creatures that we are, waiting for someone to open the door and lead us out to execution, to our death. When the belief that we can make our own decisions is firm in us, then, and only then, shall we achieve a greater measure of responsibility for ourselves", wrote Beckmann in 1927.[34] Unlike his earlier pictures, however, this recognition of the truth does not take the form of reproaches and accusations. These figures retain a high degree of human worth in spite of inner emptiness. He discovers this worth in the formal quality of the human figure, in the upholding of outer form, in "life simply existing" (Beckmann, see above). The severe simplicity of body line, the pallid but smooth whites of the arms which convey corporeality without lapsing into banal illusionism, is expressive of human dignity and self-respect. Beckmann comes extraordinarily close to Picasso's so-called "classical" phase of the early twenties, as is demonstrated by the comparison between the *Portrait of Minna Beckmann-Tube* and Picasso's *Seated Woman* (p. 69).

The marvellous 1924 *Portrait of Minna Beckmann-Tube* marks the culmination of this phase in Beckmann's work. It is in every way a classical study, in which everything is reduced to apparently straightforward, unforced, unconvoluted "simply existing" forms. This is evident in the well-proportioned lightness of the upright format, in which the seated figure, visible down to the knee, finds a natural place. It is true also of the harmonious earthy grey tones; there are only a few contrasting colours, and they again are accented with white. It is true of the simple grey background, of Minna's equally simple dress and hair, of the scant furnishings with mirror (or picture?) and chair. Classical, too, is Minna's posture: without exertion or stress she lays one hand over the other, yet this simple gesture is enough to create a firm stability for the entire upper body. This "framework" is matched by the mirror image in its frame on the right. The draped folds of the curtain, gathered together in a knot, echo the form and structure of Minna's arms. In the purple folds there is a subtle allusion to the trappings of the traditional aristocratic portrait, but at the

Pablo Picasso
Seated Woman (Woman in a Shift), 1921
Femme assise (Femme à la chemise)
Oil on canvas, 116 x 73 cm
Stuttgart, Staatsgalerie Stuttgart

Portrait of Minna Beckmann-Tube
Bildnis Minna Beckmann-Tube
Frankfurt am Main 1924
Oil on canvas, 92.5 x 73 cm
Göpel 233
Munich, Bayerische Staatsgemäldesammlungen, Staatsgalerie moderner Kunst,
Stiftung Günther Franke

same time the motif is reduced to what is in effect a traditional portrait motif by the very fact that it appears only in a picture. Since this picture might also be a mirror reflecting the draped curtain, Beckmann endows the art historical tradition with new life. Indeed he succeeds in creating nothing less than a metaphor of classicism, with this protean switch between art past and present.

There are further layers of meaning in the deceptively simple curtain motif. For one thing, it is indicative of Minna's career on the stage as a successful opera singer. Furthermore, since it is drawn back in the picture, it shows what painting can do: namely, cast a look behind the scene. The setting of the picture like a mirror in which Minna's reflection should actually be seen – and in a sense it is, in the analogy of arms and drapery – leaves no room for doubt as to what it is that can be seen. The little picture with curtain drawn back shows that Beckmann's portrait of Minna also takes a look behind her façade. Minna's cool aloofness, which one might be inclined to regard as a pose, can be recognised as a profound trait in her character.

In fact this portrait also permits the viewer a glance behind Beckmann's own façade. It was painted at the very time when he was resolving on a separation. The picture may therefore be regarded as the documentation of his relationship with her. Her aloofness and unapproachability, and her gaze which does not meet the viewer's eye, suggest a woman who leads her own life, from whom Beckmann's inner parting has already taken place. Yet the echoes of the aristocratic portrait, the dignified posture, the uncluttered elegance of her appearance as well as the simple classic style, all bear witness to the respect that Beckmann felt for her. The picture therefore makes manifest the separation but constitutes at the same time Beckmann's homage to the woman who was his first wife. "Above all else my love for you will last. Whether you stop belonging to me or I to you. Whether you like it or not, whether you hate me or love me or become indifferent to me, you will always be part of my soul, you will stay in my work and in my life. Beyond time and place friend of my soul you belong to me," Beckmann had acknowledged in a letter to her in 1910.[35] This remained valid throughout his life. The close bond with his first wife was never broken.

Beckmann judged himself more harshly. The *Self-Portrait with Cigarette on Yellow Ground* (p. 71) shows that although there may be an easing of tension in his view of other figures, he cannot resign himself to "simple existence" in his own case. His own figure has to be consciously stylised, in this case in a decidedly belligerent pose, as if an inner doggedness had to be defended. The view is provocatively block-like and frontal. The sharp features are drawn into hard right angles. The narrowed eyes and mouth form clear horizontals, the nose a forceful vertical line, emphasised by collar tips and tie. The cigarette might suggest casual sophistication, but instead the gesture of the hand holding it seems contrived.

Once more Beckmann has paid close attention to the forming of the hands. They differ in size. The right hand with the cigarette is performing a social gesture, and it has turned out noticeably smaller than the left hand, which may be taken to represent the instrument of art. Powerful, yet with softly sensuous curves, the hand at the bottom edge of the picture is in counterpoise to the head, and the unclenched fist betrays a slight yielding of the tense, somewhat recalcitrant posture.

Max Beckmann, towards the end of the 1920s
Photo: Hugo Erfurth

Self-Portrait with Cigarette on Yellow Ground
Selbstbildnis auf gelbem Grund mit Zigarette
Frankfurt am Main 1923
Oil on canvas, 60 x 40 cm
Göpel 221
New York, The Museum of Modern Art, Gift of Dr. and Mrs. F.H. Hirschland

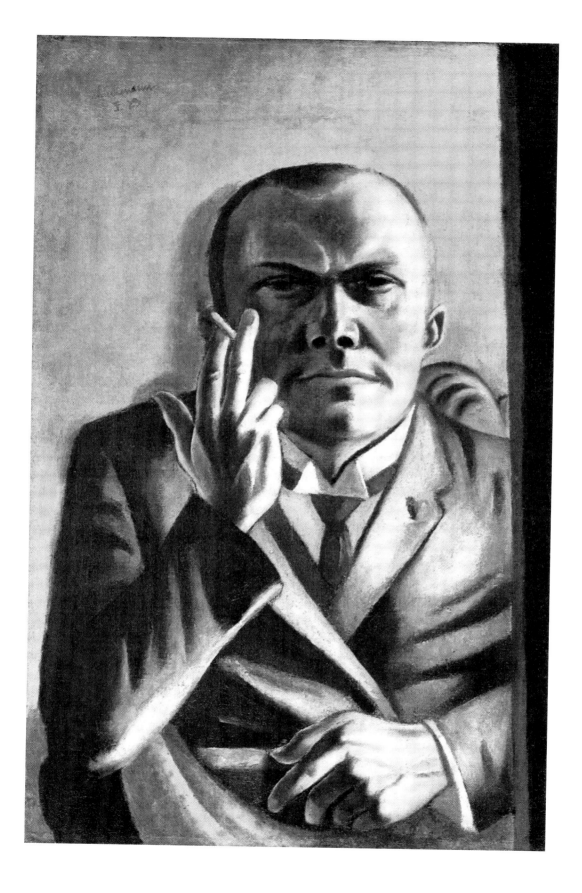

Self-Portrait in Front of a Red Curtain
Selbstbildnis vor rotem Vorhang
Frankfurt am Main 1923
Oil on canvas, 110 x 59.5 cm
Göpel 218
Private Collection

By the mid nineteen-twenties it is possible to discern behind the pictures a Beckmann whose war wounds are healed, who, after the bitter incriminations of the first postwar years, has reached a point where he can see things and people for what they are, and yet stand by them. In this he differs markedly from other leading figures of German art such as Dix or Grosz. Their art incorporated a social criticism which did not permit them to rise above contemporary society; they were constantly at odds with it, and ran the risk of injuring themselves in the process. This is particularly true of Grosz. Loosening the bonds of cynicism and the "terrible power of negation" (a phrase from one of Beckmann's letters) and the ensuing search for a positive definition of life was a process in which Dix and Grosz did not share, whereas for Beckmann it became the new starting-point from which ultimately he could progress beyond the point of merely accepting things as they were, in order to develop his art in new creative spheres.

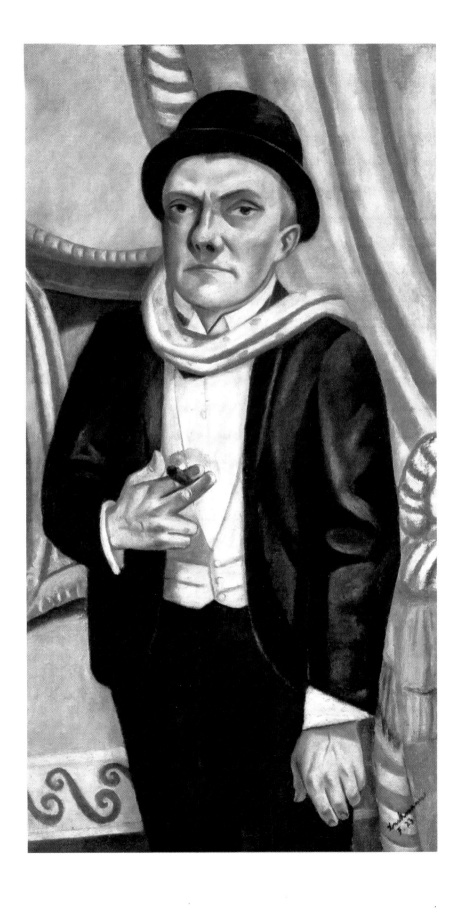

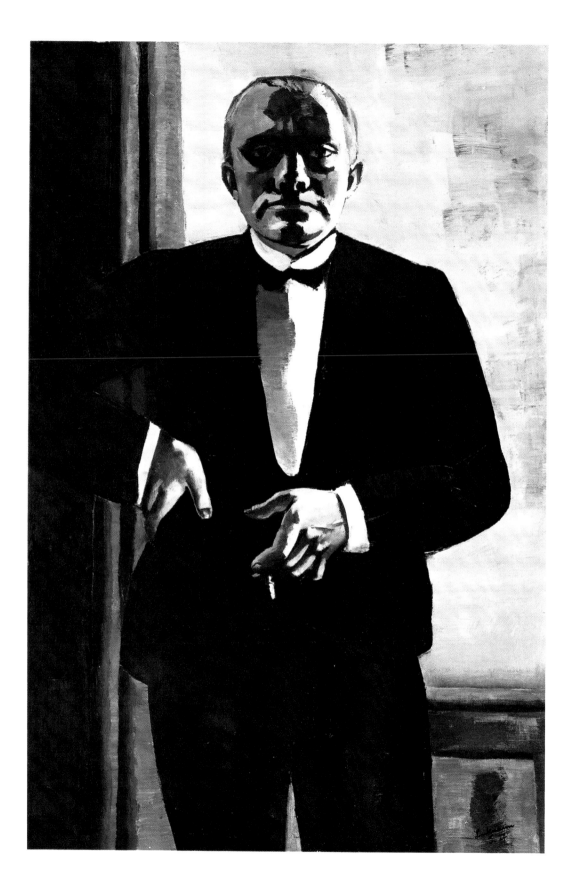

The Path to Myth

Even the hardened sceptic must recognise the breakthrough in this exhibition. One need only see one of these pictures, the harvest of a single year, in order to comprehend the incomprehensible: once more we have a master in our midst. God knows how this happened to us," wrote Julius Meier-Graefe (1867–1935) on the occasion of a Beckmann exhibition in 1929.[36] This patriarch of German art criticism was not easily enthused.

The process of liberation which enabled Beckmann finally to achieve the status of a "star" on the art scene and to take his place with more assurance in society, no longer assuming a role, was closely linked with a decisive change in his private life. In 1924 he met Mathilde "Quappi" von Kaulbach, daughter of the Munich painter Friedrich August von Kaulbach (1850–1920), and fell in love with her. In 1925, after the divorce from Minna who for some time had been engaged in Graz as an opera singer, he married Quappi, and she was the mainstay of his life from then on. The letters Beckmann wrote to her in the months before the marriage show how much he needed the support she gave him, how essential the absolute security she gave him was to his blueprint for life, how fundamental for the further development of his art: "I have to tell you. You are my last hope of shaping this life we happen to have been born into, whose contradictions and madness are only too clear to me, in such a way that there is some sense in it. Meaning in banal terms 'happiness' or 'harmony'. I have known many people and many women but never yet a woman with whom I could have thought it possible to live even when I was very much in love. Now I believe that in your soul I have discovered a great and genuine and unpretentious goodness, so much so that it might border on weakness, but perhaps it really is profound and boundless. If it is as I believe it to be then it will make me like that too and if fate gives us time it will give me the strength to do something useful for mankind. By letting me complete my work and restore people's belief in themselves which they have lost whether they know it or not… I have a terrible power of negation in me. Your task, small, sweet Cynthia, is to transpose this power into affirmation…. I am striving for the rehabilitation of dear god, my child my sweet. Do you understand?"[37]

The *Carnival Double-Portrait* (p. 77), expressly described in letters from Beckmann to Quappi as a marriage portrait, tells something of what the new relationship meant to him, what he hoped for from it. Out of the darkness of a (circus) tent or stage, the two have emerged into the light. They are wearing

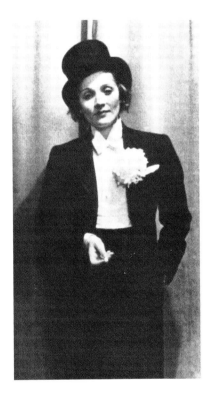

Marlene Dietrich, 1929
Photo: Alfred Eisenstaedt

Self-Portrait in Tuxedo
Selbstbildnis im Smoking
Frankfurt am Main 1927
Oil on canvas, 141 x 96 cm
Göpel 274
Cambridge (MA), Busch Reisinger Museum,
Harvard University, Association Fund

fancy dress; Beckmann appears as melancholy harlequin, like the *Gilles* of Jean Antoine Watteau (1684–1721) (Paris, Louvre), Quappi as Napoleon with horse and tricorne hat.

These disguises are eloquent in themselves, for the mask serves to unmask reality: "Big Max", as he sometimes called himself in his letters, ironically but with an edge of seriousness, and as he liked to show himself to the world, for instance in the *Self-Portrait with Cigarette on Yellow Ground*, has been cut down to size. He stands with drooping shoulders, awkward, almost clumsy. He is not playing the clown, he really is a mournful Gilles. His gaze is not fixed on anything real but has something of the visionary inner "sight" of a blind man who knows the way, or rather the goal, and is waiting to be led there. His pale face, loosely held arms and not least the scarf wrapped round his head like a bandage, give him the air of someone convalescing from an illness, taking his first hesitant steps and needing help to do so. Willingly and full of trust he lets himself be led – by Quappi, who, as Napoleon, holds the reins in her hand and whose firm step identifies her as the active one. The inner harmony between the two is expressed in the analogous way both hold their hands, whereby her left hand and his right hand also form a mirror image of one another. It is disturbing that they do not touch. Although Beckmann's arm, like a blind man's, is there to be taken, she does not take it; so his arm is left just holding the cigarette in a strangely cumbersome and forlorn manner.

The picture attests Quappi's enormous importance to Beckmann and to his art. With this strong personal support to back him Beckmann took on a quite different role in society: in October 1925 he was appointed to the renowned art school attached to the Städel Art Institute in Frankfurt, with responsibility for running a master class. At the same time he signed a three-year contract with the gallery proprietor I.B. Neumann for sole rights to the sale of his pictures, guaranteeing him an income of 10,000 marks per year and an easy lifestyle. The big successes of 1925, for instance at the New Objectivity exhibition in Mannheim and at the great International Art Exhibition in Zurich, where he showed an exceptional twelve pictures, marked the beginning of the most successful period in Beckmann's career. In 1928 there was a major retrospective in Mannheim which generated numerous purchases by museums and, in 1933, a Beckmann room was opened at the Berlin Nationalgalerie Kronprinzenpalais, to be closed, however, a few months later by the Nazis. The move to a newly built apartment in the Steinhauserstrasse 7, a second apartment in Paris, where Beckmann spent the winter from 1929 to 1932, afternoon tea in the grand "Frankfurter Hof" hotel, exclusive champagne suppers and finally the purchase of an automobile are outer signs of Beckmann's new self-assurance and what he came to see as his place in society.

The absolute support that he found in his relations with Quappi, and his secure social status, allowed new artistic powers to be set free. Beckmann distanced himself increasingly from "simply living" and from the outer appearance of things which had initially given him reassurance after the inner and outer trauma of war. Now he turned instead to the mysterious, to the mystical and mythical dimension veiled behind the visible. Later, he put this into words: "It is my constant aim to comprehend the magic of reality and transmute that reality into painting. Paradoxical as it may sound, it is reality that constitutes the true mystery of existence".[38]

Mathilde Quappi Beckmann before a fancy dress ball in the garden of the Kaulbach House, 1925

Carnival Double-Portrait, Max Beckmann and Quappi
Doppelbildnis Karneval, Max Beckmann und Quappi
Frankfurt am Main 1925
Oil on canvas, 160 x 105.5 cm
Göpel 240
Düsseldorf, Kunstmuseum Düsseldorf im Ehrenhof

"You are my last hope of shaping this life we happen to have been born into, whose contradictions and madness are only too clear to me, in such a way that there is some sense in it ... I have a terrible power of negation in me. Your task, small, sweet Cynthia, is to transpose this power into affirmation."
Max Beckmann to his second wife Mathilde Quappi (Letter of 16 June 1925)

Postcard with a view of the harbour of Genoa, from Beckmann's personal collection

The *Harbour of Genoa* (p. 78) illustrates Beckmann's intended meaning. The landscapes of the early nineteen-twenties, such as the *Iron Footbridge* (p. 63), were marked by precise realism in detail on the one hand and grotesque juxtapositions on the other, and this was indicative of his attitude to the world at the time: realism was the expression of inner distance from what he saw, indicating the cool gaze of the outsider, while the emphasis on the grotesque signalled a fluctuating interaction between baffled amusement at the incongruities of existence, irony, mild scorn and sarcasm.

There is no trace of this in *The Harbour of Genoa*. Beckmann conjures from the otherwise unspectacular view of the industrial harbour a positively mystical effect. Against a black night sky the harbour is bathed in cold white moonlight, which contrasts with the dark green glow of the sea and the pervading black ground colour. There is no continuum of space. Contiguity and distance, entirely disparate things like the vase on the balcony and the trains moving far below, seem to be accorded equal weight above and below and alongside one another and are hardly distinguished from one another in form. They are united by the abstract planar application of white that suggests a numinous and penetrating mysterious light which causes the objects to glow with a mystical inner life. The objects themselves seem to be made active by it. They develop a dynamic relationship to one another, quite different from the "simply living" quality that Beckmann had previously depicted. The town is given the mysteriously unreal, quasi-metaphysical radiance of a ghost town. It is this quality in particular which reveals Beckmann's altered view of the world around him. The view of nature and the environment is no longer ironically fractured but has altered to become respect, in this case even awe, for the mystical greatness of the world and its uniqueness.

The uncanny atmosphere is reminiscent of the "pittura metafisica" of De

The Harbour of Genoa
Der Hafen von Genua
Frankfurt am Main 1927
Oil on canvas, 90.5 x 195.5 cm
Göpel 269
St. Louis (MO), The Saint Louis Art Museum,
Bequest of Morton D. May

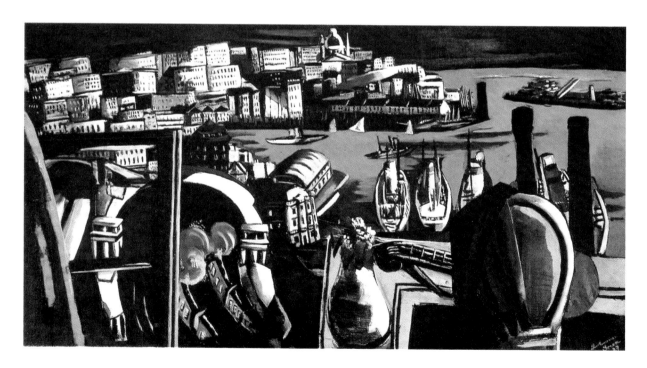

Chirico or the Surrealists, but Beckmann differs from them on two important points. His mystery is not found in the inner dreamworld of mankind or in the unconscious explored at the beginning of the century by Sigmund Freud (1856–1939) but in objects themselves. Unlike those who worked with illusionist means such as perfect linear perspective, Beckmann achieved the eerie effect by means of the increased use of abstract painting techniques. To put it more simply: De Chirico and the Surrealists use realist techniques to paint an abstract world whereas Beckmann creates "reality" by abstract means.

It follows that Beckmann's altered relationship to objects is most apparent in the still life genre. The "nature morte", or "dead life" as it is termed in the Romance languages, becomes in Beckmann's hands "nature animée", or "animated life". In *Large Still Life with Musical Instruments* (p. 79) the saxophones do not lie rigid on the table; they extend their sensuous curves towards the viewer, stretched out lasciviously on table and chair. This sensuousness and the pairing of objects bring to the forefront the phallic and vaginal symbolism of the objects, which is expressed also in their vertical and horizontal orientation. Beckmann discovers between objects the same sensual tension that marks the relationship between man and woman. Even without people to play them, the instruments radiate the vital force that can emanate from their music.

What is true of Beckmann's landscapes and still life is also true of his view of human beings. They no longer sit submissive, numbed into their own "nature morte", but become mobile and active, claiming space for themselves and lending it dynamic shape. This development can be demonstrated by the comparison between two nudes. *Sleeping Woman* (p. 80 below) painted in 1924 draws the eye to the reclining nude, "simply living" in repose, represented in the manner of a still life. The *Reclining Female Nude* of 1929 (p. 80 above) treats exactly the same theme, but here the body is actively involved: the full breasts curve up towards the viewer, the body is mobile and the dynamics break through normal proportions to achieve an enormous expressiveness. The in-

Large Still Life with Musical Instruments
Großes Stilleben mit Musikinstrumenten
(Stilleben mit Saxophonen)
Frankfurt am Main 1926
Oil on canvas, 85 x 195 cm
Göpel 257
Frankfurt am Main, Städelsches Kunstinstitut
und Städtische Galerie

"I love jazz so much. Especially because of the
cow bells and the car horn. That is sensible
music. What you could do with that!"
Beckmann in the Piper Verlag Almanac, 1923

Reclining Female Nude
Liegender weiblicher Akt
Frankfurt am Main 1929
Charcoal on paper, 63 x 47.5 cm
Bielefeld 132
Hanover, Sprengel Museum Hannover

terplay of close-up and upward view with foreshortened perspective gives maximum tension and vitality to the body. Constricted at the edges by the harsh, almost crystalline forms of the chaise longue and the white linen that mark the outer contour of the body, the firm sensuous curves of breasts and legs dominate all the more strongly. Only the head of the sleeping woman has fallen to one side, apparently unaware of the dynamic forces that are sporting with her body. The anatomical drawing and line are no longer determined by realistic appearance, as much as by the sensuous expressivity of certain forms. The formal organisation of the picture is also more important than before. Form and colour are deployed not only with relation to objects; they also have an abstract function in the composition, as is the case for instance with the blue areas in *Reclining Female Nude* where the flat unbroken colour holds the parts of the picture together.

The same is apparent in the *Portrait of Quappi in Blue* (p. 82): blue is not only the colour of Quappi's dress, there is also an abstract blue area of colour which can be interpreted independently of the meaning of the dress. The colour blue is accorded great significance by the title and in the picture, and there is a further programmatic significance in the colour blue on a different level: the Romantic poet Novalis (1772–1801) invoked blue (the magical "blue flower" for which the hero of his mythical novel *Heinrich von Ofterdingen* searches) as the essence of the spirit; the Modern group "Der Blaue Reiter" (The Blue Rider) emphasised the importance of blue, referring to it as the principle of "the spiritual in art" (Wassily Kandinsky, *On the Spiritual in Art*, 1912). Whereas Beckmann's earlier figures had displayed a distinctive inner emptiness, here he re-established the dimension of the spirit in human existence through the iconography of colour. Not only the colour itself but also the manner of its application becomes a metaphor of spirit. The paint is given a certain life of

Sleeping Woman
Schlafende
Frankfurt am Main 1924
Oil on canvas, 48 x 61 cm
Göpel 227
Private Collection

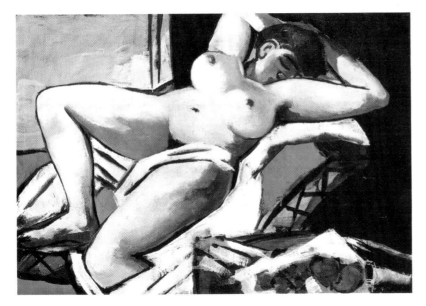

Reclining Nude
Liegender Akt
Frankfurt am Main 1929
Oil on canvas, 83.5 x 119 cm
Göpel 308
Chicago (IL), The Art Institute of Chicago,
Joseph Winterbotham Collection

"Beckmann rarely achieved greater work than
the large Reclining Nude, which shows an im-
mense power of imagination in form, while
also resolving all violence into flowering
beauty."
Curt Glaser in the *Berliner Börsen-Kurier*, 1930

its own by means of the perfect evenness of application and its own material
quality, so it starts to become independent of the body, almost like a second
layer with a separate existence. This is true of the blue of the dress and also of
the white on Quappi's skin, which in figural terms could be said to represent
the incidence of light.

Beckmann formulates the abstract planarity of colour even more pointedly
in the *Self-Portrait in a White Cap* (p. 85) of the same year. The light falling on
cap, jacket, face, hands and especially trousers is portrayed by a distinctly
smooth and unstructured application of paint. In earlier works, for instance
in the *Double Portrait of Frau Swarzenski and Carola Netter*, Beckmann had achieved
the impression of plasticity illusionistically by means of sculptural gradua-
tions of light and dark. Here he is aiming to achieve plasticity by abstract
means which actually seem to contradict illusionist logic. For instance, the
absolute planarity of the white on the thighs is exactly the opposite of illu-
sionist three-dimensionality, yet it succeeds in creating the impression of
plasticity on a quite different abstract level: the white comes to the fore while
the grey recedes. The spectator perceives a certain spatial tension, which, in
the context of the figure is cognitively interpreted as a rounding of the thigh.
In addition the white also suggests the incidence of light, in which context
the grey of the trousers may be interpreted as shadow – independent of the
fact that it is also their actual colour.

With this new structural concept Beckmann loosens his ties with New Ob-
jectivity and enters for the first time into the actual discourse of the Modern.
It is the beginning of Beckmann's entirely independent path in Modern paint-
ing: with the techniques and rules established in abstract painting Beckmann
sets out to develop a new style of figurative painting far removed from any
kind of illusionism. Conceptually he takes up the baton from Cézanne, who
in his attempt to create in the picture a reality "parallel to nature" (Cézanne)
had taken the first step towards autonomy of the image (thereby becoming
the father of "pure" painting), but who still wanted painterly reality to be
indissolubly linked with nature itself. In his works Beckmann employs abstract,

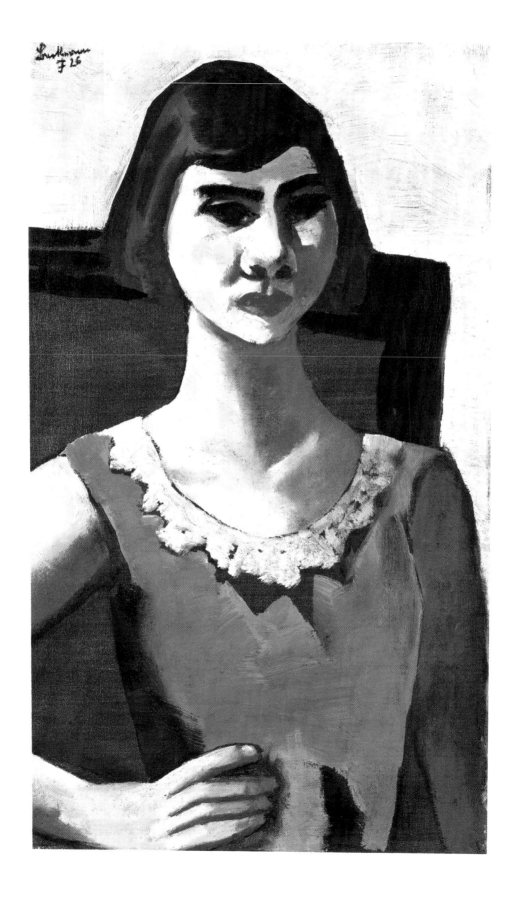

non-illusionist techniques to create a reality which functions according to its own laws, but which at the same time never entirely abandons the figurative.

As always with Beckmann, the formal concept was not an end in itself – nor did he have any ambition to present a visual concept in keeping with the latest trends. Beckman's use of abstract techniques, particularly in the portraits, became the vehicle for an entirely new view of humanity in which he addressed the problems of spiritual and physical existence that had concerned him even in his early *Self-Portrait with Bubbles* (p. 13). In the early self-portrait there was already a planar treatment of light and shadow as layer and foil in their own right, emancipated from the body. Light and shadow as spiritual, immaterial "substance" – their distinctive feature being their very insubstantiality – are unthinkable without matter or body, but it is light and shadow that render them visible. Light and shadow, therefore, in their immateriality are always inseparably linked with matter. Beckmann's techniques enable him to show them as independent principles; he detaches light and shadow as foil to such an extent from the human body that they become recognisable as abstract counterpart to the figuration of the body. This is a fascinating metaphor for humanity's spiritual emancipation: Our spiritual existence is superimposed upon our bodily existence as a kind of bas-relief in abstract areas of colour – light and shade.

A comparison with the portraits of the early nineteen-twenties clarifies the sense and significance of this metaphor. A distinctive characteristic of the people portrayed was their inner emptiness. Light and shadow moulded the bodies without themselves becoming tangible – for it was in their physical existence, in the "preserving of external form", that Beckmann understood and defined the human dignity of these characters. That which had been found wanting in his earlier portraits, he now sought to fulfil, showing people as emancipated free beings, defined not only by their outer shell but also by their spiritual existence.

The growing emancipation of a responsible, free existence as a human being can be traced step by step from *Portrait of Quappi in Blue* – the colour is an additional programmatic upbeat here – by way of the *Self-Portrait in a White Cap* right through to the magnificent apogee of this development, the *Self-Portrait in Tuxedo* (p. 74). This interpretation is supported by the parallel growth discernible in the increasing use of the abstract techniques described and in their psychological characterisation. A self-confident Quappi props her hand on her hip; a thoughtful but relaxed Beckmann is shown in the *Self-Portrait in a White Cap*, the loose and open gesture of the hand contrasting programmatically with earlier cramped tension of the hand.

The uncontested apogee in the vision of the free, self-assured and responsible individual is the *Self-Portrait in Tuxedo* of 1927 which was bought one year later by the Berlin Nationalgalerie and celebrated as an exceptional Beckmann work, but which also, as expression of the superman ideology, provoked severe criticism. This self-portrait and *Night* were Beckmann's most intensively discussed works up to this time. Defamed as "degenerate" in 1937 and confiscated, it was eventually purchased by an American museum.

In elegant black tuxedo Beckmann displays himself as lordly cosmopolitan, confident and at ease in society, fully aware of his significance and status. Four years earlier, in *Self-Portrait in Front of a Red Curtain* (p. 73), Beckmann had donned a black tuxedo in melancholy irony – as ringmaster of a tragi-comic circus

Mathilde Quappi Beckmann, 1928
Photo: Hugo Erfurth

Portrait of Quappi in Blue
Bildnis Quappi in Blau
Frankfurt am Main 1926
Oil on canvas, 60.5 x 35.5 cm
Göpel 256
Munich, Bayerische Staatsgemäldesammlungen, Staatsgalerie moderner Kunst,
Stiftung Günther Franke

performance. Now everything in the picture expresses self-assurance and assertiveness. He stands in strictly frontal posture in the central axis of the picture, in full confrontation with the viewer, with one powerful arm encompassing space and propped akimbo, the other in casually sophisticated posture completed by cigarette – the casual pose of the man of the world demonstrated by numerous contemporary photographs, for instance of Marlene Dietrich (p.75). The light view from below makes his figure seem all the more monumental, as it was emphatically described by his patron and admirer, the writer Stephan Lackner, "On the powerful body, usually slow and straddled in motion, sat a round granite head."[39] The sharp contrast of the imposing bone-structure of the head and the block-like figure against the light background further enhances the enormous presence of his person. The firm, calm and hypnotically sure gaze has something of the iconic appearance of Christ the Pantocrator. There is a striking compactness in the dominating head, and such plasticity in the deep, sharp-edged shadows that it almost seems carved out of wood.

Max Beckmann, Frankfurt am Main 1927
Photo: Hess

The special quality observed in *Portrait of Quappi in Blue* and in *Self-Portrait in a White Cap* is even more strongly in evidence in this self-portrait: Beckmann has turned illusionist logic upside down. Light and shadow and the ochre tones on the left – and indeed the shirt and the black tuxedo – are painted in an entirely planar manner, tangible in their material presence as thick, compact layers of paint. But that is not enough. Beckmann has reversed the customary deployment of light. He is clearly "lit" not by light but by dark. Across the middle of his face, even across the bridge of the nose, a dark shadow spreads, while the areas to the left and the right are lighter. The result is an almost mystical transparency of the skull; the dark colour makes the more prominent parts recede, while the parts further back come forward. What should be a positive form becomes negative, instead of plasticity there is transparency. It is as if one could look straight inside the head: the supposedly imposing "granite-like" head suddenly turns out, especially in the area around the nose, to be a dead man's hollow skull.

It is this effect, rather than any other, which gives his person a whole new dimension. Whereas in the earlier pictures the abstract planar foil of light and shade had appeared in its own right as the spiritual layer of man's being, now this meaning is rendered concrete. The quite simple associations of the dark shadow on the face are indicative of a dark and mysterious premonition that has spread over him. A premonition – as implied by the reversal of the light metaphor – from a world of shadows. The background, too, is suggestive of both worlds. Beckmann stands before the pale light grey, but with his elbow, he has metaphorically speaking, struck open the door to the shadowland, of this world or the other. That which is already implicit in the colour black as metaphor, is quite explicit in the skull-like quality of the face around the nose: the land beyond is also the land of death. Beckmann appears as magician who has established contact with the realm of shadows, and who not only bears the stamp of the beyond but is also able to behold it face to face and to invoke it as a priest of the occult. "It is a matter of achieving an elegant mastery of the metaphysical," wrote Beckmann shortly before the picture was painted.[40] A master of metaphysics, a magician from a secret lodge, with one foot, or rather one elbow, in the beyond – that is the Beckmann portrayed in this picture.[41]

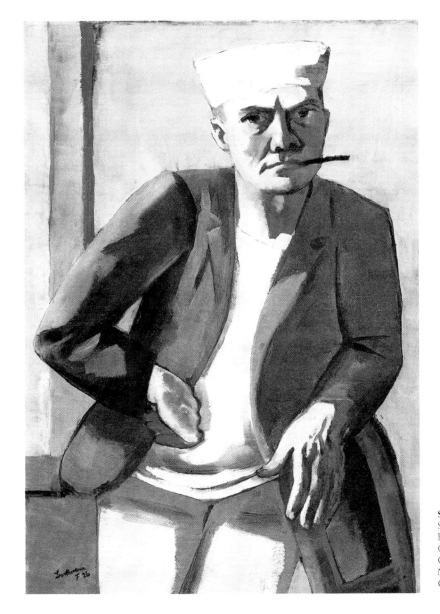

Self-Portrait in a White Cap
Selbstbildnis mit weißer Mütze
Frankfurt am Main 1926
Oil on canvas, 100 x 71 cm
Göpel 262
New York, Collection ADF International
Co./F. Elghanayan

One further comment seems important in this connection: the white or grey
of the background has a clearly discernible black underlay, while the dark area
on the left has a light underlay. So each area includes the other in nucleo – the
other world is contained in this, and vice versa. White and black are at their
most pure, though still with complementary underlay, in Beckmann's shirt and
dinner jacket.

The programmatic symbolic significance of this is made clear by Beckmann
himself in his London lecture of 1938: " Yes, black and white are the two
elements I have to do with. For good or evil, I cannot see everything in black
or everything in white: if I could, it would be simpler and less ambiguous, but
it would also be unreal. Many people, I know, would likte to see everything
white, that is objectively beautiful, or black, that is negative and ugly; but I

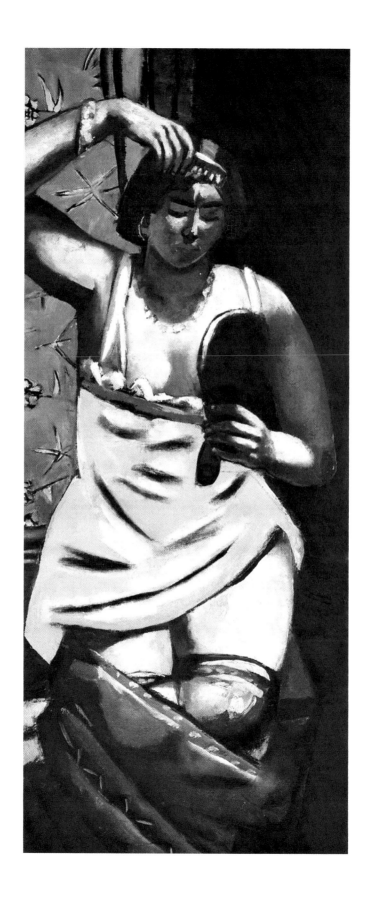

can only express myself in both together. Only in the combination of white and black can I see God as a unity, taking shape again and again in the great, ever-changing spectacle of the world."[42]

Beckmann comes on stage as "God" in the union of black and white. In his figure all contrasts are concentrated, his face includes all the other colours that occur in the picture. He stands in the light of this world, but his elbow testifies to the link with the darkness of the other world also present in his face. As elegant representative of high society he portrays himself in the upper echelons of this world, as magician and priest he is in touch with the other world. He is a superb mediator between and shaper of the two worlds, at once product and producer of their perfect equilibrium. On an intellectual level and on the level of formal realisation the *Self-Portrait in Tuxedo* is one of the most impressive portraits of the twentieth century.

A few weeks before the picture was completed Beckmann also verbalised his vision of the "new" man, or artist. In the memorable article *Der Künstler im Staat* (The Artist and the State) of 1927, Beckmann composed a literary picture to match his *Self-Portrait in Tuxedo*, which expresses better than any interpretation could this picture's lofty aims. In it Beckmann postulates for the artist the role formerly filled by the priest, and demands that man should finally come to see himself as God: "The artist in the new sense of our time is the conscious former of the transcendent idea. He is at once the shaper and the vessel shaped... The artist in the new sense is the actual creator of the world, which did not exist before him. The new idea which the artist, and all of mankind with him, must fashion is self-responsibility. Autonomy in relation to infinity. Nothing can be expected any more from outside. Only from ourselves. *Because we are God*. Still a very inadequate and paltry God – but by Jove, God nonetheless. The collective intellectual achievement of mankind thought of as a unity, is God. Has always been God. It is the consciousness of the world that is constantly moving towards its goal – or one might say, towards its end. The thermometer or measure of the equilibrium or completeness already achieved is art. And then all the other products of the human brain. There we find our own image. *Art is the mirror of God who is mankind...*

What we need is a new cultural focus, a new focus of belief... It is a matter of achieving an elegant mastery of the metaphysical. Of living a taut, clear, disciplined Romanticisim in this utterly unreal existence of ours. The new priests of this new cultural centre must appear in black suits, or top-hatted for major ceremonies, unless we can in time discover a still more fitting and elegant item of male clothing. Moreover, it is essential that the worker should also appear in tuxedo or top hat. That means: we desire a kind of aristocratic bolshevism. A social levelling in which, however, the fundamental idea is not the satisfaction of unalloyed materialism but the conscious and organised drive to become a God oneself...

If we are not willing to place our faith, just once in the course of human development, in becoming God, that is to say, in becoming free, in seeing, or seeing through, the hidden purposefulness of everything incomprehensible, frail and impossible that we still call life, then the whole of humanity from the beginning will remain a farce. In order to concentrate this will we must gather ourselves. In order to give solidity to this belief and to transpose it into reality, we must create a new art form, a new state form... *Now we want to have faith in ourselves...*

Portrait of Quappi on Pink and Violet
Bildnis Quappi auf Rosa und Violett
Paris 1931
Oil on canvas, 110 x 70 cm
Göpel 339. Private Collection

Gypsy Woman
Zigeunerin
Frankfurt am Main 1928
Oil on canvas, 136 x 58 cm
Göpel 289
Hamburg, Hamburger Kunsthalle

Once the belief that we can decide for ourselves has been firmly established in us, then self-responsibility also will be strengthened. Only by thrusting back the weakness, egoism and so-called evil in ourselves in favour of the common love that will enable us to perform *in common as human beings the great decisive tasks* shall we find the strength to become God ourselves. That means to be free – to be able to decide ourselves whether to live or die. Conscious owners of eternity – free from time and space."[43]

That Beckmann did not project this image of the free, emancipated human being only onto himself is made clear by the other portraits of this period. The *Gypsy Woman* of 1928 (p. 86) and the *Portrait of an Argentinian* (p. 89) of 1929 equally show a human being not only beautiful and noble, but also radiating an aura of mystery. The tradition on which Beckmann draws in both pictures throws a significant light on the intended effect. The *Gypsy Woman* is painted in the manner of a *Venus with Mirror* and is thereby ennobled, becoming a mythical "Goddess by the grace of Titian". The *Argentinian* is presented as one of a dynastic line – unmistakably recalling the famous portrait of Emperor Charles V (p. 88) by Titian (c. 1477–1490 to 1576). The *Gypsy Woman* and the *Argentinian* refer also in their "colour aura" to the great Titian, himself a mythical figure as artist.

And it is not only human beings that Beckmann sees maturing beyond their external material existence to a free existence pervaded by mystery. Objects, too, reveal hidden truths within themselves, showing that they too have a soul, a spiritual existence. The *Large Still Life with Telescope* (p. 91) is in many ways a counterpart and companion piece to the *Self-Portrait in Tuxedo* – transferring to inaminate objects the portrait's insights and views of people. Beckmann worked on both pictures at the same time and completed the still life one week after the completion of the self-portrait.

The *Saturn Still Life*, as it was called by Beckmann's students in the studio, is in format alone – being the same height as the *Self-Portrait in Tuxedo* – exceptionally ambitious for a still life, and should perhaps be described as an interior rather than as a still life. Like Beckmann's own figure in the self-portrait, the objects are represented at the very prime of their wordly existence. Oversized flowers, objects and instruments display their shining colours with an abundance that relegates the human figure to the periphery. The black-and-white contrast of the tuxedo picture is repeated in the black table and white tablecloth, and in the background too there is a similar division. With regard to the self-portrait, mention was made of Beckmann's figurative opening of the door to the shadow-world; here the figurative meaning has been concretised: on the right-hand edge of the picture a mysterious black door closes the composition and suggests to the viewer a "Beyond". The direction in which the door closes is, however, not indicated, and it remains undecided whether the "Beyond" is the interior shown in the picture or an adjacent hidden room to the right of the interior. The door is open, the key – an old-fashioned set of keys like those of a conjuror – is still in the lock; the door-handle is made up of strange signs, among them a question mark.

The telescope named by Beckmann in the title is indicative of the central theme apparent in this picture: the discovery of what is hidden. The telescope makes it possible to discover the properties of another world, at a great distance from us. A world on which the door seems to open, while at the same time denying the viewer the possibility of looking in. In conversation, Beck-

Titian
Emperor Charles V, 1548
Oil on canvas, 203.5 x 122 cm
Munich, Bayerische Staatsgemäldesammlungen, Alte Pinakothek

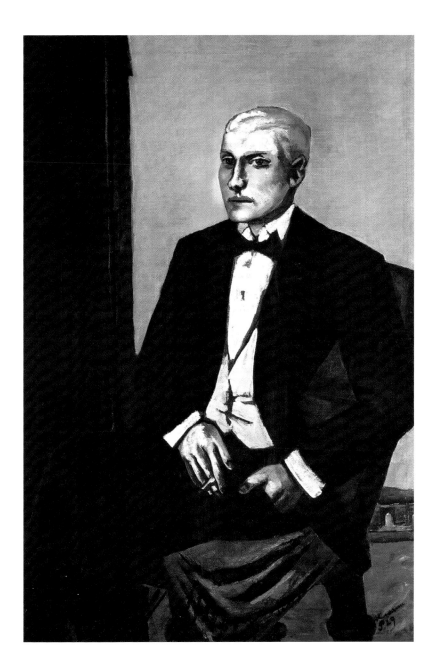

Portrait of an Argentinian
Bildnis eines Argentiniers
Frankfurt am Main and Paris 1929
Oil on canvas, 125 x 83.5 cm
Göpel 305
Munich, Bayerische Staatsgemäldesamm-
lungen, Staatsgalerie moderner Kunst,
Stiftung Günther Franke

mann replied to the question as to whether it was in any way possible "to make it easier for the viewer to enter, to find keys to secret doors": "Keys, mon Dieu, if I had them. By looking one can reach the depths, yet never deep enough."[44] It is not only the sense of sight that is alluded to as a means of achieving insight. The wind instrument is very similar to the telescope in form and it introduces the sense of hearing as another means. Like a superdimensional ear it reaches towards the arcane mystery hidden behind the door.

The sheet of paper on the table with two concentric circles and the letters SA[T]URN can likewise be linked with this theme – exposure of the hidden. At the same time it introduces the tradition of metaphysics, alchemy and magic.

In this tradition Saturn is lode-star of genius and "draws the soul up to the heights", in the words of the astrologer Agrippa von Nettesheim (1486–1535). Saturn endows those born under his sign with the greatest wisdom and knowledge, but is at the same time the cause of dejection and melancholy. Viewed in this way he became the lode-star of artists, as shown for instance in the famous engraving *Melancholia* (1514) by Albrecht Dürer (1471–1528). Beckmann himself was born under the sign of Aquarius, which in turn is ruled by Saturn, so that he stood by reason of his biography and as artist under the aegis of Saturn. The letters therefore bring together several different aspects of the picture, testifying to the secret magic of things, which the artist is privileged to see, and also identifying Beckmann as son of Saturn and great magician, in which capacity he does not appear here (his chair is empty) but in his own picture, the *Self-Portrait in Tuxedo*.

With the *Self-Portrait in Tuxedo* and the *Large Still Life with Telescope* of 1927 Beckmann created two great representative works which are to be taken together as a programmatic commentary on things, nature and man: nature and man have a magnetic and splendid outer form, but also an existence in the spirit, which gives them the freedom to transcend the material determinants of time and space; man, nature and things, in equal measure, have become "conscious owners of eternity".

This insight leads Beckmann to a quite new area of interest, namely myth. What has been labelled as his "flight to mythology", and attributed to an iconographic game of hide-and-seek with the Nazis (who are said to have forced him into an encoded manner of representation), should be interpreted rather in the light of his new insight: at the moment when Beckmann recognised and came to value nature and man as "conscious owners of eternity", he began to seek for archetypal, timeless images and metaphors of human life, and he found them in myth.

Only with the freedom to have at his disposal this *and* the other world, as displayed in the *Self-Portrait in Tuxedo*, the *Gypsy Woman* and the *Argentinian*, does Beckmann find the prerequisite with which to anchor his picture of man in myth. It is not that he is in any way interested in seeking in myth a transfigured Arcadia, an idealised world of antiquity – quite the opposite. The turning of his attention to myth marks a remarkable, almost, it seems, a paradoxical watershed in his creative life. Steeped in myth, Beckmann's utopia of humanity's autonomy and freedom of mind and spirit is lost; instead the pictures speak increasingly of the human race's fateful lack of freedom and of the inevitability of its conflicts.

The short phase of apparently unbounded confidence in the positive powers of mankind, in the possibility of transposing the "terrible power of negation... into affirmation" (letter of 16 June 1925 to Quappi) which had begun with the marriage to Quappi, ended as the twenties drew to a close. This change coincides with the end of the "golden years" of the Stresemann era (Gustav Stresemann, 1874–1929; minister for Foreign Affairs in Germany 1923–1929) and the emergence of the brute force of National Socialist barbarism, which was increasingly gaining ground in the public arena, and was to win the upper hand conclusively with the seizure of power on 30 January 1933. Even though Beckmann's works rarely dwelt specifically on the political situation around him, it would be a mistake to underestimate its influence on his art and on his view of the world. In order to protect himself against increasing signs of hos-

tility Beckmann felt obliged, in January 1933, to abandon his Frankfurt home in favour of the anonymity of Berlin.

The effects of Beckmann's renunciation of the utopia of human freedom first became apparent in his vision of the relationship between the sexes, which now became a central theme. In the relationship between man and woman he saw the ambivalence of human existence, the positive search for fulfilment and belief in a possible oneness in union on the one hand, and negative instinctual dependence, coupled often enough with bondage and violence, on the other hand.

The monumental chalk drawing *The Night* of 1928 (p. 93) is the first in a whole series of pictures on the theme of man and woman, which increasingly

speak from within a world of myth. There is no longer anything anecdotal in the encounter between man and woman; what is visible of the bed has become a timeless stage for an archetypal pair. Man and woman are inextricably entwined – or bound? – Antipodean opposites, the man oppressed with troubling thoughts and dark, the woman fair, sensuous and relaxed. Beckmann is deliberately alluding here to the primaeval mythic pair *Mars and Venus* in a rendering by the Italian Renaissance painter Piero di Cosimo (c. 1462–1521); moreover

Large Still Life with Telescope
Großes Stilleben mit Fernrohr
Frankfurt am Main 1927
Oil on canvas, 141 x 207cm
Göpel 275
Munich, Bayerische Staatsgemäldesamm-
lungen, Staatsgalerie moderner Kunst,
Gift of Sofie and Emanuel Fohn

the 65 × 187 cm format, most unusual for a drawing, corresponds almost exactly to the *cassone* (a painted wedding chest) by Piero di Cosimo in the Berlin Nationalgalerie.

The drawing *Encounter in the Night* (p. 92), executed at the same time and likewise in large format, also presents male and female as Antipodean opposites. Man and woman are pressed close together in the narrow high format, and almost seem bound to one another at first glance, as Beckmann portrayed them later in the *Journey on the Fish* (p. 101), for instance, and in the right-hand panel of the triptych *Departure* (p. 109). Again the contrasting qualities of man and woman are demonstrated first by the colour contrast; in addition, the woman is shown hanging upside down from the ceiling, her nudity indicating the erotic nature of the relationship, the open palm of the man crouching beside her suggestive even of prostitution or slavery. His demonic face, at the right edge of the picture, implies an element of aggressive instinctual drive in the relationship between the sexes.

The Bath of 1930 (p. 94) suggests even more strongly the allure of sensual tension in the relationship between man and woman. The viewer slips into the role of voyeur, witnessing an intimate bathroom scene, in which a naked woman proffers her extremely sensual charms to the male figure in the bath tub as well as to the viewer, while at the same time veiling them with a cloth. The relationship of the two is extreme ambivalent. On the one hand she turns towards the apparently non-participative man in the bath tub and attemps to provoke further excitement with her foot, but on the other hand her monumentally placed thigh introduces a barrier, and her left arm, held across her upper body, and her downward gaze express modest aloofness. The gesture with the foot can be understood as an expression of eroticism, but also one of domination. It is much the same with the man, who has been taken as a self-portrait of Beckmann because of the black cap, with which he often portrayed himself. His arm demonstrates aloofness and makes him seem to turn away – his foot, by contrast, expresses openness and makes him seem to turn towards the woman. The bathroom scene is by definition private and intimate, the man is holding a cigarette, typical attribute of sophisticated male charm in the public domain.

Even though the charm of sensual erotic tension between man and woman may seem to take first place here, the allusions to myth and to history paintings which have almost taken on the quality of myth are expressive also of the latent violence in the man-woman relationship. The scene arouses compelling associations with the Greek myth of Agamemnon and Clytemnestra. Clytemnestra betrayed her husband Agamemnon during his absence at the siege of Troy, with Aegisthos. When Agamemnon returned home she threw a net over him as he lay, unsuspecting, in his bath and he was killed with an axe. Another famous episode recalled by the picture is the death of Marat. Marat, hero of the French revolution, who spent several hours of each day in the bath because of a skin complaint, was stabbed to death by Charlotte Corday. Jacques-Louis David (1748–1825) raised the scene to the level of martyr myth in his picture *The Death of Marat* (Brussels, Musées Royaux des Beaux-Arts), which became an icon of the revolution and ensured for Marat undying fame.

The powerful body of the male figure is wedged in and moulded to the form of the bath tub, seemingly leaving him no freedom to move. This, and the

Encounter in the Night
Begegnung in der Nacht
Frankfurt am Main 1928
Pastel on black paper, 109 x 50.5 cm
Bielefeld 124
Princeton, Princeton University Art Museum

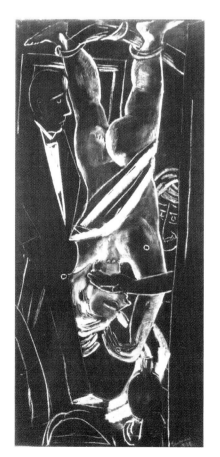

supposedly victorious pose of the woman, recall these murderous analogues. The crooked row of hooks, clearly threatening to fall, contributes further to the impression of uncertainty and shifting ground that emanates from the picture. The scene therefore comprises a whole spectrum of exemplars for the relationship between the sexes – from primarily libidinous erotic tension through seduction, oppression, loss of trust to the deadly violence resonant in the connotations of myth.

Man and Woman of 1932 (p. 97), often also entitled *Adam and Eve*, sees the relationship between the sexes in terms of a general formula, freed from any narrative element. In a place without specified location, but with archetypal symbols, man and woman meet in mythic nakedness. The man stands upright, vertical beyond the horizon, turning towards the infinite blue-grey distance, while the woman reclines horizontal and earth-bound with downcast gaze at the foreground edge of the picture. Cornucopia-like blooms suggest her fertility, while a sapless tree extends upwards behind the back of the man. The two trees allotted to man and woman display in each case the phallic or vaginal symbolism customarily ascribed to the opposite sex. There is a clear reference to the traditional image of the Fall with the tree of knowledge – Beckmann has taken the Christian myth quite literally. The Bible uses for the sexual union of man and woman the word "knowledge". Knowledge, sexuality and guilt are inextricably involved in the relationship between the sexes, in Christian myth and also in Beckmann's picture.

The picture is like a painted version of the psychoanalytical doctrine of archetypes put forward by Carl Gustav Jung (1875–1961), who in the nineteen-twenties significantly extended the fundamentals of psychoanalysis developed by Freud at the beginning of the century. Beckmann's interest in the psychological works concerned is known from his letters and comments, and from the contents of his library.[45] The recurrent mythic symbols in his work from this time on, such as sea, fish, and flowers, were closely related to the insights of psychoanalysis. In this respect Beckmann is very close to the painting of the Surrealists, whose main theme was the dream world discovered by psychoanalysts, and the human subconscious. In formal terms, also, Beckmann drew closer to Surrealism during this period. A comparison, for instance, of *The Serpent King and the Stagbeetle Bride* (p. 97) with *Le déjeuner sur l'herbe* (p. 96) by Max Ernst (1891–1976) can demonstrate this. Here, too, one can see the

The Night
Die Nacht
Frankfurt am Main 1928
Black chalk, 65.5 x 187 cm
Bielefeld 123
Private Collection

The Bath
Das Bad
Paris 1930
Oil on canvas, 174 x 120 cm
Göpel 334
St. Louis (MO), The Saint Louis Art Museum,
Bequest of Morton D. May

potential for violence and harm that Beckmann associates with the relationship between the sexes.

Beckmann does not restrict himself to veiled allusions to mythic themes, he also incorporates explicit materials from ancient tales. In 1933 he painted two large-format aquarelles, *Odysseus and the Siren* (p. 99) and *Rape of Europa* (p. 98), which clothe the relationship of the sexes in the mythology of classical antiquity. The mythic theme corresponds with a specific kind of creation of space; in the abstract planar representation of sea and sky, non-specific time and place are presented as characteristic structures of myth.

The two paintings only achieve their full impact when they are looked at together. *Odysseus and the Siren* shows man as a victim. Bound to the mast, he is defenceless against the sensual seductiveness of the siren, and beneath her

Portrait of Minna Beckmann-Tube
Bildnis Minna Beckmann-Tube
Frankfurt am Main 1930
Oil on canvas, 160.5 x 83.5 cm
Göpel 337
Kaiserslautern, Pfalzgalerie

alluring exterior a terrible claw can be seen which attests to the deadly peril of her charms. In *Rape of Europa* by contrast it is the woman who falls victim to male force. The ancient myth narrates how Zeus, father of the gods, changed himself into a bull and abducted Princess Europa from a sea-shore to Crete, where he begot three sons with her. Beckmann portrays the bull as the energy-laden vital image of male potency and potential violence, Europa hangs over his back with a pain-filled face, and yet she forms in this posture a kind of yoke against which the bull must pit his superior strength. One is almost tempted to surmise that the enormous sensual tension and passionate force with which Beckmann here characterised the relationship between the sexes may have inspired the late Picasso to his bull-fight pictures (p. 98). Beckmann here designs a picture of the battle of the sexes rather than harmony

between them, and sees man and woman equally in the roles of aggressor and victim.

In addition to the theme of the sexes the two paintings also include a political dimension. At the time of their execution Beckmann had already been dismissed from his post in Frankfurt and public exhibition of his work was forbidden; in the wake of Hitler's seizure of power the re-structuring of Germany, which involved the use of force, was already in full swing. In *Odysseus and the Siren* Beckmann shows the danger lurking beneath a seductive surface. There is ample justification for the view that this is a warning delivered by Beckmann to the credulous who too easily trusted in the demagogic slogans and promises of the Nazis. History also gives the theme of the violent overpowering of Europa a sinister dimension of foreboding with regard to the destiny of Europe.

Another product of Germany's fateful year, 1933, is the picture *Brother and Sister* (p. 103), which again links the guilt-laden and violent relationship between man and woman to the current history of Germany. Beckmann originally called the picture *Siegmund and Sieglinde*, but the ominous political circumstances led him to discard this explicit reference to the Germanic world of myth. The picture alludes to the version of the Nibelungen saga portrayed by Richard Wagner (1813–1883) in *Die Walküre* (The Valkyrie) which tells of incest between the twin brother and sister, Sigmund and Siglinde. Again it is a question of the sensual-erotic attraction between man and woman and the reverse side of the coin, violence and guilt.

Beckmann found a fascinating formal solution to the problem of the brother-and-sister incest. On the one hand he characterised the identity of the twins by means of absolute parallels of form in shoulder, leg and foot posture; on the other hand he demonstrated by means of the mirror-image polarity of his knee and her buttocks, of the two heads, and of his right and her left foot, the utmost tension in the attraction of male and female opposites. The formal analogy represents the sibling quality, whereas the mirror-image polarity represents erotic tension. The sword, presented as outsized phallus, comes between the union or even the physical contact of the two. Any closer approach to the pole which is drawing them with maximum force to the centre and to physical union would threaten the woman with transfixation by the sword. Yet she seems to caress the threatening weapon tenderly, and has clearly already wounded herself in the process, as is shown by the drops of red. The red cloth on which they are lying emphasises the erotic character of the scene and at the same time arouses associations with a bloodbath – much in the same way as Eugène Delacroix's *Death of Sardanapalus* (p. 102), to which Beckmann had referred once before.

As in the pictures already discussed , the role of man and woman is here once more highly ambivalent. At first glance it seems that the man is harassing the woman. The part of his body turned towards the woman is in shadow and it is of a brown colour indicative of his animal and instinctual nature; the point of the phallic sword is directed towards the woman. Yet the woman's flowing hair and sensuous curves make her seem a seducer and *femme fatale* whose dominant role becomes all the more obvious when one turns the picture by ninety degrees, as would be tempting for an impartial viewer. In this position it seems rather that she is pushing the sword aside in order to be able to seduce the man without any obstacle, while he suddenly becomes a frightened prisoner

Max Ernst
Déjeuner sur l'herbe, 1936
Oil on canvas, 46 x 55 cm
Private Collection

of her seductive arts and no longer matches up at all to the Wagnerian hero.
Both are equally seducers and seduced who, as is suggested by the high format,
are soaring or falling in the uncontrollable tumult of their emotions. With the
thrust of the sword Beckmann shows clearly the destructive and deadly con-
sequence of incest between brother and sister. Furthermore their tragedy lies
in the fact that they are not only guilty themselves of a moral misdeed, they
are also victims of the godly conflict of interest between Wotan, Freya and the
Valkyrie. Here for the first time Beckmann gives full expression to his view of
the insoluble dilemma of man's entanglement in sexuality and the whims of
destiny, a dilemma to which he returned repeatedly right up to the time of his
death. In the theme of the Germanic pair guilty of self-destructive moral error
there seems also to be an allusion to Germany's catastrophic and self-destruc-
tive bond with Hitler.

The *Journey on the Fish* (p. 101) treats the same themes. This time Beckmann
draws not on Greek or Germanic myth, but on his own genuine Beckmann
myth. The mythic structure results from the use of archaic symbolic images
such as fish, sea and land, which create a timeles system of reference matched
on the level of painterly technique by the abstract treatment of space and
figure, which follows the principles and formal analogies inherent in the pic-
ture and not illusionist principles.

Man and woman together are bound to a pair of fish, precipitated down-
wards at speed. A blue-grey area is identified as sea by a sailing-boat, but the

Left:
The Serpent King and the Stagbeetle Bride
Schlangenkönig und Hirschkäferbraut
Berlin 1933
Aquarelle, 61.5 x 48.2 cm
Bielefeld 142
Bloomington (IL), Mr. and Mrs. Bernhard
Heiden Collection

Right:
Man and Woman
Mann und Frau
Frankfurt am Main 1932
Oil on canvas, 175 x 120 cm
Göpel 363
Private Collection

Page 99:
Odysseus and the Siren
Odysseus und Sirene
Berlin 1933
Watercolour, 101 x 68 cm
Bielefeld 141
New York, Private Collection

Rape of Europa
Der Raub der Europa
Aquarelle over graphite, 51.1 x 69.9 cm
Bielefeld 140
Private Collection

two pairs threaten to plunge not into the sea but rather onto a black strip before or beneath it. The fish is in many cultures an ancient symbol of life-giving force and vitality, usually equated – by Beckmann as well as others – with a phallus. Man and woman seem to be bound jointly to this instinctual force, which draws them forcibly to the depths, to a black area in which the life-giving force of the fish is condemned to wither. The body of the man is likened formally to that of the fish; while the woman sits upright, he is stretched lengthways like the fish and his feet have almost turned into flippers.

The hand held in front of his face expresses fear and horror at the fall; the figure seems like a blend of two of the "damned" from the *Last Judgement* in the Sistine Chapel by Michelangelo (1475–1564). The vision of the damned being cast into hell is suggested also by the black abyss at the lower edge of the picture, towards which the figures hurtle. The contrast with the light blue of the sea sharpens the sense of the black zone as abyss and zone of death: if the fish were to plunge into the sea one could speak of a return to their natural element, and the positive associations of the sea as location of endless expanse and freedom are aroused by the ship sailing away. But as it is, the plunge is

Pablo Picasso
Bullfight Scene, 1955
Scène de tauromachie
Oil on canvas, 79.5 x 190.4 cm
Jacqueline Picasso heirs

The Catfish
Der Wels
Frankfurt am Main 1929
Oil on canvas,
125 x 125.5 cm
Göpel 312
New York, Mr. Richard L.
Feigen Collection

presented as the fall into absolute darkness. Black occurs a second time in the masks held by man and woman. They do not have direct contact with one another, but with the mask – only a dead imprint, a cliché picture of the partner playing the opposite role. The mask becomes a grimace of de-masking exposure, a mirror of self-deception. As if it was their own black existence displayed before their eyes, neither man nor woman dares to look upon the mask.

With great subtlety Beckmann here combines elements of traditional Christian iconography with his own profaned and mythologised world of images. The iconography of Last Judgement and infernal damnation is crucially modified: in the place of Christ enthroned, there is woman. She is not any kind of judge, but rather she is herself guilty and condemned to descend into hell. The descent into hell becomes the expulsion from paradise after the fall.

Yet the picture is not entirely negative, for Beckmann's images are ambiguously constructed: the mysterious black mask which seems to plunge the man into depths of despair as mirror of his own self-deception, combines with the curves of the woman's thigh to form an enigmatic sphinx. The man's hand, which seemed to express despair, can be interpreted in this new context as

Journey on the Fish
Reise auf dem Fisch (Mann und Frau)
Berlin 1934
Oil on canvas, 134.5 x 115.5 cm
Göpel 403
Stuttgart, Staatsgalerie Stuttgart

the hand of the sphinx bringing comfort to the man. Nor are the fish entirely negative in their presentation as phallic symbol dragging the pair irremediably downwards. In the Old Testament the whale who swallows Jonah is the symbol of re-birth, just as in Christianity the fish is a symbol of Christ, and therefore an emblem of resurrection and eternal life. The striking representation of the ship's mast as cross is a further indication of the theme of salvation, already suggested by its apparent sailing away to freedom.

In this exceptionally complex picture, which is rendered all the stronger and firmer in formal structure by its complexity, Beckmann presents the relationship of man and woman, charged with the tensions of sexual drive, guilt, bondage, damnation and descent into darkness, but also suggesting salvation and new departure. They are bound to the force of life; but it is this very life-force – in the form of the fish – that seems to drag them down irrevocably to the black region of death. In the metaphor of the fall or "journey", as Beckmann puts it in the title, life is shown as a transient stage linking all regions – heavens, water and the black "zone of death" – with one another, as exemplified formally by the two pairs of figures.

Ten years after his second marriage in 1925, to Quappi, Beckmann had now completed the most profound and far-reaching artistic development. Starting

from the inner emptiness of mankind, he had come to demand and eventually to assert and define man's status as free agent with perfect self-responsibility: as self-confident dweller in this world and as confident owner of eternity. His view of the emancipation of mind and spirit was matched by the techniques of abstract painting, on which he now focused his attention, rather than on naturalism or New Objectivity. The abstract language of art that he discovered and his awareness of intellectual and spiritual freedom enabled him to transcend the empirical reality of the present and reach the ultimate questions of human existence in universal and timeless images – in myth. The relationship of man and woman as one of the fundamental themes of myth recalled for him the limitations of freedom, which he was now constrained to register painfully as historic reality with the Nazis' rise to power. The indissoluble mutuality of love and suffering, libido and guilt, downfall and salvation, is the theme of his mythic pictures. By the beginning of the nineteen-thirties the fifty-year-old artist had achieved maturity in his art; he was equally at home formally in abstract and in figurative art, thematically in myth and in the present. It is a sad paradox of German history that at the height of his artistic development, when he had most to say and the most varied means with which to say it, Beckmann sank into complete anonymity. Dismissed from his position as professor and discredited as artist, there was in 1934 only one brave man, Erhard Göpel in the *Leipziger Neuesten Nachrichten* who considered Beckmann's fiftieth birthday to be worth honouring.

Eugène Delacroix
The Death of Sardanapalus, 1827/28
La mort de Sardanapale
Oil on canvas, 392 x 496 cm
Paris, Musée National du Louvre

Brother and Sister
Geschwister
Berlin 1933
Oil on canvas, 135 x 100.5 cm
Göpel 381
Private Collection

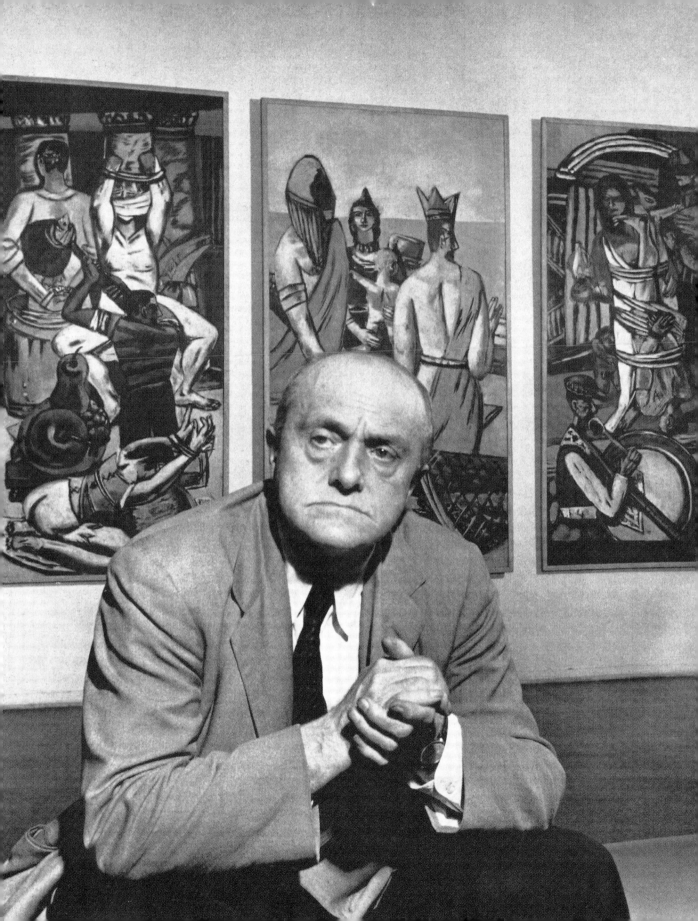

Departure and *Temptation*:
World Views of the Thirties

In May 1932 Beckmann began work on his first triptych, *Departure*, which was not completed until one-and-a-half years later, on 31 December 1933. The protracted process alone shows what great significance Beckmann attached to this first work in what was a new format for him: the monumental three-panelled picture. Forming a genre of their own, the triptychs ran through his work as a distinctive thread from then on, signalling points of crystallisation and emphases, highly ambitious world-views with regard both to form and to content. Altogether Beckmann painted nine triptychs. The last – *The Argonauts* (pp. 190/191) – was completed the day before he died, and another remained unfinished.

Beckmann did not arrive at the large format of the triptych at a random point in time. As a fifty-year-old, he had finally found his own style and reached full maturity and mastery. With the establishment of a Beckmann Room at the Berlin Nationalgalerie in 1932 he was at the height of public acclaim as an artist, although at this very moment ominous signs of hostility from the National Socialists were beginning to emerge. To choose at this time the monumental format of the triptych, with its historic and emotional resonance of the altar, must be understood as an act of self-assertion. When eventually the Nazi State deprived him of a public platform for his art – the Beckmann Room at the Berlin Nationalgalerie was dismantled in 1933 and a planned Beckmann exhibition in Erfurt was banned – the triptych became a manifesto, an assertion of his right to public display.

However, the triptych format includes more than a mere assertion of the right to exhibit. For centuries this art form had been reserved for the altar, profoundly bound up with Christian liturgy and the idea of humankind's redemption through the crucifixion and resurrection of Christ. Beckmann's triptychs draw on this tradition with full awareness, and refer directly to Christian iconography, as is particularly evident in *Departure*. Yet his triptychs, as "post-Christian altarpieces" (Lackner), announce programmatically that it is no longer religion but art alone that holds the key to redemption: "The artist in the new sense of the times is the conscious former of the transcendental"[46], he wrote as early as 1927, underlining the artist's hieratic role. "Creation is redemption!" he noted in his diary on 2 May 1941, after completing his fourth triptych, *Perseus*. All Beckmann's triptychs address art's role in defining the purpose of human existence, which threatens to be lost in the confusion of dependence on the whims of deities, the battle of the sexes and historic destiny.

Max Beckmann 1947 in the New York Museum of Modern Art, in front of the triptych *Departure*, in the museum's keeping since 1942

Regarded from the viewpoint of format alone, the three-part division lends itself to specific ways of seeing. It is especially well suited to the presentation of a dialectic view which, philosophically speaking, is made up of opposites and contradictions, of thesis, antithesis and synthesis. The complex demands of presenting a "world view" are therefore better served by the triptych than by a single picture. In all Beckmann's triptychs empiric logic and classical unity of time and space yield to a world based purely on artistic order. Myth and history, imagination and reality co-exist side by side, are pitched against one another and mixed together.

In none of the other Beckmann triptychs is the juxtaposition of crass opposites so evident as in *Departure*. The contrast between the side panels and the central panel is at first the most striking aspect of the triptych. The side panels show a threatening picture of existence in cramped interiors: bonds and brute violence in its historic reality on the left, the battle between the sexes and mutual oppression on the right. By contrast the central panel portrays in magnificent blue an existence in mythical infinity and freedom. Discontinuity and contradiction between the panels are the guiding principle. Only on closer inspection does it become apparent that Beckmann has linked the panels in composition, formal analogy and specific motifs. The lines of the boat in the central panel, for instance, are continued on the balustrade and in the back edge of the room in the right panel; diagonal composition lines extend across all three panels (for example, cowering woman – large fish – lower stair); the king in the central panel is matched by the figure in striped shirt in the left panel, and the fish is a key motif in all three panels.

The left panel, which Beckmann entitled *The Castle*, leads us into a pillared room in which brutal scenes of torture and violence are frozen into permanence, as in a film still. In the background a bound and gagged man has had his hands hacked off; on the left, another prisoner is condemned to stand in a water barrel. In the foreground a corseted woman cowers in distinctly erotic posture. The ropes indicate that the erotic pose is forced upon her, with the threat of imminent rape. The individuals are set in their role as victims, no action is shown. In this way the impression is created that we are dealing not with a sequence of scenes in a finite space of time, but with a lasting condition.

The only exception to this absence of action lies in the figure in the middle of the panel, who is also the only one not bound. At first glance, one sees the figure as executioner, as one who swings the axe and is responsible for the mutilation of the man above, or behind, him. But on closer inspection the supposed axe turns out to be a harmless fish creel, in which two fish are held. The scene takes on grotesque features: the wheels of torture and violence turn without any visible purpose or perpetrator. The pointlessness and anonymity of the violence recall the novel of the same name, *The Castle*, by Franz Kafka (1883–1924), which had appeared only a few years earlier. Kafka's work, too, is built around the ever-present and insurmountable consequences of an all-powerful institution, which itself remains anonymous, abstract and intangible.

The figure invites further interpretation, beyond the Kafkaesque. The ambivalence between brutal executioner and harmless fisherman seems to be a deliberate device; for the figure proves to be the negative counterpart to the king in the central panel. Like the king, the "fisherman" is viewed from behind,

and his face – in analogy to the king's – turns to the right. Yet while the king releases the fish into their natural watery element with a gesture of blessing, his gnome-like counterpart has robbed them of their freedom and holds them up in the air, where they must suffocate. We have already encountered the fish as symbol of life-giving force several times in Beckmann's work; but the man is denying the fish their life-force, holding them instead in captivity and isolation. The formal shaping of the fish creel does in fact allow for its interpretation as an executioner's axe or club. Taken literally, Beckmann is demonstrating that the stifling and "drying up" of life – as inflicted by the man on the fish – can gain the same murderous potential as an executioner's blade. To add a further dimension of possible interpretation: the "stifling" of artistic life force – by means, for instance, of a ban on public exhibition of art – had become bitter reality for Beckmann himself while this work was in progress. The consequences of the withdrawal of the foundation of life and art are implied by the fish creel's formal resemblance to an executioner's axe. One can recognise in this figure Beckmann's veiled indictment of the apparently inoffensive helpers of the totalitarian regime. He shows how fine the dividing line can be between something as comparatively harmless as fishing, and torture or even execution.

Beside the man a huge fruit still-life is placed centre stage. To cite painting, and art, in this manner creates a grave sense of artistic alienation. Set on a

Max Beckmann in Amsterdam, 1938
Photo: Helga Fietz

small trolley, the work of art has become a transferable mass. As a still-life with nothing to say, but formally pleasing with its bright colours and sensual round shapes, it displays a suggestive power of seduction that may distract attention from the gruesomeness of the scene. Yet Beckmann does give some indication of the visionary possibilities of art by alluding, in the form and colour of the still life, to the crystal ball – the apple takes the ball's shape, the pear its colour – even though nobody heeds the possibilities. It is tempting to decipher this as a tendentious commentary or charge levelled by Beckmann against the trite realism of art in the Third Reich, but in fact he pulls the rug from under such interpretations. He has painted the still-life so attractively, so forcefully and so resolutely, that art establishes a place of its own in the midst of this gruesome scene, and maintains its position in defiance of violence. The woman at the lower edge of the painting is bent over a crystal ball in which she searches for knowledge of the future. But her efforts are grotesque: directly beneath the crystal ball a newspaper is to be seen (clearly identified as such by the heading "ZEITU" (Newspa), upside down at bottom right), implying that the "prophetess" only discovers a blur of what has already long since occurred and can anyway be found in the newspaper.

The newspaper determines the theme of the left panel: it raises awareness of the current reality of the whole scene, referring as it does to actual violence and brutality. The political reality of the year 1933, in which this work was created, springs to mind first of all. But the newspaper has no date. Beyond the specific context of the age in which the work was produced, there is a much broader challenge to every viewer – including the viewer of today – to relate what is happening in the picture to his own era. "One can only say that *Departure* is not tendentious, and that it can apply anywhere at any time", wrote Beckmann to his New York art dealer, Curt Valentin, who had requested an interpretation of the triptych.[47]

The right-hand panel, to which Beckmann gave the title *Stairs*, is shown to be the complementary counterpiece to the left panel by the black strip at the lower edge of the painting, matching the black strip at the upper edge on the left. Here we again find ourselves in a claustrophobic interior space, with a couple standing bound together in the centre, clearly demonstrating the problematic relationship between man and woman. The woman's bared breast and the strikingly presented phallic fish as emblems of eroticism and sexuality link bondage and compulsive lust. The lift attendant in livery, whom Beckmann once described as a modern harbinger of fate, blindly parades the fish as symbol of male sexuality before him: fate distributes the burden of compulsive sexuality with blind and grotesque arbitrariness. An ugly dwarf appears as negative caricature of Cupid.

Departure
Abfahrt
Triptych
Frankfurt am Main and Berlin 1932/33
Oil on canvas
Wing Panels 215.1 x 99.5 cm
Central Panel 215.5 x 115 cm
Göpel 412
New York, The Museum of Modern Art

"For me, the picture is a kind of rosary or ring of colourless figures, that sometimes, when the contact is there, can take on a sudden glow and tell me truths that I cannot express in words, and did not know before. – It can only speak to people who, consciously or unconsciously, carry much the same metaphysical code within them.
Departure. Yes, departure from the deceptive appearance of life to the things themselves that matter, behind the appearances. But, in the final analysis, this applies to all my pictures…"
Max Beckmann in a letter to the gallery owner Curt Valentin, 11 February 1938

Rigid posture, dull skin colour, and traces of blood on head and back give the man the appearance of a corpse – for the woman, a terrible burden to carry around with her. Gert Schiff has interpreted the couple as an inversion of the Orpheus myth. It is not Orpheus searching for a dead Eurydice, but Eurydice dragging a dead Orpheus through the underworld, searching with a lamp for the exit which is hinted at in the stairs in the background.[18]

In conversation with his friend and patron Lilly von Schnitzler, Beckmann himself gave a different explanation for the scene: "In the right panel you can see yourself trying to find your way in the darkness. You are illuminating the room and the stairwell with a miserable lamp and, as part of yourself, you are dragging with you the corpse of your memories, your wrong-doings and failures, the murder that everyone commits at some stage in their lives. You can never free yourself from your past, you must carry this corpse with you, moving to the beat of life's drum."[49] Beckmann's words do not exclude Schiff's interpretation, since the Orpheus myth is also about the burden of memories of the dead. Yet what becomes clear through Beckmann's comments is the multi-layered meaning of the work. It is not simply a question of the tragic impossibility of the man-woman relationship, but also more generally of the guilt that everyone bears, even if guilt and the fall from grace are attributed crucially to relationships between the sexes by his representation of man as "burden" and by the emphasis on sexuality in the shape of the fish and ugly Cupid.

If one takes Beckmann's comment at face value, it would mean that each individual bears some responsibility for the circumstances presented on the left wing-panel. Perhaps this could explain why there is no instigator, no actual torturer to be seen. What we are shown are the "wrong-doings", the "murder that everyone commits at some stage in their lives" – including the viewer. While the left-hand panel registers the reality of violence suffered and perpetrated, the right-hand panel is concerned with the weight of individual responsibility for it – and with the search for an escape from this labyrinth of bonds and violence.

The path taken by the woman leads towards the centre of the triptych; the space she treads on converges towards the boat and the king's gesture of blessing is directed to the right, towards the woman. In spite of the contradiction and irreconcilability of the two panels, a "bridge" leads from one to the other, and the boat in the central panel is presented as the goal of her path, offering the possibility of escape from the dilemma of guilt and sexual entanglement. The composition of the left panel displays no such connection with the central panel, in which free existence – portrayed by the radiant blue and infinite vastness of the sea – functions as the antithesis to the world of the outer panels. But what does this antithesis, this utopia of freedom, really look like? Obvious as the central panel's initial meaning may be, on closer inspection its message turns out to be puzzling and complex.

Beckmann's vision of liberated existence is a blend of several different models and notions of "redemption". One of these is the image of the boat and water that alludes to the flood and the myth of Noah's Ark. This myth, which appears in similar form in many other cultures, tells of the absolving and purification of past sin and the concomitant new beginning. The idea of cleansing and rebirth is mirrored in the Christian ritual of baptism as a "symbolically curtailed flood".

Max Beckmann in the Amsterdam Studio, 1938. Photo: Helga Fietz

Pages 112/113:
Temptation
Versuchung
Triptych
Berlin 1936/37
Oil on canvas
Wing Panels 215.5 x 100 cm
Central Panel 200 x 170 cm
Göpel 439
Munich, Bayerische Staatsgemäldesammlungen, Staatsgalerie moderner Kunst

Birds' Hell
Hölle der Vögel
Amsterdam or Paris 1937
Oil on canvas, 120 x 160.5 cm
Göpel 506
New York, Mr. Richard L. Feigen Collection

The boat's crew clearly comprises quite different stylised figures who together form the archetypes for Beckmann's utopia of free existence. The protagonists in this "ark" are the king, the woman, and the warrior at the left edge of the picture. Their headdress rises above the level of the horizon. This formal device lends emblematic symbolism to crown, Phrygian cap and helmet, adding to each figure a layer of meaning at the level of abstract principle. A similar mechanism is at work in Beckmann's representation of the water: in the foreground there is an almost illusionistic sense of actual water, depicted with a variety of blue tones and currents within a spatial dimension. The background, however, is formed by a pure, homogeneous blue surface that creates no illusion of depth; the colour blue is an abstract representation of the ocean's immensity.

Warrior and king form a striking pair of opposites. Mystery and unfathomable vitality on the one hand and clear rationality on the other confront one another as two opposing principles of life. The one is characterised by the dominant fish, symbol of pure physical life-force, and the intense, almost fiery red, the other by the cool blue. The one grasps, while the other nonchalantly returns the fish to freedom. The helmet, half fish-head and half phallus, gives the figure on the left an archaic, mask-like anonymity which is at once mysterious and frightening. The crown on the other hand stands for a civilised form of human society organised as state; being the ideal image of a king, one associates him with prudent, far-sighted, and rational action. Furthermore, his gesture of benediction and the garb of antiquity recall the iconography of Christ.

Between the representatives of archaic and civilised society appears the woman with child. Modelled on the Madonna with infant Christ, she is the most obvious motif from Christian iconography, evoking also the notion of Christian redemption. Beckmann has merged this Christian mother of God with a heathen type. The woman is wearing a Phrygian cap, traditional symbol of freedom, although in classical times also a distinctively barbarian fea-

ture. She has some of the hallmarks of "Marianne", figurehead and emblem of the French Revolution, who embodied the ideal of liberty. The woman can be seen as the synthesis of archaic warrior and king: she unites primaeval "barbarism" with the French Revolution's modern ideal of freedom within the state; furthermore she unites this profane ideal of liberty with the Christian concept of salvation.

The child corresponds at one level to the Redeemer Christ. There is good reason also to see a link between the child and art, especially since the head one can see behind him has frequently been interpreted as one of Beckmann's self-portrayals. Which other "child" of Beckmann's could be intended, if not art? Art as the child of freedom, bearer of hope on the journey to new worlds. By depicting the child as Redeemer Christ, Beckmann is articulating the great claim that he makes for art: namely that art is the only possible form of salvation for humanity, as he was to write later in his diary too: "Gestaltung ist Erlösung" ("Creation is redemption.")[50] With its several metaphors of salvation (the deluge, the Christ child, the Madonna, Marianne), the central panel is designed as ideal blueprint to counter the outer panels. Archaic vitality and civilised rationality are central components of this ideal, which has liberty as its central point, to which art alone holds the key.

Failure to observe the simple fact that the three panels are intended to be viewed simultaneously alongside one another, and that it is this simultaneous presentation which actually constitutes the work, has repeatedly led scholars to misunderstand and misinterpret this triptych, which has been the subject of more research than almost any other of Beckmann's works. The three panels should not be understood, for instance, as chronological scenes in a development leading ultimately to a freedom that has left behind it all the wrongs shown in the outer panels. The simultaneity of the panels signifies that all three scenes are happening at the same time. For Beckmann, utopia without reality is unthinkable. On the contary: utopia is a component of reality. *Departure* therefore does not represent a definitive leaving behind, in a single act, but a continuing process that must constantly be re-enacted within the reality of violence and bondage. For this reason Beckmann would not allow the central panel to stand on its own. He expressed his views on the subject unequivocally

Exhibition of "Degenerate Art", Munich 1937.
Left Beckmann's lost painting *The Beach*.
Photo: Hoffmann

in a conversation with Lilly von Schnitzler: "You want to buy the central panel, Lilly, but I cannot give it to you on its own. The three panels belong together – the centre is the end of the tragedy, but its meaning can only be understood when all three panels are viewed together."[51]

Three years later Beckmann began work on his second triptych, *Temptation* (pp. 112/113) which, with reference to the novel by Gustave Flaubert (1821 – 1880), he also sometimes called *Temptation of St Anthony*. Like *Departure*, *Temptation* also makes the ambitious claim to be a "world view". Fleeing from constant harassment, Beckmann had, in the meantime, moved to Berlin, and it was only a short while after completion of this triptych that he left Germany for good.

The years of Nazi dictatorship that lie between *Departure* and *Temptation* had clearly wrought a profound change in his view of the world, and his second triptych is a decided counter-representation as compared with the first. In his new work, having been taught a lesson by political reality and the prevailing conditions of life, Beckmann rescinded in *Temptation* the vision of utopian freedom portrayed in *Departure*. The figures which in the central panel of *Departure* brought tidings of a liberated, free existence, are banished in *Temptation* to the outer panels, where they are thralls to bondage and violence. In these outer panels the open sea has become the site of captivity, debasement and brutality; the central panel no longer represents an endless expanse, but a windowless interior in which a young man sits bound. The "profane Madonna" of the centre panel of *Departure* is now imprisoned in a cage, suckling an animal instead of a child, no more than a parody of a Madonna. With its cargo piled so high, the boat lists rudderless in the ocean, and appears dangerously close to capsizing. Of the king from *Departure* only the crown remains, served up on a platter by the lift-boy: power has become a moveable commodity, available to order. In the left panel the warrior from *Departure* has become a violent criminal who has just murdered another figure; instead of the life-giving fish he holds a sword, on which drops of blood are still visible.

The dismantling of the utopia of freedom and redemption from *Departure* is, however, only one dimension of the significance of *Temptation*. Once again, contemporary history, the relationship between the sexes and the role of art are woven into a complex panorama, but developed this time much more strongly from the viewpoint of art, or the artist. The outer panels are characterised, as they were in *Departure*, by oppression, violence and bondage. In 1937, the year of the new triptych's completion, the biographical and historical background of the Nazi state is even more insistently present than in the earlier work. The more or less veiled allusions to time and place indicate the background against which Beckmann wishes the action to be viewed. The letters (Kem)PINSKI on the bellboy's cap point unequivocally to the renowned Kempinski restaurant in Berlin (today a hotel), and therefore to the Berlin of the twenties and thirties. The uniformed lackey marches into the picture in aggressive military manner, almost in Prussian goose-step, and at the same time humiliates another figure, whom he has crawling on all fours, bridled like an animal. Significantly Beckmann does not introduce a brown-shirted thug into the picture, but a seemingly harmless lift-boy. It is the nice, fresh-faced "boy from next door" who acquires a certain status by means of a dapper uniform, and as one of the system's bully boys applies the boot to others, as is demonstrated by the view of his sole from below. He exemplifies the horri-

View of the exhibition "Twentieth Century German Art" held to counter Hitler's "Degenerate Art". In the centre is Beckmann's *Temptation* triptych. London 1938.
Photo: Ewan Phillps

Early Man – Prehistoric Landscape
Frühe Menschen – Urlandschaft
Amsterdam 1946 and St. Louis 1948/49
Aquarelle or gouache and ink,
49.8 x 64.5 cm
Bielefeld 197
Herford, Ahlers Collection

fying transformation of the inoffensive average individual from hanger-on to active criminal.

Behind the lackey a colourful and exotic bird appears with a giant eye. With a strangely ambivalent blend of tenderness and threat, it stretches out its supra-dimensional beak towards the woman's ear. Beneath its brilliant feathers – just as in *Odysseus and the Siren* – powerful claws are concealed that arouse associations with the German Eagle rather than with a harmless parrot; moreover the magic eye turns the bird into an all-seeing Orwellian nightmare: big bird is watching you. What depths of depravity can lie beneath exotically glittering feathers is shown in the picture *Birds' Hell* (p. 114), which was painted at almost the same time. Before a rabble with hands raised in Heil Hitler salute, colourful birds act as brutal torturers, tormenting a man with a knife and with their terrifying claws. The bright "golden pheasants' – as the party bosses of the Third Reich were called – represent the Nazi criminals who, resplendent in their uniforms, cynically assume the role of lords over life and death. *Temptation* shows the colourful "party bird" in an ambivalent role. The parrot represents the flattering enticements of a society that keeps everyone under close surveill-ance with its myriad eyes and beneath the guise of the colourful surface threatens violence (with beak and claws). The right panel shows how an inof-fensive hanger-on can become incriminated, how in the subtle interplay be-tween society and the individual, vanity and flattery can become dependence and entrapment.

In the left panel the helmeted hero figure, a hybrid of Greek and Germanic legend, is the most insistent reminder of Hitler's propaganda: "The present time is working on a new type of human being… Never was mankind closer in appearance and in sensibility to classical antiquity than is the case today. Millions of youthful bodies are being steeled in sport, competing and vying with one another… A bright and beautiful human type is evolving," Hitler had declared in opening the "Große Deutsche Kunstausstellung" (Great German

Art Exhibition) of 1937. At the same time he challenged this "bright and beautiful human type" to take up the battle against "deformed cripples and cretins, women who can only inspire disgust, men who are closer to animals than to human beings, children who, were they to live, would have to be regarded as nothing less than a curse of God !"[52] Hitler's belittling scorn of mankind was a horrific reality not only for art, but also for human beings.

The left panel has often been interpreted as the liberation of Andromeda by Perseus, but it takes on a quite different meaning against the background of Hitler's ideals of the Aryan and ancient Greek hero: Beckmann exposes the "shining hero" as a demagogic sham. Hidden behind his mask of anonymity, he is characterised only by the force he wields. There is no indication that he intends to free the woman, who is in any case not a lovely princess, but a woman reduced to her instinctual structure with a stupidly apathetic expression on her face. Three years later, when war was raging across the whole of Europe, Beckmann removed the seductive mask from his "hero": in the *Perseus* triptych Perseus has become a crude blond Aryan monster who, far from liberating Andromeda, abducts her with raw violence. Thus in *Temptation* the battle of the "hero" turns out to be the battle of the "bright and beautiful human type" against "deformed cripples". The dark-skinned sailor in the background is designated by the blend of Jewish (hook nose) and gypsy features as a member of the ethnic groups persecuted by Hitler, and his departure too seems about to be enforced by the presence of the monster of "virtue".

Even though Beckmann always distanced himself from direct political influence or comment, his criticism of the Nazi state and its demagogy is unmistakable in this triptych. ("Politics is a servile business, changing its form to suit the needs of the moment, just as harlots manage to adapt to the needs of each man, changing and masking themselves. – Therefore not of the essence."[53]) Beckmann's concern was less with the business of day to day politics than with the universal, recurrent patterns of human behaviour underlying the immediate social and political catastrophe: "To create the mythical out of the present, that is the purpose", was his way of defining his aim.[54]

The second major theme in *Temptation* is the relationship between the sexes. Beckmann attributes blame for the enthralment and violence shown in the panels not only to specific conditions at the time, but also to relationships between man and woman. The woman on the left, with her large eyes, heavily made up lips and bared breasts, is stylised into a sex object and bound to a spear, an unambiguous phallic symbol. The phallus virtually splits her in two, while her ripped dress is a further indication of man's violence. In the right panel the woman is suckling a kind of weasel, known during the Renaissance as a symbol of libido and passion. Within her cage she falls captive to her own libidinous desire. The portrayal of the "Bridle", with the group of figures in the foreground, was often cited by Beckmann as illustrating that the issue is not only power, but also, as he expressed it, "the lewd enticements with which time and again we are pulled back to the bit of life." In his diary he once asked himself, "Are we never to get away from this unending, appalling, vegetative carnality".[55] Self-abasement of woman and violent humiliation inflicted by man find expression in the relationship between lift boy and crawling woman. Both wing-panels thus create a climate of violence and oppression resulting from the battle of the sexes which can deform and isolate a human being just as surely as do the mechanisms of totalitarian society.

By contrast, a quite different presentation of the relationship between man and woman is shown in the central panel. Although there are bonds here too – binding only the man, unlike in the outer panels – there is nothing violent about the relationship. The assigning to both figures of their own half of the picture, and of the angular frame to the man and the round to the woman, makes the encounter between man and woman into a confrontation of two principles. While Beckmann documents separation and opposition between the youth and the woman by means of the objects assigned to each, yet in the background the pillar and the black duplex figure are symbols of the unity of these opposites. The pillar viewed as two-dimensional shape is rectangular and would therefore belong to the man's sphere, but in a three-dimensional view the pillar would be seen as round, matching the form of the oval frame that characterises the woman's sphere. In its colours of black and white the pillar again brings together the greatest possible contrasts. A further symbol uniting

Perseus
Triptych
Amsterdam 1940/41
Oil on canvas
Left Panel 150.5 x 56 cm
Central Panel 150.5 x 110.5 cm
Right Panel 150.5 x 55 cm
Göpel 570
Essen, Museum Folkwang

two in one is conveyed by the mysterious doublet. The rear part of the figure, with face and large eye, expresses an intellectual dimension, while the front part emphasises corporeality, with breasts as a fertility symbol – seemingly referring to the oneness of mind and body. Moreover the figure bears a striking resemblance to one of Beckmann's watercolours which shows the human being as an androgynous creature prior to the separation into male and female, prior also to the division of mind and matter (*Early Man*, p. 117).

The idea of an original androgynous proto-human that was split into male and female by the gods correlates with an ancient myth described by Plato (427–347 B.C.), among others, which was fascinating to Beckmann: "It has to be admitted that the trick of splitting oneself into male and female is a truly fabulous and almost inextinguishable incitement to us to be dragged back to the bridle time and again."[56] The pillar and the androgynous doublet in the background are images of the original oneness of man and woman, which is ruptured in the foreground: the pillar has fallen over, man and woman are separate.

In spite of his bound legs, which are obviously causing him great pain as well as hindering him, the young man's body seems to be reaching out towards the woman, just as hers is turned towards him, with a light, even provocative, touch of her toe. Yet his concentrated, searching gaze is not directed towards her alluring body, but to a point outside the picture – as hers is too – outside the reality visible to the viewer. It represents a spiritual dimension in their relationship, which is not restricted to the immediate here and now, but is directed to a shared goal, as described by the writer Antoine de Saint-Exupéry (1900–1944) who once said: "Love lies not in contemplating one another, but in looking together in the same direction." The relationship between man and woman in the central panel has a shared perspective, which does not exist in the outer panels: it is the search for lost oneness. This perspective helps the young man to surmount the pain inflicted by his bonds: instead of causing loss of liberty, the relationship between the sexes is here shown as the drive to live and survive, and life's motivating force.

Whether the woman is intended as a real figure or as a vision, a figment of the young man's imagination, remains open to question. Clearly she is located on a level of reality quite different from the level occupied by the young man. In the right-hand part of the picture the room changes; the wall is grey, whereas it is yellow on the other side. The skirting-board only defines the space on the left, in which the young man sits, while the right-hand side remains undefined. Moreover, the woman's strangely hovering pose adds a sense of irreality.

One explanation for this could lie in the young man's role as artist. The easel with picture, which serves as a support and also as protection against the flames, identifies the protagonist of the triptych as an artist, a painter. Beckmann repeatedly stressed the significance of the artist's eye as his most important organ, and his "imagination is perhaps the divinest attribute of man"[57] as his most important quality. The concentrated visionary gaze of the young man is therefore to be understood not only in the context of human relationships, but also in a wider sense with reference to the inner eye and imagination of the artist. So the young man's highly focused gaze is not only relevant to Beckmann's portrayal of the human condition, but also a representation of the artist's inner vision and imagination. The right-hand part of the picture with

Max Beckmann at Stephens College Columbia (Missouri), 1948

pillar, religious statue, and woman, would emanate from his imagination. Significantly, there are no bonds here. The quality of his imagination is visible also in the background colour. The yellow of the left-hand side of the painting has a discernible underlay of grey. On the right-hand side the grey beneath the yellow is clearly exposed – the artist's vision sees what lies behind the superficiality of things, as Beckmann had outlined in his London lecture: "What I am chiefly concerned with in my painting is the ideality that lies concealed behind surface reality. I seek, in the here and now, a bridge to the invisible…"[58]

That we are indeed dealing with art in the centre panel is shown by the "properties" that Beckmann has included in the scene. All genres of art are assembled: painting (easel, picture frames), architecture (pillars) and sculpture (religious statue), whereby pillar and statue serve a special function. They not only represent art, but also belong to classical temple cult and ritual. Being at once both artefacts and cult objects, they evoke an archaic era in which cult and culture (or art) were still identical. What was said of the relationship between the sexes applies also to art: in the foreground the oneness has been ruptured, the pillar has been knocked down and robbed of its function, religion literally exists only on paper – on one of the sheets of paper is the beginning of St. John's Gospel ("In the beginning was the word"). The splitting of the original unity of religion and art has robbed art of its sense and religion of its sensuality. Ever since, the search of each for the lost part has on the one hand – just as is the case with man and woman – resulted in the danger of each being led astray, but on the other hand it has also been one of the most dynamic sources of inspiration.

Ultimately *Temptation* deals with the inner conditions necessary for the creation of art. Beckmann depicts the artist as a modern St. Anthony, exposed to a myriad of temptations; at the same time these temptations are the foundation and mainspring of his art. In the side panels it is the confusions of a contemporary society that has lost its way, as well as the egotistical battle between the sexes, that create a climate of violence and loss of liberty. Power, false heroic ideals and sexuality storm in upon the young man, who has withdrawn to an inner space in order to follow the leadings of his imagination in tranquillity. Even here he is not unscathed by the reality of the outer panels: flames rise, a pillar has fallen, cords leave him only just enough freedom to move his hands – to create art. The outstretched palm as an image of the Passion has already been observed in *The Night* and *Self-Portrait as Clown*. It defines the suffering of the artist-saint, who nevertheless strives not to be absorbed by the absurdities of life, but rather to draw from them strength for his art.

In spite of his determined stance, "Salvation" is not achieved. This is the decisive step, the antithesis to *Departure*. *Temptation* expresses an unequivocal rejection of the earlier triptych's utopia of freedom. Freedom is present here only in the imagination, and even in his effort to represent it, the artist is severely limited by the constraints of his bonds. Freedom lies only in the imagination, but imagination empowers man to suffer lack of freedom with dignity – this is the verdict Beckmann presents in *Temptation*.

Self-Portrait
Selbstbildnis
Berlin 1936
Graphite on paper, 20 x 13.5 cm
Bielefeld 152. Private Collection

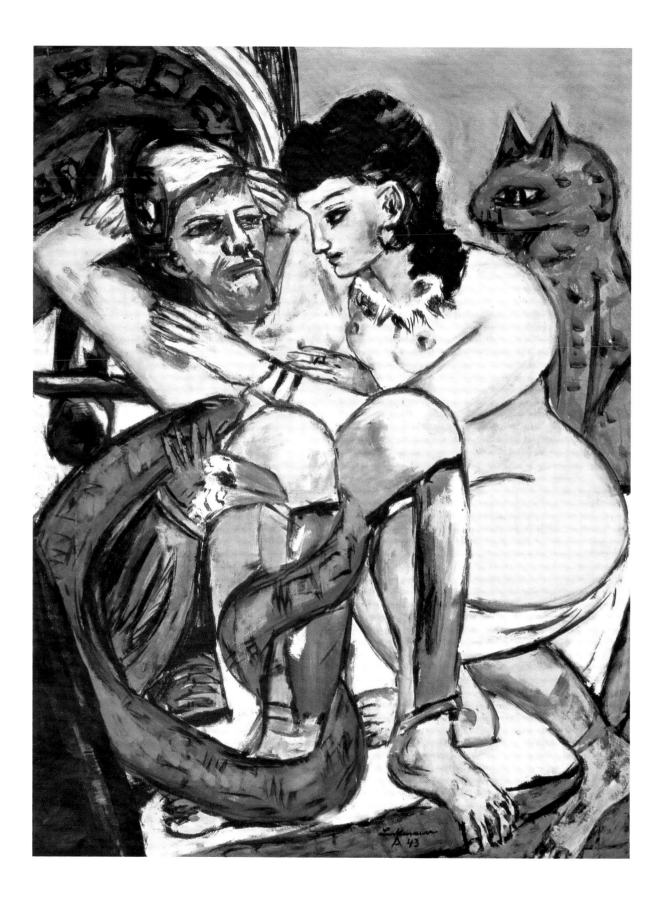

Survival in Exile: Amsterdam 1937–1947

Misshapen cripples and cretins... are what these appalling dilettantes in our midst dare to put forward as the art of our time... No, there are only two possibilities here: either these so-called 'artists' really do see things this way and therefore believe in what they are presenting, in which case it would simply be a question of clarifying whether their defective vision has been caused by mechanical means or by heredity. If the former, then how unfortunate for these miserable people; if the latter, then how important that the Reich's ministry for internal affairs should consider how at the very least to prevent any further transmission of such terrible sight defects. Or these people do not believe themselves in the reality of such representations but have quite different reasons for oppressing the nation with such humbug, in which case such activity falls within the remit of criminal investigation."[59]

When Beckmann heard Hitler's broadcast denigration and threats on the occasion of the opening of the "Great German Art Exhibition" on 18 July 1937, his mind was made up. Without further preparation he and his wife Quappi left the next day for Amsterdam, and exile. It was a final farewell, for Beckmann never returned to Germany. In Amsterdam the Beckmanns found refuge first with Quappi's sister; then, with the help of friends, they found a small apartment. The concierge in Germany packed up household effects and studio works and had them taken by a removal firm to Amsterdam before they could be confiscated by the Nazis. Beckmann reflected on the burdens and tensions of this time in a letter written in 1939 to the New York gallery proprietor Curt Valentin: "The last five years have been a terrible strain for me and I did not actually expect to survive them, it was a dire gamble."[60] As always, Beckmann's self-portraits reveal most clearly what he was thinking and feeling, what toll the events of the time were taking, and what consequences they had for him as an artist.

Confronted by the tense storm signals of 1936, Beckmann painted himself as prophetic seer with crystal ball (*Self-Portrait with Crystal Ball*, p. 123). He perceived his task as artist in prophecy and heightened attentiveness. Like a superdimensional third eye the crystal ball rests in the almond-shaped opening of his jacket; protectively and carefully he cherishes this instrument of his prophetic gift, truly the apple of his eye. The potential catastrophe has perhaps come to be seen as reality in the *Self-Portrait* of the same year (p. 121). The drawing is a shattering representation of the condition described by Beckmann in the letter to Valentin: deeply chiselled features distort the face into a gri-

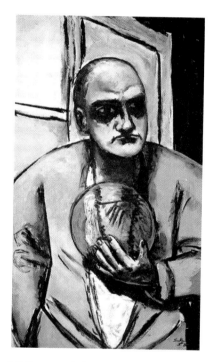

Self-Portrait with Crystal Ball
Selbstbildnis mit Glaskugel
Berlin 1936
Oil on canvas, 110 x 65 cm
Göpel 434. Private Collection

Odysseus and Calypso
Odysseus und Kalypso
Amsterdam 1943
Oil on canvas, 150 x 115.5 cm
Göpel 646
Hamburg, Hamburger Kunsthalle

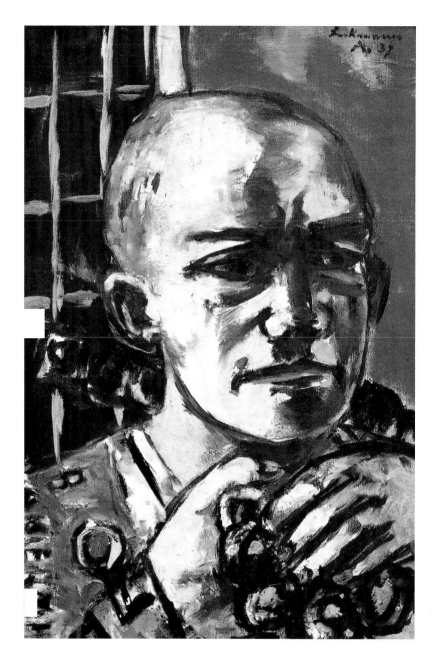

Released
Der Befreite
Amsterdam 1937
Oil on canvas, 60 x 40 cm
Göpel 476
Germany, Private Collection

mace; the wide open eye reflects distraught, almost incredulous horror; the chin jutting squarely forward and the drawn mouth express impotent rage – in imminent danger of losing all control.

The first picture painted in Amsterdam tells of Beckmann's attitude to exile. *Released* (p. 124) is the title of this self-portrait, a title which is shown by the picture itself to be deeply ironical. For the released man is still a convict who is by no means free of his heavy chains. The key is there in the lock of his manacles, but Beckmann is still bound and enclosed in a barred dungeon. The pained expression attests to the bitter experience that "liberation" means nothing other than being moved to a new prison. For Beckmann exile remained

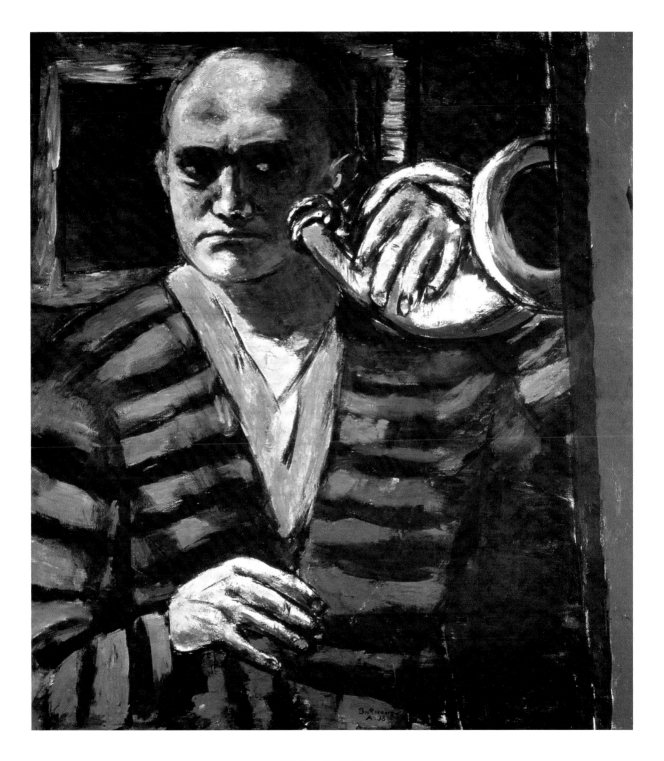

Self-Portrait with Horn
Selbstbildnis mit Horn
Amsterdam 1938
Oil on canvas, 110 x 101 cm
Göpel 489
Private Collection

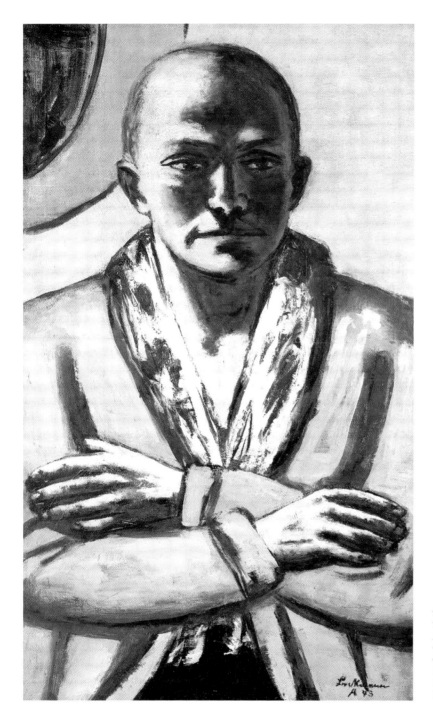

Self-Portrait in Yellow and Pink
Selbstbildnis gelb-rosa
Amsterdam 1943
Oil on canvas, 94.5 x 56 cm
Göpel 645
Berlin, Staatliche Museen zu Berlin –
Preußischer Kulturbesitz, Nationalgalerie,
Loan from private collection

synonymous with isolation and incarceration. In spite of the warm feelings
that he had for Amsterdam, it never became a home during the ten long years
that he spent there. The word "AMERIKA" stamped on his shoulder alludes to
his hopes of taking up a professorship which had been offered to him in the
United States, but his application for a visa was turned down. An attempt to
settle in Paris was equally unsuccessful; although he had been granted a French

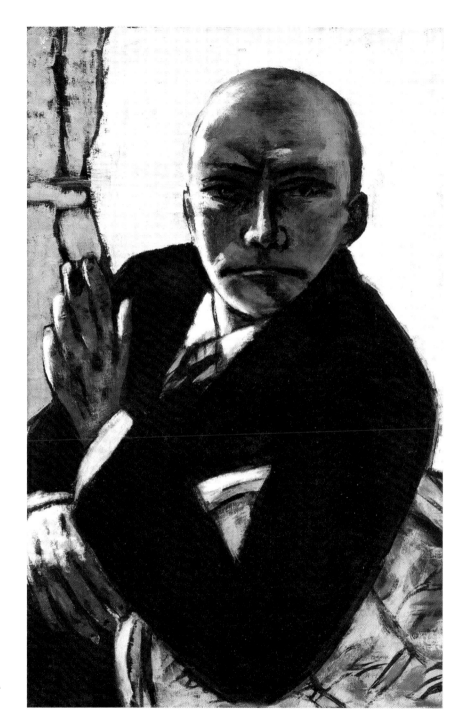

Self-Portrait in Black
Selbstbildnis in Schwarz
Amsterdam 1944
Oil on canvas, 95 x 60 cm
Göpel 655
Munich, Bayerische Staatsgemäldesamm-
lungen, Staatsgalerie moderner Kunst

residence permit, the outbreak of the second world war put an end to all
dreams of moving.

In 1938 Beckmann painted himself as musician with horn (p. 125). The
striped garment still recalls his "convict life" in exile. As in *Self-Portrait with
Crystal Ball* (p. 123) he is entirely absorbed in seeing and listening. But whereas
in his role as seer he still sought to exert an influence on events by means of

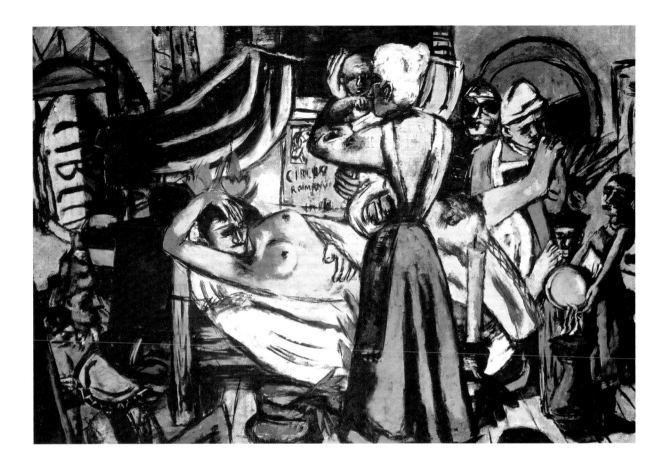

Birth
Geburt
Amsterdam 1937
Oil on canvas, 121 x 176.5 cm
Göpel 478
Berlin, Staatliche Museen zu Berlin –
Preußischer Kulturbesitz, Nationalgalerie

prophecy, *Self-Portrait with Horn* conveys his withdrawal from active intervention. In the isolation of exile, cut off from the world outside, Beckmann tries with all the means at his disposal to receive messages from that world. More than any of the other self-portraits, this one shows Beckmann's profound sensibility, receptive to the most delicate of stimuli. The function of the horn is shown in reverse: rather than transmitting signals with it, Beckmann is trying to use the funnel as an ear-trumpet to pick up distant sounds. The funnel opens at the level of eye, nose, mouth and ear; all the senses are invoked in the intense process of perception. Beckmann's whole body becomes an instrument, His hand seems to be transcribing onto the "keyboard" of his striped garment the inner melody derived from the tones picked up by the funnel of the horn.

The sequence moves from admonishing prophecy by way of responsive listening finally to inner emigration. In the *Self-Portrait in Yellow and Pink* (p. 126) of 1943 Beckmann has his arms demonstratively folded – condemned to inactivity, holding himself at a distance, defending his inner self. With the diagonal lines of the jacket the cross-over point of the folded arms forms a centre at the solar plexus, the point of inner gathering and concentration in Eastern meditative practices. Like a Buddha with gentle but melancholy mien, Beckmann has gathered all his powers within himself, in meditation, and has shut himself off from the exterior.

A year later, when the war at its fiercest was turning the world into an

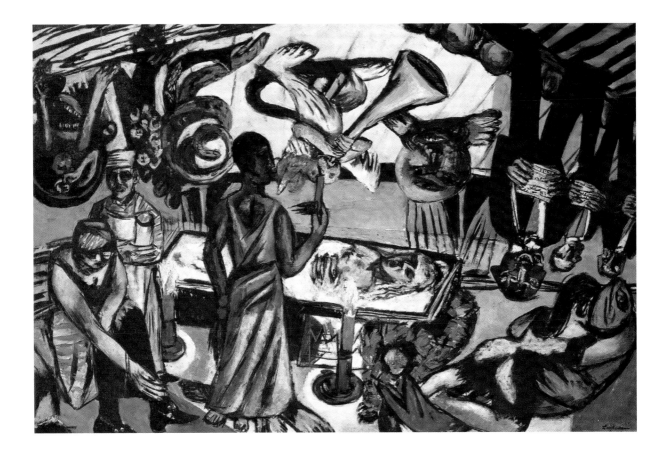

inferno, Beckmann abandoned this position. In *Self-Portrait in Black* (p. 127) the threshold of control seems to have been passed. As if provoked beyond the point of endurance the artist has turned in his seat to hurl upon the viewer the full frontal force of his scorn and bitterness. With lips pressed together in determined silence, the hard lines of his face form an uncompromising grid. The severe contrast of dark and light, the pallidness and the brusquely positioned arm all heighten the aggressive coldness of his expression. Picture and person are one in their expression of total rejection and negation.

The years in Amsterdam brought every sort of hardship. Cut off from friends and supportive acclaim, the Beckmanns were almost entirely dependent on their own resources. With very few exceptions – Beckmann's son Peter, and Lackner and Göpel – hardly any of the old friends were able to keep in touch. For Beckmann this meant not only the decline into anonymity as an artist after the years of success in Frankfurt, but also a bitter social decline. As the war took its course, conditions became more and more difficult. It had become almost impossible to sell pictures, in the end it was hardly possible to pay the coal bill, food was scarce, the Beckmanns were not spared the hardship that spread all over Europe.

More serious than outer material circumstances were fear and the threat to inner equilibrium. When the Germans invaded Holland in 1940 the "safety" of exile was over. For fear of incriminating themselves and others, in 1940 Beckmann burnt his own and Quappi's diaries for the years 1925–1940, an act

Death
Tod
Amsterdam 1938
Oil on canvas, 121 x 176.5 cm
Göpel 497
Berlin, Staatliche Museen zu Berlin –
Preußischer Kulturbesitz, Nationalgalerie

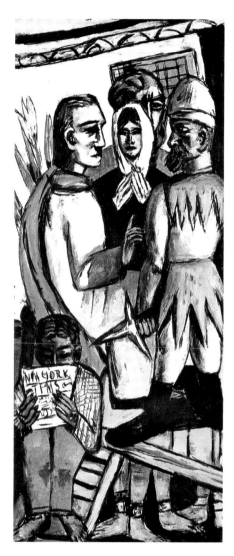

The Actors
Die Schauspieler
Triptych
Amsterdam 1941/42
Oil on canvas
Wing Panels 200 x 85 cm
Central Panel 200 x 150 cm
Göpel 604
Cambridge (MA), Fogg Art
Museum, Harvard University,
Gift of Lois Orswell

"If one takes all this – the whole war, or
even the whole of life, just as a scene
from the theatre of eternity, much is ea-
sier to bear."
Max Beckmann, diary entry 12.9.1940

which almost amounted to extinction of their past and which testifies to the
enormous anxiety that he felt. A single diary page that Quappi tore out be-
forehand gives some insight into his profound inner turmoil and despair: "I
begin this book in the most complete state of uncertainty about my existence
and the condition of our planet. Chaos and disorder wherever one looks. Total
impenetrability of politics and war... Holding one's head up with all that
going on is not easy and it is actually a miracle that I still exist at all." Three
times Beckmann, by now almost sixty years old and with a longstanding heart
condition, was sent call-up papers. He was very nearly sent to the front, to the
renewed madness that he still remembered so painfully from the first world
war. His life in Amsterdam became a daily fight for survival, fought out in his
painting, but it was a quite different fight from that of the first world war. The
earlier war had destroyed Beckmann's existence as an artist. The way in which
he had painted up to that time had become questionable, indeed impossible;
uncertainty about his art had compounded the uncertainties of his life.

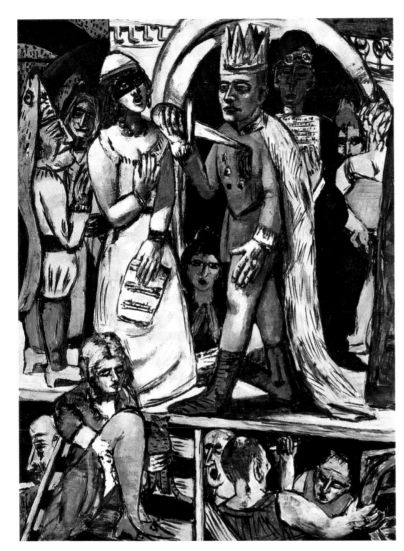

This time it was different. The pictorial language he had sought and found over the years, and the powers of artistic expression he had developed, together with the support of his wife Quappi, may be regarded as Beckmann's prop and stay in these difficult times. Often enough, painting seemed the only thing that made life worth living: "Then I shall be locked up and die there, or I shall be hit by the famous bomb so often referred to. Well, that's all right by me. Provided it happens quickly, just to me. Pity, since I'm a good painter," he wrote in his diary in one of his many spells of depression.[61]

As the inner and outer pressures increased, so also did the intensity of Beckmann's untiring labours. 280 oil paintings, one-third of the total, were produced in the ten years in Amsterdam. It is hard to find a common denominator for the abundant output of this decade in which neither exile nor the second world war seem to have caused a recognisable disjunction in the œuvre. In fact, the only noticeable change during the Amsterdam years is the developement of a freer brushstroke, matched by increasingly brilliant colours – the more

Left:

Apocalypse
Apokalypse
Amsterdam 1941/42
Book with 27 lithographs, some hand-
coloured, 16 full-page.
Edition: 24; No.1
33.3 x 27.8cm
Hofmaier 330
Private Collection
Frontispiece: illustration drawn from the
Gospel according to St. John, 1:1

"In the Beginning was the Word" and Revela-
tion of St. John The Divine, 14:13: "Blessed
are the dead which die in the Lord from
henceforth: Yea, saith the Spirit, that they
may rest from their labours; and their works
do follow them."

Right:

Apocalypse
Apokalypse
Illustration to Revelation 12:14
31.9 x 26.7cm
Hofmaier 344

"And to the woman were given two wings of a
great eagle, that she might fly into the wilder-
ness, into her place, where she is nourished
for a time, and times, and half a time, from the
face of the serpent."

oppressive circumstances became, the more vital and intense were Beckmann's images. There is no distinctive emphasis on particular themes. Beckmann draws rather on the full spectrum of his artistic resources, with themes ranging from human peril and existential doom to the ever-present dilemma of sexual relations and to portraits, still life and landscapes in large numbers.

Current circumstances prompted Beckmann time and again to confront existential themes. In times of constant danger, when every new air-raid could bring death, he sought in a whole sequence of pictures to find the basic deter-minants of life. *Birth* (p. 128) and *Death* (p. 129) were the first "existential themes" on which Beckmann worked in Amsterdam. The two pictures, painted in 1937 and 1938, were conceived as a matching pair with the same format, but were not sold as diptych. In *Birth* Beckmann takes up the familiar Christian iconography of Mary and parturition. The mother lies on the bed, a midwife tends the child, another helper fills a vessel with hot water. The analogy raises the commonplace event to the level of redemptive parable, but as always Beckmann merges traditional iconography with his own icons. The event has been transposed to a circus setting, indicated by several signs and boards, and by the fact that the birth takes place in a caravan. The image of the unsettled life of the bohemian traveller and nomad may be interpreted also as an allusion to Beckmann's own enforced homelessness. In the performance setting and the performers it is possible also to recognise the world theatre metaphor which had preoccupied Beckmann particularly in the early twenties. Composition and design are reminiscent of *Before the Masquerade Ball* (p. 55). The figure of the midwife matches the figure of Beckmann's mother-in-law Minna Tube in the earlier picture. There the figure was a symbol of life on the ebb, and here too

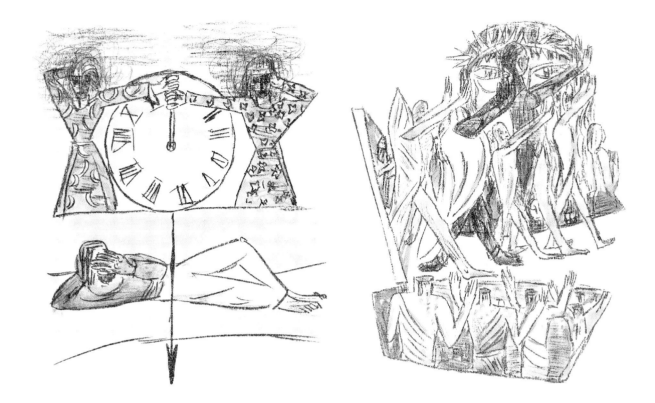

she appears in sombre black colours, juxtaposing the beginning of life with its ending. Strangely Beckmann has given the newborn child the head of an old man. In the background stands a male nurse or doctor in white apron with Beckmann's features – the artist assisting at birth.

In *Death* he is also the "assistant". He and the woman in front of him, who has Quappi's features, are the only ones in this macabre scene who are in any sense real beings. Dream and reality are blended in a topsy-turvy world of multi-faced figures and obscene fabulous creatures arching over the bier. A woman seems about to soar upwards, moving from one sphere to the other in the erotic embraces of a huge fish. Sinister choir members, a trump-blowing angel with strikingly red penis and the soaring ("resurrected") embracing couple create the impression of a thoroughly scurrilous Day of Judgement in which Christian morality has been displaced by demoniacs.

Death is also the central focus of Beckmann's fifth triptych *The Actors* (p. 130/131), which was painted in Amsterdam in 1941/42. In the centre panel the king has plunged a knife into his breast. It is perhaps a stage representation of death, but perhaps also a representation of an actual death on stage, as for instance in the opera *Bajazzo* or in the novel *Titan* by Jean Paul (1763–1825), in which stage drama suddenly becomes actuality and the actor does indeed kill himself. The world is a stage, drama and reality can no longer be distinguished. Beneath the platform there are catacombs, perhaps part of a multi-layered stage set – some researchers have seen in the triptych the simultaneous stage sets of the nineteen-twenties[62] – or perhaps representing an actual drama taking place beneath the level of the staged one. On the left at the bottom there is a glimpse of shackled feet, while the figures in the centre are confined

Left:
Apocalypse
Apokalypse
Illustration to Revelation 10:5–7
31.1 x 25.4 cm
Hofmaier 342

"And the angel which I saw stand upon the sea and upon the earth lifted up his hand to heaven, and sware by him that liveth for ever and ever, who created heaven, and the things that therein are, and the earth, and the things that therein are, and the sea, and the things which are therein, that there should be time no longer: But in the days of the voice of the seventh angel, when he shall begin to sound, the mystery of God should be finished, as he hath declared to his servants the prophets."

Right:
Apocalypse
Apokalypse
Illustration to Revelation 20:4
33.2 x 26.1 cm
Hofmaier 353

"And I saw thrones, and they sat upon them, and judgement was given unto them: and I saw the souls of them that were beheaded for the witness of Jesus, and for the word of God, and which had not worshipped the beast, neither his image, neither had received his mark upon their foreheads, or in their hands; and they lived and reigned with Christ a thousand years."

Right:
Adam and Eve
Adam und Eva
Berlin 1936
Terracotta, 88 x 33 x 36 cm
Private Collection

Page 134:
Self-Portrait in Grey Robe
Selbstbildnis mit grauem Schlafrock
Amsterdam 1941
Oil on canvas, 95.5 x 55.5 cm
Göpel 578
Munich, Bayerische Staatsgemäldesammlungen, Staatsgalerie moderner Kunst,
Stiftung Günther Franke

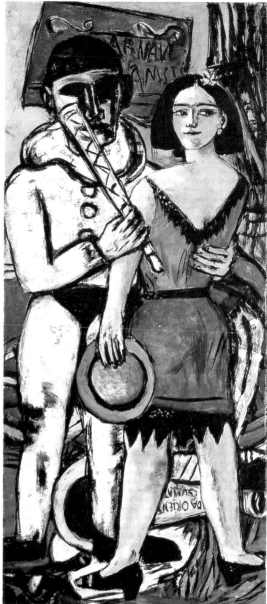

as in a dungeon. In all three panels there are stairs linking stage and catacomb, on each of which sits someone from Beckmann's immediate circle: on the left his New York gallery associate I.B. Neumann (with the *New York Times*), in the centre his Frankfurt friend Fridel Battenberg, on the right his wife Quappi and her friend Marie Louise von Motesiczky – those closest to him make the connection between the great drama on the public stage and the intimate drama that is played out beneath it. The figure of the king has, unmistakably, Beckmann's own features. Once more Beckmann is placing his own life and his own time in the context of a great world theatre, juxtaposing figures from a variety of eras and cultures.

At the same time as working on *The Actors* Beckmann was working on *Apo-*

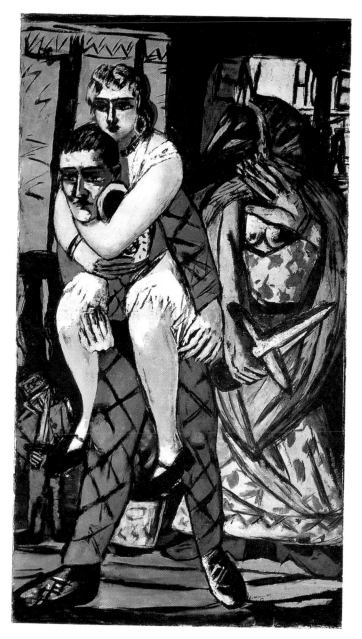

Carnival
Karneval
Triptych
Amsterdam 1942/43
Oil on canvas
Wing Panels 190 x 104, 5 cm
Central Panel 190 x 84.5 cm
Göpel 649
Iowa City (IA), The University of Iowa
Museum of Art, Mark Ranney Memorial Fund

calypse (p. 132/133). Georg Hartmann, a Frankfurt typefounder (owner of the "Bauersche Schriftgiesserei"), commissioned him to illustrate the biblical "Book of the Apocalypse", and this, together with the "Faust" illustrations commissioned also by Hartmann two years later, may be counted among the major achievements of twentieth century German book production. The imprint leaves no doubt as to the intended meaning of *Apocalypse*: "printed in the fourth year of the second world war when the visions of the apocalyptic prophet became reality".

As in the novel *Doctor Faustus* by Thomas Mann (1875–1955), which was published in 1947, the apocalypse signifies the fall of Germany in the second world war. The title-page vignette gives additional emphasis to this symbol-

Illustration to Goethe's *Faust II*
Chorus mysticus: All that is perishable is but a likeness
Amsterdam 1943/44
Pen and ink, 24.7 x 18.4cm
Frankfurt am Main, Freies Deutsches
Hochstift, Goethemuseum

Double-Portrait of Max and Quappi Beck-mann
Doppelbildnis Max und Quappi Beckmann
Amsterdam 1941
Oil on canvas, 194 x 89cm
Göpel 564
Amsterdam, Stedelijk Museum

ism. The sacred book opens like a temple door, on Beckmann himself, appearing in the darkness like a priest in the inner recess: John's revelation of the end of the world becomes Beckmann's vision of the present. His body is encircled by a serpent, biblical symbol of knowledge and of the fall associated with it. Yet the snake entwines not only Beckmann but also a staff (or, Beckmann's leg is seen as a staff), which evokes the image of the Aesculapian staff, the association with the cult of Aesculapius being strengthened by reference to the healing quality of sleep in the temple – Beckmann's eyes are closed. Aesculapius, the ancient god of healing, attained such skill in his art that he could recall the dead to life. Knowledge, fall and salvation are inextricably intertwined in this highly complex vignette. Christian symbols such as the fish (representing Christ) and the serpent associated with the tree of knowledge and the fall, are extended in scope to include the symbolism of classical antiquity and mythology, co-referents for past and present.

In *Dream of Monte Carlo* (p.141) again there is a collision between a dream of paradise and brute reality. The prestigious casino in the holiday paradise of Monte Carlo is presented with amazing intensity and, for Beckmann, in unusually vivid and decorative colours. The marble columns, the pleasing colour contrast between green gaming table and red carpet and the mauve glow of the dinner jackets, all contribute to the choice atmosphere of a luxury establishment such as Beckmann himself had enjoyed on numerous occasions. But things have taken a sinister turn – clearly this is not the scene of a pleasurable game, but rather of a threatening conflict. The card players in dinner jackets and even the little child are armed with swords, but only the women in the foreground seem to grasp the fatefulness of their situation. In the background loom two dark messengers of death, masked and swathed, each bearing a bomb with lighted fuse: the game is up.

The apparent spontaneity of presentation adds a strange tension to the situation. Whereas the fleetingly impulsive draughtsmanship and brilliant colours create a very vivid impression, the scene actually expresses the opposite: stasis, and suspended anticipation of the final great explosion. What looks like the spontaneous verve of artistic genius is in fact the result of a lengthy and laborious process involving innumerable corrections and revisions, which has nothing in common with the gestural painting of Abstract Expressionism as practised, for instance, by Jackson Pollock (1912–1956). The impression of spontaneity and impulsive liveliness is a deliberate and precisely calculated ploy to counter the motifs of destruction and annihilation with the principle of the life force: creative art as vital counterpoise to threatening peril and destruction.

In the 1941 *Self-Portrait in Grey Robe* (p.134) Beckmann makes a similar point. With the frenzy of wartime air-raids at its height around him, he perceives with heightened intensity himself in his true role: as artist participating in moulding the image of man. The grey barred world drained of colour on the left of the picture, his own field of action, is contrasted with the warm brown tones of his "creation" and the hopeful green behind it. The creation of the sculpture is to be understood less as a reference to his own work as sculptor – he created eight bronze pieces (including *Adam and Eve*, p.135, on which he was working at this time) – and more as a citation of the creation myth, with the image of the forming of man. It is not only the Christian creation myth that is important here; even more relevant is the story of Prometheus as proto-

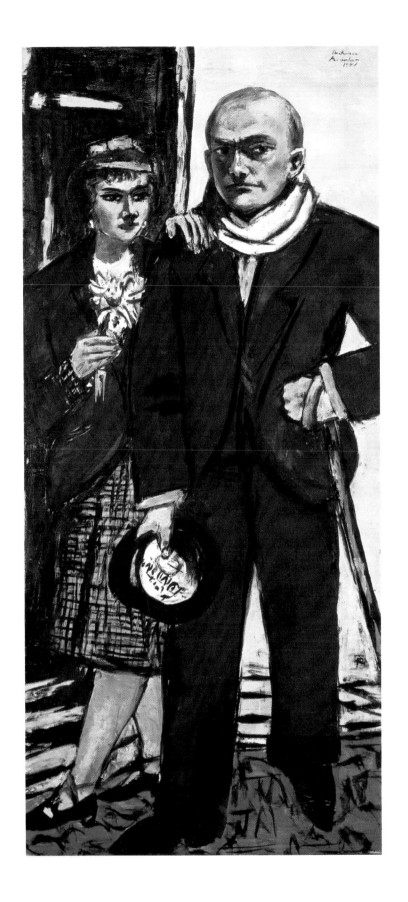

type of the artist-creator, who wrests the monopoly of knowledge from the gods and thinks to equal them. Goethe gives this description in his "Prometheus" poem: "Hier sitz ich, forme Menschen nach meinem Bilde" ("I sit here, forming humans after my own image"). For this Prometheus is punished by the gods and condemned to eternal martyrdom. In *Self-Portrait in Grey Robe* the dismal grey and the nocturnal solitude suggested by dressing-gown and deeply shadowed face, evince the "martyrdom of creation". A diary entry three years later expresses all this, and the visible sorrow of his facial expression: "Sadly we are called to play the impotent role of the creator"[63]. But where there is suffering of the creator, there also is the radiant force of creation to shine back on him. Like a lamp the sculpture illuminates Beckmann's face in warm brown tones, the green is reflected in his eyes. A reflection of creation's redemptive power, if nothing more, alights on disconsolate reality: "To create is to be saved" Beckmann had noted three months earlier in his diary. He challenged with the act of creation the existential crisis which befell not only himself but the whole world around him.

In addition to the "existential" themes, in which the crisis of the world war is always evident to a greater or lesser degree, relations between the sexes remain a constantly important theme for Beckmann. The word "theme" is used

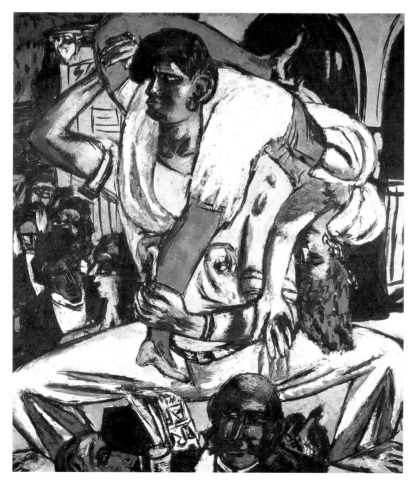

Apache Dance
Apachentanz
Amsterdam 1938
Oil on canvas, 171.5 x 151 cm
Göpel 495
Bremen, Kunsthalle Bremen

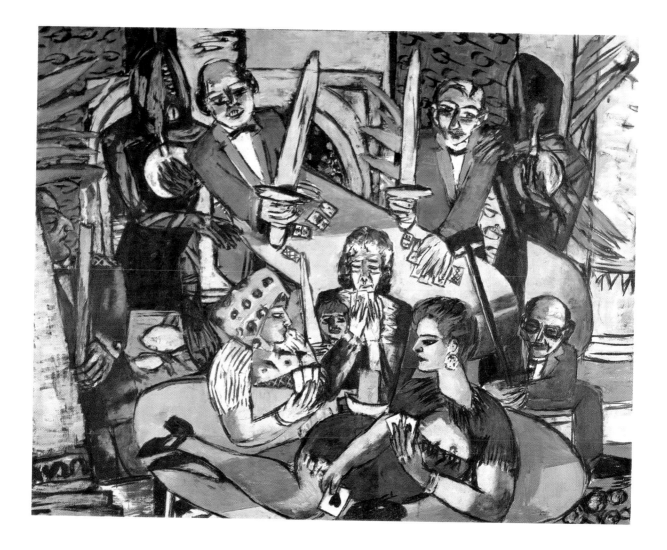

here with certain reservations. Although the main import in a particular instance may lie with a particular theme, yet it is the ambivalence and intertwining of themes that is characteristic of many of Beckmann's most inventive pieces: the oppressiveness of the times penetrated his view of relationships between men and women, just as the battle of the sexes could be employed as an image of the contemporary belligerence of nations.

A central work with regard to his view of relationships between men and women, and at the same time one of the most poignant testimonies to his own relationship with Quappi, is the *Double-Portrait of Max and Quappi Beckmann* (p. 139) painted in Amsterdam in 1941. The constellation is reminiscent of the *Carnival Double-Portrait, Max Beckmann and Quappi* (p. 77), that had testified at the beginning of their marriage to the hopes but also to the difficulties of their relationship. Gone is the fancy dress, and the unknown quality of each to the other that accompanied it. The stiff, somewhat uncomfortable and wooden stance has given way to a relaxed understanding and harmony where words are no longer necessary. It is still Quappi who leads the way with one foot forward, while Beckmann stands still. The hardness in Quappi's features has

Dream of Monte Carlo
Traum von Monte Carlo
Amsterdam 1940–1943
Oil on canvas, 160 x 200 cm
Göpel 633
Stuttgart, Staatsgalerie Stuttgart

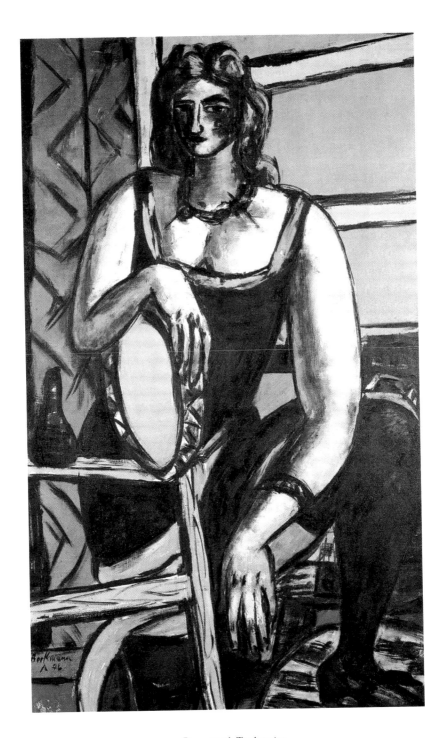

Dancer with Tambourine
Tänzerin mit Tamburin
Amsterdam 1946
Oil on canvas, 146 x 89 cm
Göpel 717
St. Louis, Private Collection

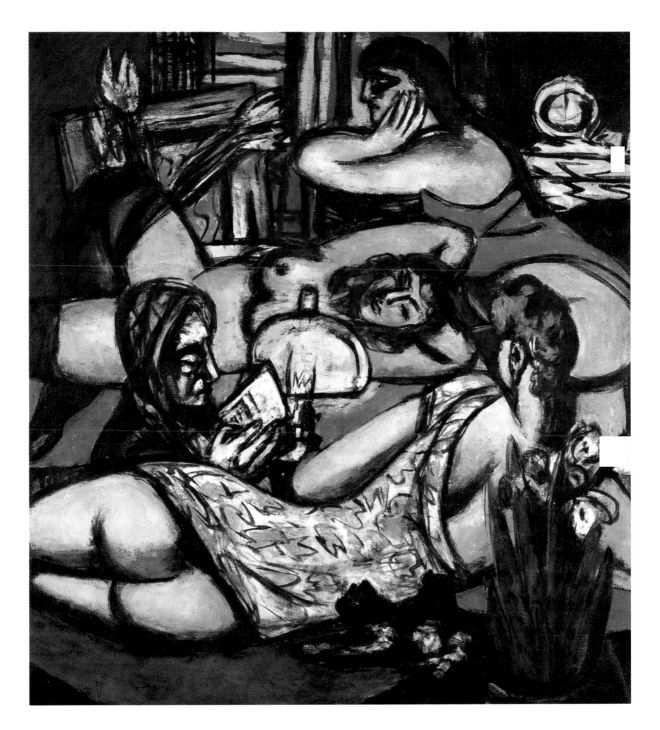

Girls' Room (Siesta)
Mädchenzimmer (Siesta)
Amsterdam 1947
Oil on canvas, 140.5 x 130.5 cm
Göpel 739
Berlin, Staatliche Museen zu Berlin –
Preußischer Kulturbesitz, Nationalgalerie

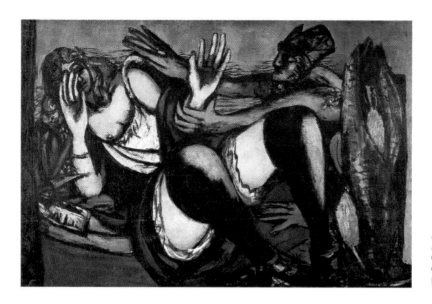

Afternoon
Amsterdam 1946
Oil on canvas, 89.5 x 133.5 cm
Göpel 724
Dortmund, Museum am Ostwall

The Letter
Der Brief
Amsterdam 1945
Oil on canvas, 50 x 60 cm
Göpel 699
Wuppertal, Von der Heydt-Museum

Page 145:
**Resting Woman with Carnations
(Portrait of Quappi)**
Ruhende Frau mit Nelken
Amsterdam 1940–1942
Oil on canvas, 90.2 x 70.5 cm
Göpel 611
Hanover, Sprengel Museum Hannover

Semi-Nude with Cat
Halbakt mit Katze
Amsterdam 1945
Oil on canvas, 55 x 95 cm
Göpel 689. Private Collection

"Oh God yes, one always regrets the lusts of
the flesh. But, my God, what else would we
have, did not at least the illusion of desire
exist."
Max Beckmann, diary entry 17.11.1946

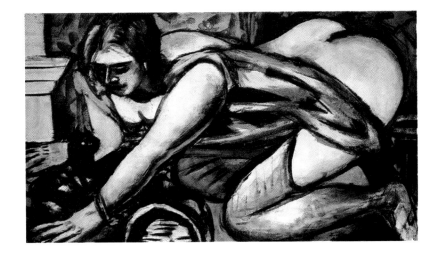

disappeared. Instead of holding her horse's reins in her hand, she now has
Beckmann "in hand" with a light grip on his shoulder, directing him with some
subtlety from the background.

Beckmann has accepted his role. He does not stand there ungainly and
awkward as he had in 1925, but stands protective in full breadth before
Quappi, ready to face whatever may come in the full blaze of the spotlight, in
sharp contrast to the background. Quappi in her brown jacket, on the other
hand, merges harmoniously with the dark background that frames her. Beck-
mann's arm is still propped antagonistically on his hip as in *Self-Portrait in Tuxedo*
(p. 74) but instead of the cold black of the cosmopolitan and conjuror he now
wears a warm brown that unites him with Quappi. Both are looking in the same
direction. The ring formed by the hat that Beckmann carries in his hand unites
them too, like an outsize wedding ring. The label LONDON in the hat lining
cites Beckmann's last great appearance on the international scene, on the oc-
casion of the "20th Century German Art" exhibition in 1938 when he delivered

Studio (Olympia)
Atelier (Olympia)
Amsterdam 1946
Oil on canvas, 90 x 135 cm
Göpel 719
St. Louis (MO), The Saint Louis Art Museum,
Bequest of Morton D. May

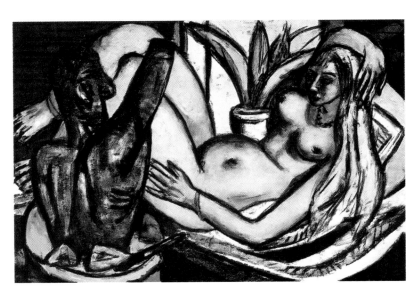

Page 146:
Girls by the Sea
Mädchen am Meer
Amsterdam 1938
Oil on canvas, 77.5 x 59.2 cm
Göpel 508
Hanover, Sprengel Museum Hannover

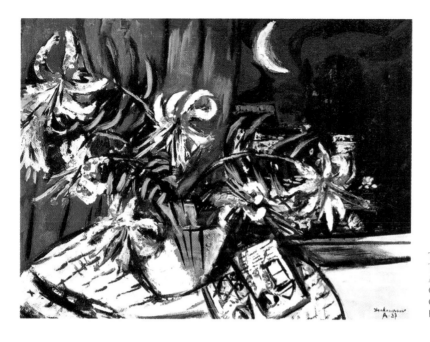

Turkish Lilies
Türkenbundlilien
Amsterdam 1937
Oil on canvas, 60 x 80.5 cm
Göpel 475
Private Collection

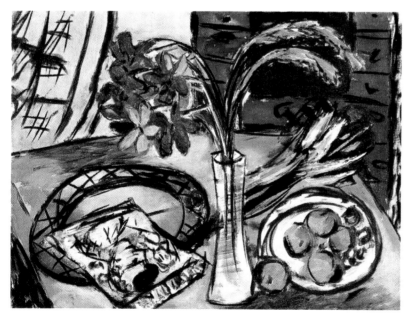

Still Life with Blue Orchids
Stilleben mit blauen Orchideen
Amsterdam 1938
Oil on canvas, 60.5 x 80.5 cm
Göpel 499
Private Collection

Page 149:
Still life with Yellow Roses
Stilleben mit gelben Rosen
Amsterdam 1937
Oil on canvas, 110 x 66 cm
Göpel 483
Madrid, Museo Thyssen-Bornemisza

Black Iris
Schwarze Iris
Frankfurt am Main 1928
Oil on canvas, 80 x 45 cm
Göpel 285. Private Collection

Woman in Front of a Mirror with Orchids
Frau vor dem Spiegel mit Orchideen
St. Louis 1947
Oil on canvas, 108.6 x 78.2 cm
Göpel 746
St. Louis (MO), The Saint Louis Art Museum

Place de la Concorde by Day
Place de la Concorde bei Tag
Paris 1939
Oil on canvas, 47 x 61 cm
Göpel 524
New York, Lafayette Parke Gallery

his famous London lecture (*On my Painting*). The inside of the hat bears the
only reminder of the occasion. The backward glance seems to signify a fare-
well from these memories: two human beings on the eve of departure who
possess nothing but their inner harmony.

A year later Beckmann drew on this double portrait, in almost the same
format, for the central panel of his *Carnival* triptych (p. 136/137). Yet this time,
although Beckmann's features can still be distinguished, it is not so much a
portrait as a portrayal of the couple as type. Striking once again is the motif
of the ring, or hat, that links the two. The *Double-Portrait of Max and Quappi* has
been transposed to a more general level, within the context of the Fall. On the
right-hand panel a figure armed with a sword is driving the pair out of the EDEN
hotel – a modern rendering of the expulsion of Adam and Eve from Paradise.
The pair make their way to the central panel, the scene of which is signed, as
is the panel on the left, as Amsterdam. A biographical layer of meaning is
discernible: the banishment of the Beckmanns from their paradise in Berlin
(with its Eden Hotel that Beckmann frequented) to exile in Amsterdam. How-
ever, as so often in Beckmann's pictures, the biographical is only one aspect of
a more universal and fundamental signifiance. The title used in the diary, *Adam
and Eve*, indicates beyond doubt that the subject matter of the triptych is not
just Beckmann and Quappi, but the archetypal meeting between man and
woman.

The double portrait painted in Amsterdam and the *Carnival* triptych posit
the harmonious co-existence of man and woman as a basis for living, for sur-
viving, in the most difficult times. In other works the focus is more on the
problematic nature of relations between the sexes. Time and again sexual re-
lations are linked with the fall from grace, as, most typically, in the 1936
sculpture *Adam and Eve*. Beckmann shows the moment of the creation of the
sexes as described in the Book of Genesis, with Eve created from the rib of
Adam. The serpent winding itself round Adam's body links this moment with

Maurice Utrillo
View of Sacre Cœur
Vue sur le Sacré-Cœur
Oil on canvas, 41 x 33 cm
Private Collection

Page 153:
Sacre Cœur in Snow
Sacré-Cœur im Schnee
Paris 1939
Oil on canvas, 73 x 54 cm
Göpel 513
Switzerland, Private Collection

Small Italian Landscape
Kleine italienische Landschaft
Amsterdam 1938
Oil on canvas, 65 x 105 cm
Göpel 498
Emden, Kunsthalle in Emden

the fall from grace into sexuality and sin, the fundamental flaw in humankind that is the cause of guilt and loss of freedom.

In Beckmann's visualisation of man and woman one finds both: on the one hand specifying the situation after the Fall, in which tension between the sexes is heightened to the point of violence and thraldom; on the other hand, the view of art as the location of a possible restoration of lost unity. Numerous examples can be found both of problematic and violent relationships and of the artistically proven unity of the sexes. Whereas *Apache Dance* (p. 140), for instance, observes man and woman as opposites, in combat, and neither of them free, the closing vignette of the "Faust" illustrations (p. 138) re-constructs in ovoid shape the original unity encompassing man, woman, snake and nature, and in *Early Man* (p. 117) the original androgyny is displayed as the ideal state.

Finally there are pictures in which both views are combined. *Odysseus and Calypso* (p. 122) and *Brother and Sister* (p. 103), discussed above, are pictures which show man and woman in a dynamic constellation characterised not only as fatal entanglement (by the sword in *Brother and Sister*, snake and cat in *Odysseus and Calypso*) but also as redeeming unity by the sheer force of their sensuous vitality. The positive uniting force is expressed notably by the recurring large round shapes which bring together the different parts of the picture and the characters with positive emphasis, for all Beckmann's negative assessment of relations between man and woman.

That for Beckmann this relationship is not only a cause of guilt and loss of liberty, but also a source of joy, strength and vitality, can be seen above all in the numerous portraits of women painted during the years in Amsterdam. Typical of Beckmann's painting of the female figure are the powerful black contour lines which yield large and highly-charged round forms and convey in their erotic sensuality an extraordinary dynamic force. His image of woman and his painterly technique are in themselves vehicles of a living intensity which holds its own against the motifs of impending violence, destruction and destabilisation. Not that the emphasis in his image of woman is always the same. Sometimes the purely erotic allure of the female body is foregrounded

Monaco
Amsterdam 1939
Oil on canvas, 90.5 x 60.5 cm
Göpel 532
Ludwigshafen, Wilhelm-Hack-Museum

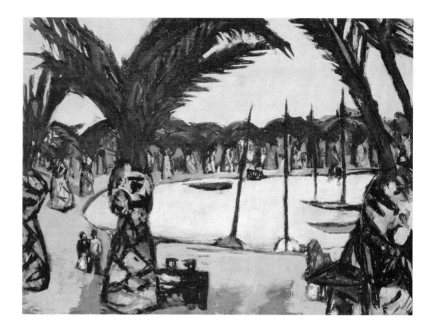

The Harbour of Bandol
Hafen von Bandol
Amsterdam 1938
Oil on canvas, 60.5 x 80 cm
Göpel 514
Dortmund, Museum am Ostwall

(*The Letter*, p. 144; *Afternoon*, p. 144; *Semi-Nude with Cat*, p. 147; *Studio*, p. 147). "Oh God yes, one always regrets the lusts of the flesh. But, my God, what else would we have, did not at least the illusion of desire exist."[64] In other pictures he seems more interested in the play of the femme fatale, behind whose sensuous charms there lurks the terror of the abyss (*Woman in Front of a Mirror with Orchids*, p. 151; *Dancer with Tambourine*, p. 142; *Girls' Room*, p. 143).

In other pictures of women, above all in the portraits of his wife Quappi (e.g. pp. 82, 87), Beckmann's psychological and formal syntax render a picture of woman that radiates self-assurance and psychological and physical stability. The *Resting Woman with Carnations* (p. 145), a portrait of Quappi, fills the space with an assured physical presence paralleled hitherto only by *Self-Portrait in Tuxedo* (p. 74). But unlike the "lordly" quality of the self-portrait, the effect of the woman seems a natural and unforced presence of self-confident inner serenity and sensuality in equal measure. The upper body viewed from below is firmly anchored in the frame with the arms, and the sharply angled lines create a stabilising pole for the eye, whereas the foreshortened perspective and dynamic curves of legs and hips create tension. "I am amazed time and again and wonder how I still have the strength to desire anything, since basically one is convinced as 'reasonable' human being that everything is senseless", observed Beckmann on 17.11.1946 in his diary. In his pictures of women the concentration of force and pleasure in life is renewed over and over again in spite of all the hindrances.

While in the pictures of women both the attraction of the female body and the attractions of painterly technique combine to radiate sensuality and a zest for life, in the still life paintings (pp. 148–151) technique is of foremost importance. The still life is always presented in a restricted space. Lattice and grid structures, and walls with no view, extending towards the front edge of the picture as hermetically sealed spaces, leave the objects arranged in the foreground hardly any room for development. In almost all Beckmann's still

life paintings at this time there are flowers in the centre. Flowers, the symbols of life in bloom, become for Beckmann a kind of manifesto of painting: for all the bars and lack of space they are made to flourish and bloom by the free and airy application of paint, by the apparent ease and spontaneity of their shaping. Painting defies confinement and constricting structures, and, on a par with nature, celebrates its own creative power, which cannot be diminished or held in check by anything. Often Beckmann adds items associated with the studio, such as picture frames or mirrors, and emphasises in this way that the picture is a work of art. Even though many of these pictures can be interpreted in more precise iconographic detail, and it is often possible to ascribe concrete meaning to the assembled objects or flowers, their central significance is as allegories of painting: their theme is painterly technique and its vital force.

Counterbalancing the enclosed, restricted still life structures, whose closure can ultimately be broken open only by art, are Beckmann's landscape paintings (pp. 152–160). They make up a considerable part of his œuvre during the Amsterdam years. Whereas Beckmann takes stricture, enclosure and inescapability as his theme in other pictures, he uses landscapes to express his yearning

Frankfurt Central Station, 1930

Frankfurt Central Station
Frankfurt am Main, Hauptbahnhof
Amsterdam 1942
Oil on canvas, 70 x 90 cm
Göpel 609
Frankfurt am Main, Städelsches Kunstinstitut,
Loan of the Adolf and Luisa-Haeuser-Stiftung

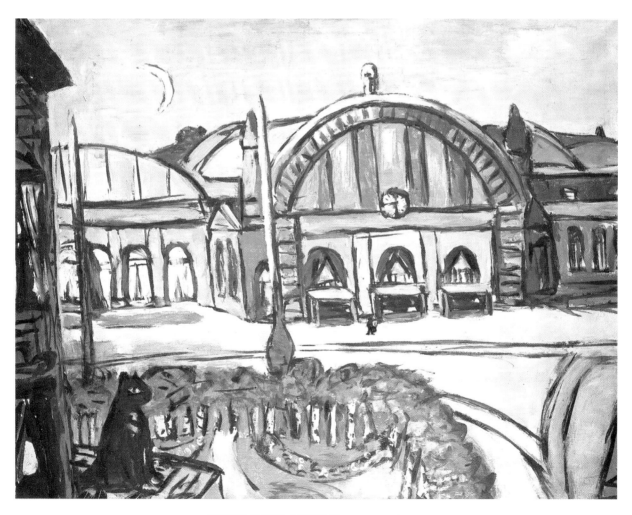

for vast expanse and infinity. In contrast to the still life, such freedom is to be found, not only in the possibilities offered by painting, but in nature itself. From the beginning of his career as an artist, the sea and the expanse of shore and sand had fascinated him, because it was there that the feeling of bound-lessness was most tangible (p.14). Almost all Beckmann's Amsterdam land-

Max and Quappi Beckmann on an outing in the Ozark Mountains (Missouri), March 1948
Photo: Walter Barker

scapes have this suggestion of expansiveness. Often the effect is heightened by optical barriers in the foreground, prison-like bars, or window frames par-tially blocking the view, but letting the sense of depth and breadth of the landscape beyond be sensed all the more intensely – a technique frequently used by van Gogh also.

The one exception is in the cityscapes, such as the views of Paris (pp. 152,153) reminiscent of the painting of Maurice Utrillo (1883–1955), or *Frankfurt Central Station* (p.157). Yet here too the theme is a feeling of distance and freedom: *Frankfurt Central Station* centres on the freedom of travel, while the Paris pictures are Beckmann's homage to a city which had become for him the embodiment of liberalism and a free way of life. Beyond the yearning for freedom and dismantling of frontiers, the landscapes of the Amsterdam years – such as *Large Laren Landscape with Windmill* (p.159) or *Balloon with Windmill* – often include, in situations and motifs, cryptic metaphors of human life which contrast the reality of imprisonment (barred sails), threat (mill) and futility (turning round in circles) with the vastness of nature.

Large Laren Landscape with Windmill
Große Landschaft aus Laren mit Windmühle
Amsterdam 1946
Oil on canvas, 129.5 x 75 cm
Göpel 726
St. Louis (MO), The Saint Louis Art Museum

Promenade des Anglais in Nice
Promenade des Anglais in Nizza
Amsterdam 1947
Oil on canvas, 80.5 x 90.5 cm
Göpel 741
Essen, Museum Folkwang

Self-Portrait
Selbstbildnis
Page One of the Series *Day and Dream*
Amsterdam 1946
Transfer Lithograph
31.8 x 26.3 cm
Hofmaier 357, Private Collection

The ten years of exile in Amsterdam were indeed the most difficult in Beckmann's life, but they were inflicted on a mature man and artist who knew how to face up to them. To an astonishing degree Beckmann won the fight for survival in exile, against poverty, loneliness and isolation, and not least against the deadly threat of wartime bombing. He won by entrusting himself entirely to his painting. The fear and peril of the time enter into all his pictures, but he confronts the motifs of violence and thraldom with creative force and the power of the imagination – substitutes, for instance in the landscapes, for the feeling of freedom. In his painting, and by means of his painting, he is able to overcome what had caused him to break down in the first world war. The Amsterdam exile is perhaps best characterised by a diary entry of 18 December 1940: "The role you are playing at the moment is the most difficult but also the grandest that life could offer you – just as it is – don't forget that – Max Beckmann."

"The days are passing, and a certain easy-going, not unjoyous resignation towards God and the world fans gently over my soul at the moment. My God – 62 years old – still there, with successes in New York, a survived apocalypse, and a helpless superabundance of strength. Just don't think too much my boy, that is still your greatest danger."
Max Beckmann, diary entry 17.6.1946

To New Shores: USA 1947–1950

Arrival in the misty dawn, Manhattan peopled with sleepy giants in damp fog... Yes, New York is truly wonderful, only it stinks of burnt fat like the roasted enemy caught by some savage tribe. All the same – fantastic, utterly fantastic – Babylon is a kindergarten by comparison and the tower of Babylon has here become the mass erection of a monstrous (senseless?) will. So I like it."[65]

Beckmann's intensely experienced arrival in New York on 8 September 1947 was the beginning of an entirely new phase of life, involving far more than a change of scene for the artist, who was by now 63 years old. The move to the USA brought to a close the years of enforced exile – and with them the inner withdrawal, artistic anonymity, and creativity in a vacuum. The American adventure not only offered Beckmann a teaching post in St. Louis, it also forced upon him a role at once new and old – America wanted Beckmann the star, the famous, celebrated and inspired painter, to whom homage could be paid with all the available machinery of public relations. The popularity he had savoured in Frankfurt in the nineteen-twenties was now a source of alarm, since he had come to value the inner concentration possible only at a distance from the public eye.

The further change of role had been prefigured one year earlier with Beckmann's rediscovery and rehabilitation in Germany. In 1946 the faithful Munich exhibitor of Beckmann's work, gallery owner Günther Franke, had put together a large Beckmann retrospective which had re-established his name.[66] In spite of his pleasure and pride, there were some misgivings in his reaction to the renewed blaze of publicity: "Great things happening in Munich, 81 pictures in the Stuck Palais with 400 people including Pierre and Minna and an opening speech by Hausenstein. Wildest dreams. They are offering me a chair in Munich and there's a big article in American Bergrün's periodical (circulation 350,000). Exhibition lasts the whole summer. Now, invisible man, you are becoming unpleasantly visible and it is high time to find some new vanishing magic," was his diary comment (9. April 1946). There is not only irony in these words but also, unmistakably, scepticism and anxiety as to what may happen when he, an old man by this time, is required to meet the challenge of stardom once again.

Scepticism with regard to the American adventure was all the greater. America threatened to make even more demands on the painter than his German homeland: "Don't do it, don't do it, says an anxious voice within me,

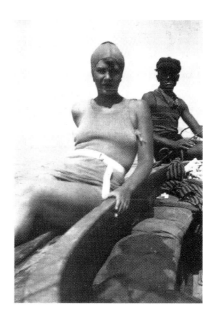

Mathilda Quappi Beckmann by the Sea, around 1926

Quappi in Blue in a Boat
Quappi in Blau mit Boot
Frankfurt am Main 1926 and New York 1950
Gouache and oil on paper, stretched over cardboard, 89.5 x 59 cm
Göpel 819
Herford, Ahlers Collection

Max Beckmann at Stephens College, Columbia (Missouri), 1948

Self-Portrait with Cigarette
Selbstbildnis mit Zigarette
St. Louis 1947
Oil on canvas, 63.5 x 45.5 cm
Göpel 752
Dortmund, Museum am Ostwall

"And then at the end Beckmann moved to a great and distant land – and slowly we saw his figure fade – Finally it vanished entirely in the uncertain expanse –."
Max Beckmann, diary entry 9.2.1949

don't go over there. It is dangerous, it will be your ruin and an embarrassment to boot – the poor in body and spirit are waiting for you to bring them delight and you can't", he wrote in his diary.[67] Behind the rather sarcastic European cultural arrogance lurked the fear that he as "German soul painter" could not offer the entertainment value that he thought the Americans expected of him.

The *Self-Portrait with Cigarette* (p. 165), the first self-portrait he painted in America, reveals much of this scepticism. Here we encounter a sullen-looking old man with a cigarette. His face expresses a measure of joylessness and melancholy, inner emptiness and remoteness. His forlorn gaze seems to focus on an interior pageant of past and present. The pained expression brings a little warmth to his features, reflecting, as it seems, the situation of the uprooted painter. The hard years in Amsterdam, which had become dear to him through their very hardship, are over and done with. In the New World he must remain a foreigner and put a good (or as here a dark) face on it, although the game is not his own. The upturned collar expresses the coldness to which Beckmann saw himself exposed: a lonely old man fighting a losing battle, who has burned his bridges to the past and yet fears that there is no place for him in the future.

Melancholy is not the only impression that the picture creates. Beckmann's clothes are vivid and brightly coloured, in remarkable contrast to his joyless mien. His original intention was to paint himself with a parrot, and as the work progressed its exotic colours were transferred to his clothing.[68] The green and yellow of the collar, the blue of the coat and above all the purple stripes on the tie are given such luminosity by the clarity of the brushwork that in spite of Beckmann's mood the picture has a powerful decorative attraction.

The sensuous and vital stimulus that appears here in muted form, enwrapping Beckmann's pensive figure literally like a cloak, was the quality that ultimately made America attractive to him. In all the bright superficiality that he saw in the country, in all the dazzling charms of New York or Las Vegas, he discerned an irrepressible sensual vitality: the "mass erection of a monstrous will", which outweighed for him the "savages' stink of burnt fat" (see above) because it satisfied the "terrible furore of the senses" invoked long ago in his London lecture. The prospect of plunging into the intoxicants of the New World and of meeting the challenge presented to an old man by this remorselessly vitalist society were finally enough to relegate his scepticism to the background: in America he resolved to plunge into the stream of life once more.

His first move was to a professorship in St Louis. Several journeys through the USA, sometimes combined with lectures and exhibitions, took him, among other places, to Chicago, Boston, Minneapolis and San Francisco, making him a popular figure. In 1949 he moved to New York where he taught at Brooklyn Art School up to the time of his death. An important showing of his work at the Venice Biennale in 1950 (with 14 of his pictures exhibited in the German pavilion) and an honorary doctorate conferred by Washington University in St. Louis in the same year were renewed pinnacles in Beckmann's career: "Crowning (university)" was his laconic diary comment on the doctoral award ceremony; "relatives moved to tears in the distance."[69]

Beckmann's view of the world did not undergo fundamental changes in the USA: "The more one gets around, the more repetitions of one and the same

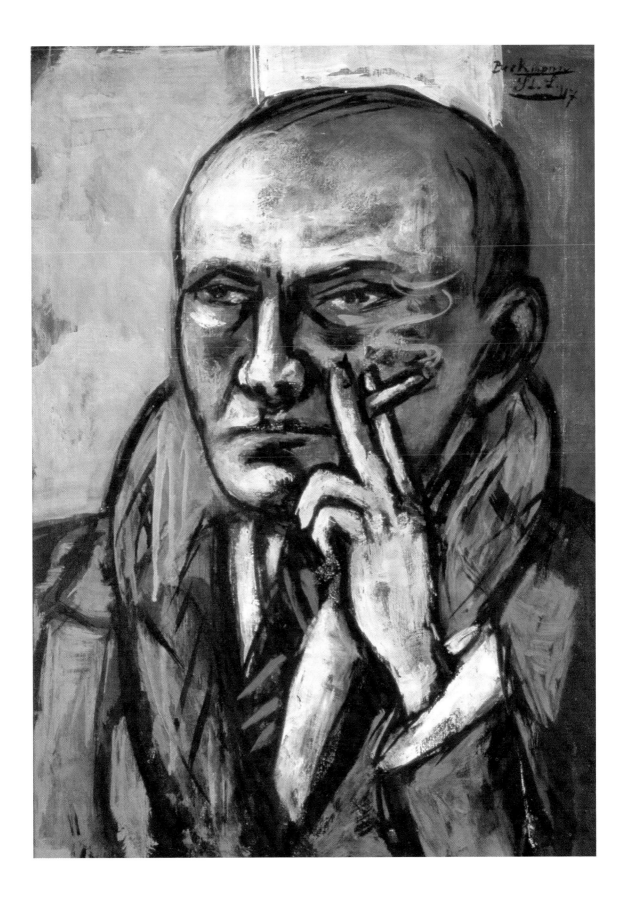

Still Life with Irises
Stilleben mit Schwertlilien
St. Louis and New York 1949
Oil on canvas, 94.5 x 61 cm
Göpel 795
Detroit (IL), The Detroit Institute of
Arts

one encounters, especially once the alien shimmer of the language begins to
fade. So I have no cause to observe great alterations in myself. My view has
not changed since Frankfurt," he wrote in 1949 to the gallery proprietor Valen-
tin.[70] Nevertheless there was once again a visible change in his painting.

He was not deflected from his path by the Abstract Expressionists of the
New York School, even though he occupied in St. Louis the chair of one of
their most important representatives, Philip Guston. He held fast to his own
figurative art with abstract technique. However, America made itself felt in

Large Still Life Interior (blue)
Großes Stilleben Interieur (blau)
New York 1949
Oil on canvas, 142.5 x 89 cm
Göpel 801
St. Louis (MO), The Saint Louis Art Museum,
Bequest of Morton D. May

Pablo Picasso
Tomato Plant, 1944
Plant de tomates
Oil on canvas, 92 x 73 cm
Private Collection

his painting in the increasingly bright range of colour that gave his pictures
a decorative charm such as they rarely had before this time. Only in his last
creative years did Beckmann find a way of lessening for the viewer the burden
of content – it was still there! – and of clothing it in a sensuous form which
was in itself a source of pleasure and wonder. In America Beckmann resolved
the somewhat awkward tension of his relationship with beauty of surface and
form. The decorative, the pure delight in form and colour that Beckmann had
criticised so vehemently in Picasso and Matisse, gained more and more

Self-Portrait in Gloves
Selbstbildnis mit schwarzblauen Handschuhen
St. Louis 1948
Oil on canvas, 91.5 x 79 cm
Göpel 776
Houston (TX), Private Collection

"My 'glorious vitality'! Has it not long since
been in decline, an artificial gimmick?"
Max Beckmann, diary entry 19.6.1949

ground in his painting, though not at the cost of content. On the contrary:
the threat of danger and the abyss, always a theme in his painting, was clothed
now in a seductive form of striking simplicity, so strong and suggestive that
one is almost tempted to overlook the inherent peril, for instance in *Carnival
Mask, Green, Violet and Pink* (p. 185) or in *Woman with Mandolin in Yellow and Red*
(p. 182).

A comparison between Beckmann's *Woman with Mandolin* and Picasso's *Large
Reclining Nude* of 1955 (p.182) shows the amazing affinity between the two
artists whose paths had already converged on several occasions, in the early
nineteen-twenties and in the early thirties. Picasso still subjects his figures to
a rigidly formalistic concept and concentrates on forms of symbolically-
charged density. He divides the figure into a prone and a recumbent view, just
as he divides the background into red and blue abstract surfaces. Beckmann's
figure is more unified – the entire composition serves to heighten the eroticism
of the woman. Her body is composed of highly charged sensuous round
shapes, which recur in sofa and cover; there is tension too in the repeated
complementary contrast of red and green, frontal and profile view. At this
point there is a marked contrast between Beckmann, in whose picture front

Max Beckmann drawing, New York, 1949
Photo: J. Raymond

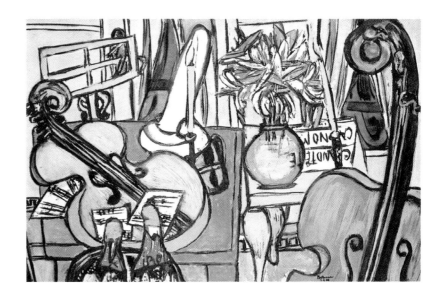

Still Life with Cello and Double Bass
Stilleben mit Cello und Baßgeige
New York 1950
Oil on canvas, 91.5 x 140 cm
Göpel 808
Washington (DC), Smithsonian Institution,
Hirshhorn Museum and Sculpture Garden

view (torso) and profile (legs) join organically at hip level, and Picasso who lets back and stomach view collide with no joint. The formalistic concept dominates and dissects the figure, while for Beckmann the unity of the figure is dominant over the formal alienation. For Picasso the human figure serves to structure the picture, while for Beckmann the picture serves to structure the human figure.

In spite of these different premises the results are similar, as is particularly evident in the still life paintings. There are similarities in the flower compositions between Picasso's *Tomato Plant* (p. 167) and, for instance, Beckmann's *Still Life with Irises* (p. 166), and *Large Still Life Interior* (p. 167); vegetable structure and luxuriant blooms counterbalance the angular severity of the lattice structure in the background. The decorative still life character, with bright glowing colours often structured only by black inside lines, and decorative planar background structure, as for instance in the fireplace in *Large Still Life with Pigeons* (p. 171), suggests also a proximity to Matisse whom Beckmann had once criticised so energetically as tapestry and wall-paper painter. Time and again Beckmann introduces into his pictures multi-paned latticed windows which, even when the view through them gives an impression of depth, are re-integrated into the plane by the frame (*San Francisco*, p. 173; compare also the left panel of the triptych *Beginning*, p. 181).

Nevertheless, as in his relationship with Picasso, there is a difference between Beckmann's position and that of Matisse in spite of the formal propinquity. While the key to the art of Matisse lies in purity of principle, in absolute planarity and dominance of stroke and line on homogeneous base, the impact of Beckmann's pictures derives from constantly competing principles. Space competes with plane, curve with angle, cool with aggressive colours. The result, most notably in *Large Still Life Interior,* is one of potent vitality that hardly lets the viewer's eye find a resting-place. With a few further sleights of hand Beckmann stimulates this contest between artistic principle and form by using motifs which seem to breathe life into inanimate form ("nature morte"): the table is given a lion's foot, the light reflexes on the vase are shaped

like great eyes or breasts, the back of the chair in the foreground seems to stare out of a great eye.

The brightly coloured and spirited vitality that marks Beckmann's pictures during his last years in America make these works seem at first glance far more positive and open and carefree than the works of his difficult Amsterdam years or of the years following the first world war. Yet the bright mise-en-scène and the uncomplicated "American" appearance of the works which is sometimes in evidence, particularly in some of the portraits (*Morton D. May*, p. 175; *Fred Conway*, p. 176; *Perry T. Rathbone*, p. 177), conceals a Beckmann who, in the battle against old age and grave illness, holds out this protective shield of vitality as a defence against his own inner reality. In his diary he does not indulge in any illusions about his condition: "My 'glorious vitality'! Has it not long since been in decline, an artificial gimmick?" is the sober entry for 19.6.1949.

For Beckmann America comes too late. The years in exile have taxed his strength too severely for him to be able to begin again. The brighter the colours become in his pictures and the more attractive and "upbeat" the form, the more clearly the process of erosion behind them can be discerned. Beckmann cannot really participate in the exuberant life force that he encounters in America, rather he experiences it from the painful distance of the ageing man: "Unfortunately I have never had S[yphilis], so that I cannot grow naturally into that final delirium, not for lack of trying. Now one just has to sit out the gruesome time until the last descent... A small part of me probably still yearns for 'life's pleasures' etc. But I am too familiar with the ever shallow course this trick of nature takes to desire it seriously any more. If only I keep sufficient strength for the last grand illusion right to the bitter end."[71]

The *Self-Portrait in Gloves* (p. 168) expresses the dilemma of his years in America: an existence between apparent vitality and bitter reality. Beckmann's

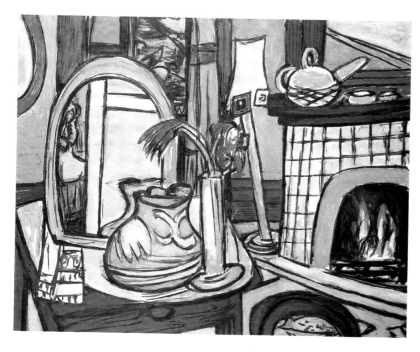

Large Still Life with Pigeons
Großes Stilleben mit Tauben
New York 1950
Oil on canvas, 102 x 127 cm
Göpel 827
Munich, Bayerische Staatsgemäldesammlungen, Staatsgalerie moderner Kunst

bodily presence here is unlike that in any of his other portraits. His bullish body seems to exude strength and threatens to rupture the almost square format. At first glance it seems that a boxer is standing there with fists at the ready. But it is only a pretence of bullishness. The body seems artificially inflated, the "boxer's" hands are much too small and seem strangely lost in front of the super-body. In his self-portraits Beckmann had always given great importance to his artist's hands and often displayed them on a disproportion-ately large scale. Their diminutive size in this picture is therefore all the more striking. The gloves add to the impression of alienation. These are not the boxer's gloves that the martial pose might lead one to expect, but fine lady's gloves entirely out of keeping with the uncouth body. The delicacy and fra-gility of gloves and hands are in curious contrast to the physical robustness and the casually rolled up sleeves symptomatic of the "American way of life". In the Renaissance portraits, for instance of Giorgione (c. 1477/78–1510) or Titian, black gloves were typical attributes of the nobility. It is not clear just what Beckmann intended in his use of them. Perhaps the gloves could be taken to signify that in America he retained something of his sensibility and discernment in spite of uncouthness, with an aristocratic touch for all his his rolled up shirt sleeves.

The features reveal beyond doubt that behind the robust exterior lies a vulnerable and broken man. Whereas in other self-portraits Beckmann's fea-tures are sharply drawn and uncompromisingly hard, here his face is softer, almost puffy. His gaze, fixed at other times in a penetrating and provocative manner on the viewer, is now entirely broken, his eyes unseeing and watery, as if close to tears, signalling disintegration in his innermost self. "And then at the end Beckmann moved to a great and distant land – and slowly we saw his figure fade – Finally it vanished entirely in the uncertain expanse –" was the description of inner disintegration that he recorded six months later in his diary.[71]

The fascination and the exceptional significance of Beckmann lie in his lucid capacity for self-knowledge even in the process of his own decline. He is fully conscious of his dwindling powers and knows just what he is doing with the "raucous coloured scenery" (Lackner) that he erects as a façade for the ageing man, and he tries nevertheless to create great art from what remains of his vitality: "What can I still get out of these last ruins of a royal house – how could I still shake the planets in their systems – ha ha ha my little flea – and yet greatness does not matter," he wrote in his diary on 19.6.1949.

Since the end of the war at the latest, bearing in mind his heart disease, Beckmann had begun to record reflections on death in his diary.[73] Words such as "Descent" and "Gate" testify to his expectation of an "after death". At the same time he decidedly refuted the Christian idea of salvation. In the 1946 portfolio Day and Dream he portrayed himself in the guise of Pilate condem-ning Christ to death (p. 189). In one of his loveliest and most poignant draw-ings, The Meeting of 1948 (p.188), Beckmann appears in dialogue with Christ: in this encounter between two "Titans", the "dialogue" is the silence of knowl-edge. There is an involuntary reminder of the Grand Inquisitor in The Brothers Karamazov by Fyodor Mikhaylovich Dostoyevsky (1821–1881), who orders the arrest of Christ returning to earth and, after delivering a long monologue to the silent Christ in prison, condemns him a second time to death. Yet Beckmann does not see death nihilistically as a senseless end. He may speak

Max Beckmann in the Ozark Mountains (Missouri), March 1948

fatalistically of the "last grand illusion" (4.4.1949), yet there is at least an expectation that death will bring a final revelation and knowledge, be it only of illusion.

Beckmann's most striking comment on the theme of death is contained in the picture *Falling Man* (p. 187) completed in 1950, the year of his death. His philosophical and religious understanding of existence is expressed once more in this picture, moulding into one form the apparently irreconcilable opposites of religiosity and existentialism. A man in mythical nudity, dressed only in a cloth, is precipitated downwards head first in steep diagonal fall between two house fronts. On the left edge of the picture is a black construction shaped like a wheel with spokes, which could be interpreted as a dynamically fore-shortened balcony balustrade viewed from above or below. From the house on the left flames leap out, while the view into the house on the right seems to reveal flowers, which, however, cannot be clearly distinguished from flames. At the bottom edge of the picture are three flowering plants. The background consists of a blue expanse which seems in the upper area to represent the sky, since it contains clouds, whereas in the lower area it suggests water. There are arguments for both: fish and boat support the interpretation of the blue expanse as water; clouds, birds and winged (angel) creatures in the boat support sky or heaven – all that is certain is the duality.

San Francisco
New York 1950
Oil on canvas, 102 x 140 cm
Göpel 823
Darmstadt, Hessisches Landesmuseum

In this very ambivalence lies the central message of the picture. Beckmann reconciles the apparently irreconcilable in the figure of the falling man. As in a picture puzzle, everything depends on whether one chooses a planar reading or one based on spatial structure. In the planar version the man plunges down parallel to the skyscrapers to his certain death. The catastrophe of the house on fire can be read as motive for the fall, with the fall promising death rather than escape. The representation of the balcony on the left, however, adds another perspective to the picture. It suggests a view from above (or below) of a balcony that the falling man has already passed. Seen from this perspective the direction of the fall is not straight down, parallel to the skyscrapers, but into the depths of the picture – seen like this the man is not falling head first, but descending, two-dimensional, like a parachutist in free fall, into the picture's inner depth. The sole of the right foot viewed from below and the foreshortened perspective of the upper body also draw the viewer's eyes to the inner depth. In this way the perspective of the falling man's view is transferred to the viewer, who may be drawn into the slipstream and begin in turn to fall.

The idea of *Falling Man* is composed of two elements. Beckmann took the figure of the falling man from his illustrations for Goethe's *Faust II* (p. 186). The relevant point in the text turns on the ambivalence of fall and rise: "Sink, then! Or I could also say: arise!" says Mephistopheles to Faust (l. 6275). Beckmann deliberately emphasised the extent to which Goethe's *Faust* matched the world of his own ideas: "Do not believe for a moment that I could not do without the old optimist [i.e. Goethe] for these drawings. I move in the same regions, there I too am at home."[74] The surround to the figure of the falling man comes from an early etching entitled *Spring* (p. 186) from the portfolio *Faces*, in which it follows directly after *Resurrection*, Beckmann's terrifying vision of total destruction (see also the painting, p. 28). Coming after the anti-*Resurrection* with its black annihilating sun, *Spring* suggests in the sequence a tentative new beginning – between chasms of houses and clouds a "real" sun is breaking through, spreading light and warmth. So Beckmann brings his falling man into the picture of spring. In this sense the *Fall* can be understood as a new beginning – just as in "Faust" the sinking could become a rising: the blue of the water is transformed into the blue of the sky, the fall to death becomes an ascent into heaven, the *Harrowing of Hell* becomes the *Assumption*.

There is yet another dimension. While the fall viewed from the perspective of the balcony suggests a movement in space from this world to the next, the diagonal line of the fall from top right to bottom left leads to the opposite conclusion: a fall from space into the here and now, indicated at the bottom left by the flowers, symbol of vegetative transience. This reading sees in *Falling Man* an existentialist picture of man, as formulated by the philospher Martin Heidegger (1889–1976) in *Sein und Zeit* (Being and Time): man as a being hurled into existence, condemned to life. Beckmann himself proposed this kind of interpretation to his wife Quappi, but it remains –even though it was put forward by the artist himself – just one of many readings: "*Falling Man* is not Icarus, but rather man, condemned to fall to earth – with all its terrors and beauties – and to live there, ejected from the dream-ship in which the angels continue on their way."[75]

In *Falling Man* Beckmann succeeds in creating a grand image of mankind's various forms of existence: seemingly mutually exclusive paradoxes in living

Beckmann with Morton D. May in St. Louis in front of his portrait, 1949

Portrait of Morton D. May
Bildnis Morton D. May
St. Louis 1949
Oil on canvas, 75.5 x 51.5 cm
Göpel 785
St. Louis (MO), The Saint Louis Art Museum

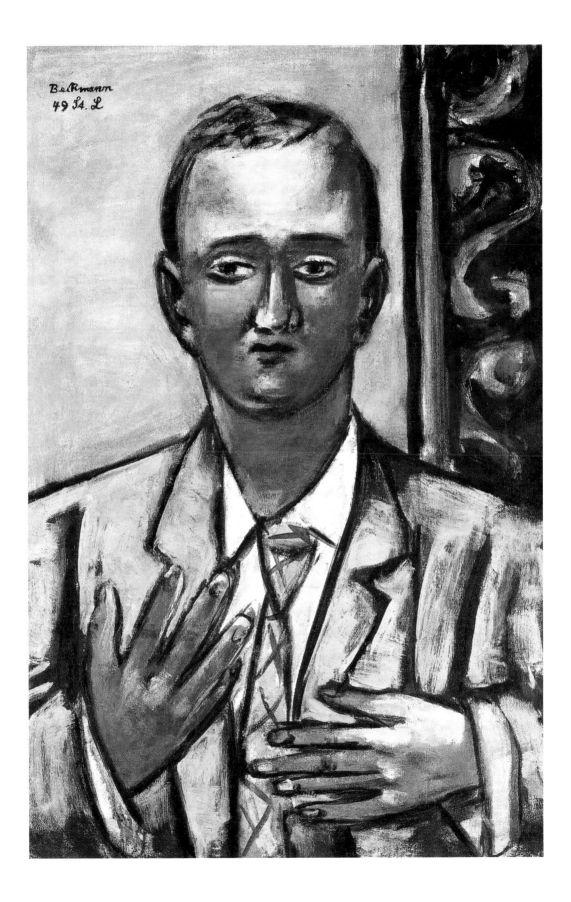

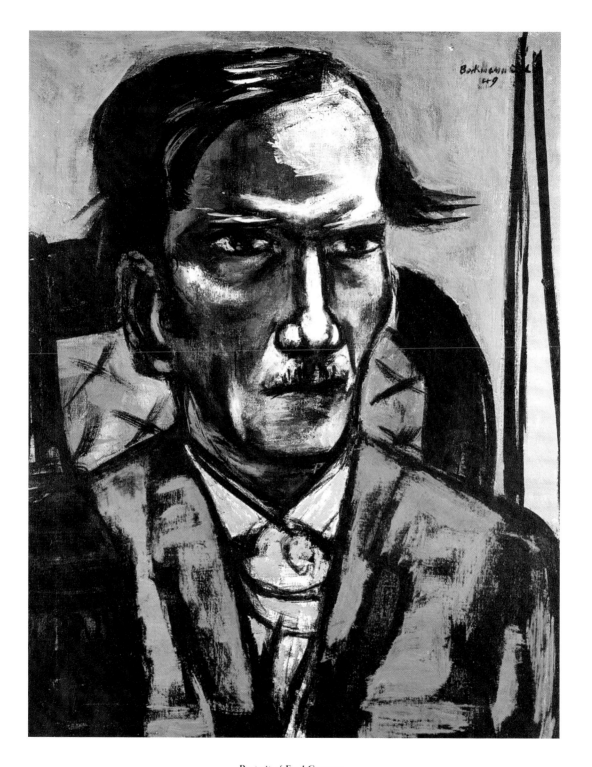

Portrait of Fred Conway
Bildnis Fred Conway
St. Louis 1949
Oil on canvas, 64 x 51 cm
Göpel 792
St. Louis (MO), The Saint Louis Art Museum,
Bequest of Morton D. May

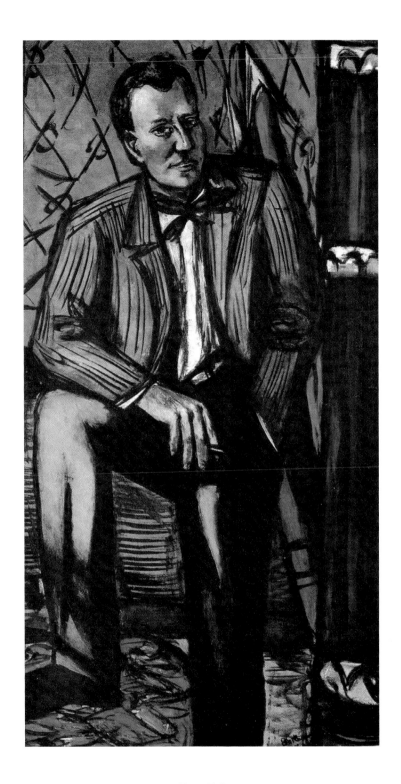

Portrait of Perry T. Rathbone
Bildnis Perry T. Rathbone
St. Louis 1948
Oil on canvas, 165 x 90 cm
Göpel 773
Cambridge (MA), Mr. and Mrs. Perry T. Rathbone Collection

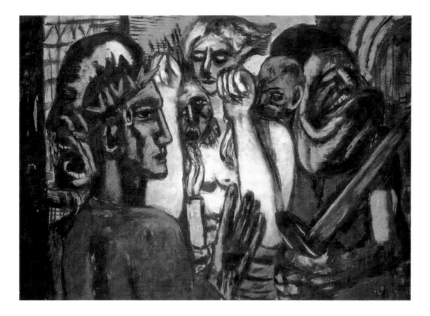

Christ in Limbo
Christus in der Vorhölle
St. Louis 1948
Oil on canvas, 78.5 x 109 cm
Göpel 758
Washington (DC), National Gallery of Art

and dying are rendered visible as a unity here. Beckmann shows existential man, hurled into existence; then there is man failing and falling in life, thrown (or leaping?) out of the house to his death; finally there is man not only falling but rising, escaping from this earthly life into the beyond, saved. Existentialism, nihilism and Christian faith in salvation all come together in the human figure with equal representation and justification. Life, death and salvation appear indissolubly united; the flight of Icarus to the sun and his fall, falling to death and resurrection, all are one. The viewer himself in the end develops a double nature: he is at once the one who observes a fatal fall and the one who falls; the opposition between distance and identification vanishes. Only a very few of Beckmann's pictures display such force of synthesis. Like his final triptych *The Argonauts* (p. 190/191), *Falling Man* belongs to those of Beckmann's last works that leave behind the somewhat histrionic vitalism for a more relaxed, serene and eminently classical form. In the masterly ease and harmony of these late works there is something of a last testimony, such as has been achieved by other artists shortly before their death, for instance by Cézanne in *Women Bathers*[76] or by Joseph Beuys (1921–1986) in his last installation *Palazzo Regale*.[77]

In *The Argonauts*, which Beckmann did not complete until the evening before his death, he was dealing once more with his life's grand theme: art. Unlike in the earlier triptychs, force and captivity, contemporary political events and the battle of the sexes, which always predominated in the wing panels, have faded away. The focus is on the essentials of art alone. Beckmann calls to witness the Greek myth of the Argonauts, in which all the Greek heroes of the pre-Trojan era, among them Jason, Orpheus, Heracles and many others, set out to recover the golden fleece. For Beckmann the Greek heroes become "The Artists", which was his name for the picture until shortly before its completion; the heroes' quest for the golden fleece becomes the artist's search for meaning and knowledge. The panels display the making of art in a narrower sense – painting on the left, music on the right. Furthermore, the

Fisherwomen
Fischerinnen
Amsterdam and St. Louis 1948
Oil on canvas, 191 x 140 cm
Göpel 777
St. Louis (MO), The Saint Louis Art Museum,
Bequest of Morton D. May

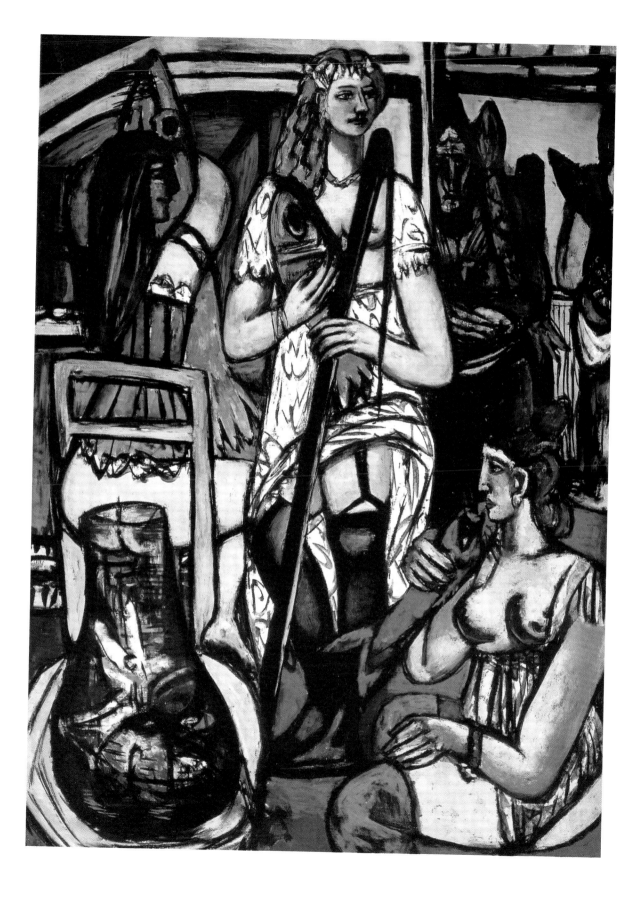

panels represent the highly charged field in which art is created and must be sustained. The artist as individual on the left contrasts with a group of women in the form of a Greek chorus on the right. The chorus in Greek tragedy is the embodiment of a relativist and generalised morality which comments on individual action. Beckmann thus sets the individualised artist against the morality of society. Art and cognition grow and synthesize in their shared field of tension.

The centre panel transcends the level of art in the making. What the painter on the left is trying to capture on his canvas, and the chorus on the right is celebrating in song, is there in the central panel: it is literally the centre, the nucleus of art – meaning and knowledge. An old man climbing up from primal depths beyond the horizon points out the way to the young men, conveying meaning and knowledge to them. Although they do not look at him, they seem to understand by means of some mysterious accord – the hands of both point to the left, in the direction indicated by the old man's hand. The gaze of one of the youths is riveted on the eye of the bird with its visionary prophetic beam. The other youth also seems gripped and spellbound by what is happening. The faint rays of the reddish sun give his face a beatific glow which Beckmann himself put into words: "The youth on the right is seeing a vision, he is oblivious to his earthly surroundings."[78]

The lyre, attribute of Orpheus, which is lying on the sand does not signify the artistic process exemplified in the outer panels; rather it serves to characterise as artist the young man to whom knowledge and insight are given. The triangular shape of the lyre appears again in his back, as if he had interiorised the instrument. In their nudity Beckmann shows the youths in the ideal condition of myth. Their gaining of knowledge is not associated as it is in the bible with original sin and therefore with shame. Natural and free they stand with

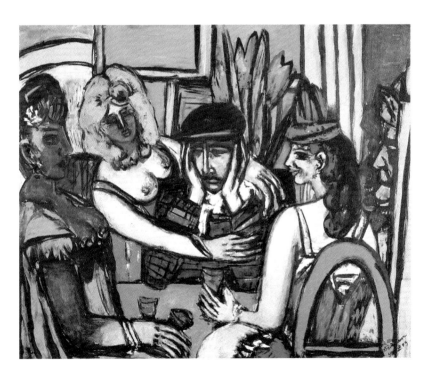

The Prodigal Son
Der verlorene Sohn
St. Louis 1949
Oil on canvas, 100 x 120 cm
Göpel 780
Hanover, Sprengel Museum Hannover

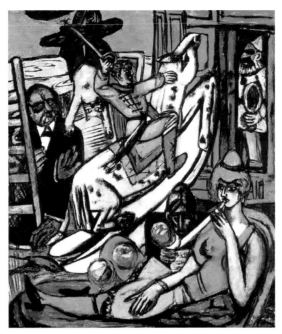

the sea in front of them. With these youths Beckmann closes the circle of his work. The *Young Men by the Sea* (p. 15) had been his first major success, and breakthrough, in 1905. In 1930 he had turned the young men into artists, and in 1943 as the bombs fell he had recalled this lyrical motif, which now gains substance as the mythic process of ideal cognition.

Beckmann made some explanatory comments on the *Argonauts* to his wife Quappi. Of the old man he remarked: "The old man in the centre panel who is climbing out of the sea on a ladder is a god who shows the young men the way to a better world – the way to a higher level of awareness, above earthly life. There is a strong wind; sun and moon are darkened, two new planets are just being created."[79] The ladder the old man is climbing is therefore the ladder of cognition. Not only does the old man climb up it, he also bears it like a yoke: the path to knowledge is also a heavy burden. The ladder re-introduces the lattice or grid structure that occurs so frequently in Beckmann's last pictures. Usually it took the form of a window (see *Large Still Life Interior*, p. 167), but the form of the ladder is very similar. On the left panel the formal structure re-appears in the shape of the canvas, which again has a formal resemblance to a window. The gesture of the old man points towards this window-canvas. He is pointing the youths towards the transformation process of knowledge, as symbolised by the ladder, into the artistic reality of the picture. Significantly the ladder and the picture are inclined in such a way that they almost seem to be leaning up against one another. But the reverse reading of the scene is also possible, if one starts with the left-hand panel. The painter beholds through the picture, which is his window, the central scene: the myth of knowledge is generated only when the gaze and the imagination of the artist are operative. The myth is created in and through his art.

The central panel of the *Argonauts* can be construed as a counterpart to the *Falling Man*. There is great similarity in form between the youth turning his

Beginning
Triptych
Amsterdam and St. Louis 1946–1949
Oil on canvas
Wing Panels 165 x 85 cm
Central Panel 175 x 150 cm
Göpel 789
New York, The Metropolitan Museum of Art,
Bequest of Miss Adelaide Milton de Groot

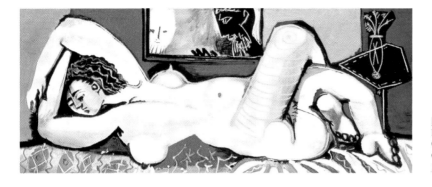

Pablo Picasso
Large Reclining Nude (The Voyeurs), 1955
Grand nue allongé (Les voyeurs)
Oil on canvas, 80 x 192 cm
Jacqueline Picasso heirs

back on the viewer and the falling man. Yet in the latter Beckmann shows man falling helpless and headlong, as plaything of the various natural forces, whether they pull him down to the depths or aloft, whereas in the *Argonauts*, which is about art and true knowledge, man stands firm. This may be understood as Beckmann's declaration that in art he found a firm stance not attainable in life.

In his last self-portrait, the *Self-Portrait in Blue Jacket* (p. 193), Beckmann referred the themes of *Falling Man* (human existence) and *Argonauts* (art) to his own person. He takes stock for the last time of his existence as man and artist. At first glance one may fail to see in this picture the significance that one would expect to attribute to a "last self-portrait". The casual pose, with hand in trouser-pocket and cigarette in mouth, the loud blue of the jacket and orange of the shirt, all create a relaxed impression in spite of Beckmann's thoughtful gaze; it seems that one is facing an American television reporter rather than a German painter. But what at first seems so uncomplicated and innocuous turns out to have something quite different behind it.

Beckmann's last self-portrait is once again a highly ambitious programmatic piece, with direct links and allusions to the two large pieces in the "public domain", the early *Self-Portrait in Florence* of 1907 (p. 8) and the *Self-Portrait in*

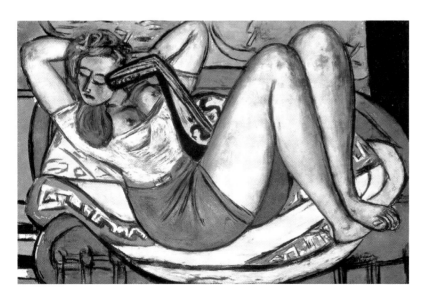

Woman with Mandolin in Yellow and Red
Frau mit Mandoline in Gelb und Rot
New York 1950
Oil on canvas, 92 x 140 cm
Göpel 818
Munich, Bayerische Staatsgemäldesammlungen, Staatsgalerie moderner Kunst

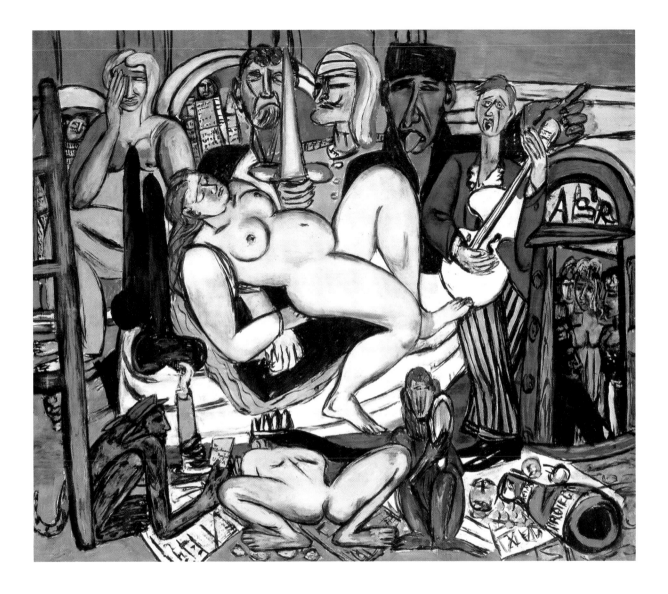

Tuxedo of 1927 (p.74) painted at the height of his success. Format and extent of the portrait are evidence of this. After the small-scale *Self-Portrait with Cigarette* of 1947 (p.165) that showed him in gloomy frame of mind, the *Self-Portrait in Gloves* of 1948 (p.168) was already larger. For the *Self-Portrait in Blue Jacket* Beckmann chose a significantly larger and at the same time quite distinctive format: it is, almost to the centimetre, the format of *Self-Portrait in Tuxedo*.

It is as though Beckmann was consciously citing the picture that showed him at the zenith of his artistic and social acclaim. The standing figure cut off at the level of the thighs, and the asymmetrical vertical division of the background allude unmistakably to the earlier picture. There is a clear parallel also in the original arm posture, subsequently over-painted. The hand thrust into the pocket was originally placed, as in *Self-Portrait in Tuxedo*, with challenging self-assurance on the hip (as evident still in the elbow). The blue jacket was not pushed back behind the lower arm, but continued straight down, as can be clearly observed from the under-painting of the trousers. Many of Beck-

The Town (City Night)
New York 1950
Oil on canvas, 165 x 191 cm
Göpel 817
St. Louis (MO), The Saint Louis Art Museum,
Bequest of Morton D. May

Beckmann in his New York studio, 234 East
19th Street, in front of his *Falling Man.*
New York, February 1950
Photo: Homer Saint-Gaudens

mann's pictures were over-painted several times during work in progress, but before over-painting he carefully removed the paint with turpentine so that, in the absence of photographic documentation, no trace of the original version was to be seen. If he leaves the under-painting so clearly visible here, then it is certainly for a purpose: Beckmann intends the "original" version to remain visible, it is part of the work – without doubt he wishes to remind the viewer of *Self-Portrait in Tuxedo.*

This citation of the tuxedo picture is the key to a true understanding, for the *Self-Portrait in Blue Jacket* is meant to be seen in the light of the comparison. It is intended to make immediately visible Beckmann's metamorphosis from the zenith to the ending of his life. That Beckmann at this point calls to mind the culmination of his career is a clear indication that he intends the *Self-Portrait in Blue Jacket* as a summing up of his life: a deliberate last self-portrait completing the triangle of "representative self-portraits" from the beginning of his career (*Self-Portrait in Florence*) via the culmination (*Self-Portrait in Tuxedo*) to its completion. What at first glance seemed so innocuous turns out to be a scrupulously planned last self-portrait, in which Beckmann contemplates the end of his career, and his death. The abstract background of the tuxedo picture has become concrete. On the left the reverse side of a mounted canvas can be seen, with wood reinforcement, but at the bottom the frame has been turned over to the right, giving the impression that the brownish area on the right is the front of a canvas. The light wooden lath with nails could be a left or right border.

In spite of the mounted canvas Beckmann does not show himself as painter in action. He has stepped forward and left his life's work, painting, behind him. In contrast to his stance in the tuxedo picture, he does not stand without support but props his elbow on the back of a chair. The motif of the chairback section recurs in many of his pictures. Beckmann had always used it as

Carnival Mask, Green, Violet and Pink
Fastnacht-Maske grün, violett und rosa
New York 1950
Oil on canvas, 135.5 x 100.5 cm
Göpel 821
St. Louis (MO), The Saint Louis Art Museum,
Bequest of Morton D. May

"A small part of me probably still yearns for 'life's pleasures' etc… But I am too familiar with the ever shallow course this trick of nature takes to desire it seriously any more. If only I keep sufficient strength for the last grand illusion right to the bitter end."
Max Beckmann, diary entry 4.4.1949

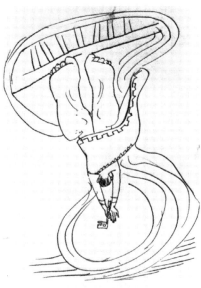

Left:
Spring
Frühling
Frankfurt am Main 1918
Drypoint, 29.8 x 20 cm
Hofmaier 133

Illustration for Goethe's *Faust II*
"Sink then! Or I could also say: arise!"
Amsterdam 1943/44
Pen and ink 24.7 x 16.7 cm
Frankfurt am Main, Freies Deutsches
Hochstift, Goethemuseum

Falling Man
Abstürzender
New York 1950
Oil on canvas, 142 x 89 cm
Göpel 809
Washington (DC), National Gallery of Art,
Gift of Mrs. Mathilde Quappi Beckmann

a barrier between the viewer and the picture's space. Here it is different: Beckmann does not stand behind the chair-back but alongside it; he has reached the threshold which used to separate the world of the picture from the viewer's world, and he signals in this way a stepping outside the picture. But at the same time it is as if Beckmann had become his own image: head and shoulders seem to suggest a later application of paint on the brown background which may be interpreted as a canvas. Standing at the threshold may be interpreted metaphorically, referring to the cross-over point between human existence and the arena of art. Beckmann is departing from life and from his painting – and becomes at the same time an image; his three-dimensional existence is transformed into a two-dimensional picture within a picture, his own self-portrayal.

The extent to which the issue is Beckmann's death is demonstrated by other elements in the picture. For one thing, his sheer physical decline cannot be overlooked. In contrast to the bullish physique that he had displayed two years earlier (p. 168), the figure that he presents here is much thinner, and his head seems likely to sink into the collar which is much too wide. The pallid complexion contrasts strikingly with the orange of the shirt and the blue of the jacket. He has retracted the challenging posture with hand on hip of the tuxedo picture. The hand in the trouser pocket signals giving up the fight, all the more so since the earlier posture is still discernible. The lit cigarette, present in almost all his self portraits, becomes here a last glimmer of departing light and life. Never before had Beckmann portrayed himself actually smoking, the cigarette had always been simply an accessory for the sophisticated man of the world. Here for the first time he has lifted it to his mouth with cramped hand. Like an addict he inhales the smoke, as if to draw in life's last breath. Red dots in eyes, ears and nose show a last flicker of the senses – a glow fanned one last time by these final breaths.

Finally his jacket has an important part to play in this connection. The fluorescent blue of the jacket, that Beckmann intends to be emphasised by the

The Meeting
Die Begegnung
New York 1948
Pen, 33 x 49.5 cm
Erpel 205
Private Collection

title, is a determining factor in the picture and is far more dominant than is Beckmann's physical appearance. The contrasting green and orange heighten the intensity of the blue even further and lend it an extraordinary air of phenomenological unreality. How important this effect of the blue of the jacket was to Beckmann, and how difficult to achieve, is shown by diary entries: "Twice in a row, painted the first blue jacket in new self-portrait, fear there will be many more" (26.1.1950). Beckmann did indeed re-work the portrait many times. Mention has already been made of the iconography of the colour blue which Beckmann deliberately employed in the portrait *Quappi in Blue*. For the Romantics, Novalis had invoked it with the symbol of the "blue flower" as the colour of one-ness transcending this world, for Kandinsky and the "Blue Rider" group it was elevated programmatically to become colour of the spiritual in art. The cornflower blue highlights of Beckmann's jacket, a very dark blue-black, is reminiscent also of van Gogh's last pictures in Auvers, such as the *Church of Auvers* (Paris, Musée d'Orsay), in which an other-wordly blue shines back through the church windows: the radiance of a world beyond this life that penetrates through the church as mediator. Beckmann's blue jacket has something of the same meaning. An otherworldly power of spirit, remarkable in its cool remoteness, has enveloped him; the aggressive life colour, orange, cannot compete with the superior power of the blue tone, but serves on the contrary to heighten its luminosity.

Beckmann's gaze confirms the picture's theme of mortality, in spite of the initial impression of casual reflection. Closer observation shows that the eyes are painted differently. The right eye is partly occluded by the eye-lid, with an inward gaze telling of disappointment, disillusion and apathy, in keeping with the hand in the pocket. Whereas the left eye is opened wide, the entire pupil is visible, its gaze apparently fixed in fear and horror on some terrible event. If one covers the left half of the face, then the hand in front of the mouth is in keeping with this: the hand is brought to the mouth in an unconscious gesture of horror, expressing dumb terror. It is as if one half of Beckmann is staring in fear at his own death, to which the other half has long since resigned itself. The gap between ideal vitality and bitter reality, already documented in *Self-Portrait in Gloves*, has widened here in a tragic manner. It is a

token of the greatness of Beckmann as an artist that he was able to give form to this vision of his own death; it is above all a token of his greatness as a man that he was able to do so without, at least on the surface, begging sympathy for the tragedy of this vision. The diary entry on completion of the self-portrait confirms once more that with this picture Beckmann has made his testament:"With ultimate exertion of last remaining strength altered and 'finished' (don't laugh!) the blue self-portrait. Tied up with it all day inside me – now – into the hand of 'God'"[80]

Beckmann's death evinced one strange last parallel with his art. On 27 December 1950 he left the house in order visit the exhibition "American Painting Today" in which his final *Self-Portrait in Blue Jacket* was hung. Death overtook him on his way to the very picture in which he had foreseen his death.

Christ and Pilate
Christus und Pilatus
Plate 15 from *Day and Dream*
Amsterdam 1946
Transfer Lithograph, 34.4 x 27.1 cm
Hofmaier 371

The Argonauts
Die Argonauten
Triptych
New York 1950
Oil on canvas
Wing Panels 189 x 84 cm
Central Panel 203 x 122 cm
Göpel 832
Washington (DC), National
Gallery of Art, Gift of Mrs.
Mathilde Quappi Beckmann

Notes

1 Max Beckmann in his London lecture *On my Painting* held on 21 July 1938, on the occasion of the exhibition "20th Century German Art" at the New Burlington Galleries, London. Reproduced in: Marlborough Gallery catalogue 1974 (translated by P. S. Falla), pp. 11–21; this quote p. 19

2 London lecture (cf. note 1), p.15

3 Letter of 14.8.1905. Published in collected letters: Max Beckmann. Briefe. Vol 1, 1899–1925. Ed. Uwe M. Schneede. Munich, 1993; Max Beckmann. Briefe im Kriege 1914/1915. Munich, 1984

4 Letter of 17.4.1904 (Briefe I, No. 12)

5 Letter of 1.2.1904 (Briefe I, No.9)

6 Beckmann in conversation with the publisher Reinhard Piper. Quoted from Piper's autobiography: Mein Leben als Verleger. Vormittag Nachmittag. Munich and Zurich, 1991, p. 328

7 Diary entry of 9 January 1909

8 Beckmann in response to a questionnaire entitled "Das neue Programm" (The New Programme) from the magazine Kunst und Künstler (Art and Artists) (1914). Quoted from: R. Pillep: Max Beckmann. Die Realität der Träume in den Bildern (The Reality of Dreams in the Pictures). Munich, 1990, p. 17

9 *Gedanken über zeitgemäße und unzeitgemäße Kunst* (Reflections on fashionable and unfashionable Art). Beckmann's response to Franz Marc's essay *Die neue Malerei* (The New Painting). In: "Pan", II, 17 (1911/12). Quoted from Pillep (note 8), p.12ff.

10 Compare Hans Belting: Max Beckmann. Die Tradition als Problem in der Kunst der Moderne (Tradition as Problem in Modern Art). Munich and Berlin, 1984

11 Paul Ferdinand Schmidt: Max Beckmann: Zur Ausstellung seiner neuesten Arbeiten in Frankfurt a. M. (On the exhibition of his most recent works in Frankfurt am Main). In: Der Cicerone 11 (1919), p. 380

12 Comment by Beckmann recorded by his first wife, Minna. In: Max Beckmann. Frühe Tagebücher (Early Diaries). Munich, 1985, p.178

13 War-time letter from Beckmann to his wife, 24.5.1915. (Briefe I, No. 130)

14 ibid.

15 Letter of 4.5.1915 (Briefe I, No. 122)

16 Letter of 16.9.1914 (Briefe I, No.88)

17 Letter of 24.9.1914 (Briefe I, No. 90)

18 Letter of 3.10.1914 (Briefe I, No.92)

19 Letter of 4.5.1915 (Briefe I, No. 122)

20 Letter of 11.5.1915 (Briefe I, No. 124)

21 Letter of 26.4.1915 (Briefe I, No. 114)

22 Letter of 6.6.1915 (Briefe I, No. 133)

23 Max Beckmann: *Creative Credo*. In: From Art in Theory 1900–1990. Ed. Ch. Harrison and P. Wood, Oxford 1992, pp. 267/268

24 *Ganymed* 3 (1921)

25 Quoted from Pillep (note 8), p.27

26 Letter of 6.6.1915 to Minna (Briefe I, No. 133)

27 Compare note 23, p.268

28 Quoted from Pillep (note 8), p.28

29 Letter of 9.8.1924 (Briefe I, No. 264)

30 From: Ein neuer Naturalismus? Eine Rundfrage (A new Naturalism? A Survey). In: Das Kunstblatt 6 (1922). Quoted from Uwe M. Schneede: Die 20er Jahre (The Twenties).

Manifeste und Dokumente deutscher Künstler. Cologne, 1986, p.150

31 Beckmann in the introduction to a catalogue for an exhibition of his graphic work in Berlin, 1917. Quoted from Pillep (note 8), p.20

32 Quoted from Pillep (note 8), p. 55

33 Letter of 13.6.1925 (Briefe I, No. 296)

34 Max Beckmann: *Der Künstler im Staat* (The Artist and the State). Article in the magazine *Europäische Revue*, 1927. Quoted from Pillep (note 8), p.41

35 Letter to Minna of 26.8.1910 (Briefe I, No. 45)

36 Meier-Graefe's critique appeared in the *Berliner Tagblatt* of 15.1.1929, on the occasion of Beckmann's exhibition "Neue Gemälde und Zeichnungen" (New Paintings and Drawings) at the Alfred Flechtheim Gallery, Berlin. Printed in: Max Beckmann in Frankfurt. Ed. Klaus Gallwitz, Frankfurt am Main, 1984, pp. 151–153

37 Letter to Quappi of 16.6.1925 (Briefe I, No. 300)

38 London lecture (cf. note 1) p. 12

39 Stephan Lackner: Max Beckmann persönlich (Max Beckmann personally). In: Max Beckmann. Selbstbildnisse. Catalogue for the exhibition held at the Hamburger Kunsthalle 1993, p.41

40 Beckmann. In: Der Künstler im Staat. Quoted from Pillep (note 34) p. 39

41 Friedhelm W. Fischer investigated in detail the dimension of gnosticism and alchemy and its inspiration in Beckmann's work, and used Beckmann's library to demonstrate how extensively he concerned himself with gnostic writings and notions, and cabbala. Friedhelm W. Fischer: Max Beckmann. Symbol und Weltbild. Munich, 1972

42 London lecture (cf. note 1) pp. 14/15

43 Cp. note 34; italics following the original typography

44 Beckmann in 1938, in conversation with the art critic Oto Bihalji-Merin. Quoted from a lecture held on 20.9.1969 for the Beckmann Society in Munich (unpublished manuscript)

45 E.g. Beckmann studied and made marginal notes which refer also to Freud in a work of C.G. Jung's published in 1928. Peter Beckmann and Joachim Schaffer, Die Bibliothek Max Beckmanns (Max Beckmann's Library) Worms, 1992, p.356

46 Cp. note 34

47 Letter of 11.2.1938. Quoted from: Max Beckmann. Die Triptychen im Städel (The Triptychs in the Frankfurt Städel). Exhibition catalogue, Frankfurt am Main, 1981, p.37

48 ibid. p. 64f.

49 Quoted from Pillep (note 8), p.46

50 Diary entry of 2.5.1941

51 See Charles P. Kessler: Max Beckmann's Triptychs. Cambridge (MA), 1970, p.16

52 Quoted from: Nationalsozialismus und "Entartete Kunst" (National Socialism and "Degenerate Art"). Ed. Peter-Klaus Schuster, Exhibition Catalogue, Munich, 1987, p. 250

53 Letter to Stephan Lackner of 29.1.1938. Quoted from Stephan Lackner: Ich erinnere mich gut an Max Beckmann (I Remember Max Beckmann Well). Mainz, 1967, p. 37

54 Quoted from Lackner (note 53), p. 32

55 Diary entry of 4.7.1946

56 Diary entry of 28.10.1945

57 London lecture (cf. note 1), p. 17

58 ibid. p. 12

59 Quoted from Schuster (note 52), p.250f.

60 Letter of 19.8.1939. Quoted from Erhard und Barbara Göpel: Max Beckmann. Katalog der Gemälde (Catalogue of the Paintings). Vol. I. Bern, 1976, p.25

61 Diary entry of 7.5.1940

62 Claude Gandelmann: Max Beckmanns Triptychen und die Simultanbühne der 20er Jahre (Max Beckmann's Triptychs and the Simultaneous Stage of the Twenties). In: Max Beckmann. Die Triptychen im Städel, Exhibition Catalogue, Frankfurt am Main, 1981, pp. 102–113

63 Diary entry of 28.10.1944

64 Diary entry of 17.11.1946

65 Diary entries of 8.9. and 9.9.1947

66 Max Beckmann Exhibition, Munich, Villa Stuck, 21 June to 21 August 1946 (in two parts). A 6-page "Catalogue" appeared

67 Diary entry of 3.8.1947

68 Cf. diary entries of 13.10. and 26.10.1947

69 Diary entry of 6 June 1950

70 Letter to Curt Valentin of 9.3.1949. Quoted from Göpel I (note 60), p. 31

71 Diary entry of 4.4.1949

72 Diary entry of 9.2.1949

73 See for instance diary entries of: 24.4.1946, 17.9.1946, 23.9.1946, 10.3.1947, 7.6.1947, 26.8.1947, 31.12.1947, 25.2.1948, 31.8.1948, 28.10.1948, 28.2.1949, 2.6.1949, 19.6.1949, 5.12.1949

74 Quoted from Erhard Göpel: Berichte eines Augenzeugen (Reports of an Eye-Witness). Frankfurt am Main, 1984, p.58

75 Quoted from Göpel I (note 60), p.492

76 Cézanne created two last monumental versions of Les Grandes Baigneuses, end point and synthesis of the numerous studies and experiments on this theme. The two works, completed in 1906, are located now in the Philadelphia Museum of Art and in the National Gallery in London.

77 Joseph Beuys: Palazzo Regale. Installation of 1985, for the Museo Capodimonte in Naples. Now in Düsseldorf, Kunstsammlung Nordrhein-Westfalen. Cf. Joseph Beuys' Palazzo Regale. Ed. Kulturstiftung der Länder (Text by Armin Zweite). Berlin and Düsseldorf, 1992

78 M.Q.Beckmann Mein Leben mit Max Beckmann, Munich, 1985, p. 179

79 ibid.

80 Diary entry of 29.3.1950

Self-Portrait in Blue Jacket
Selbstbildnis in blauer Jacke
New York 1950
Oil on canvas, 139.5 x 91.5 cm
Göpel 816
St. Louis (MO), The Saint Louis Art Museum,
Bequest of Morton D. May

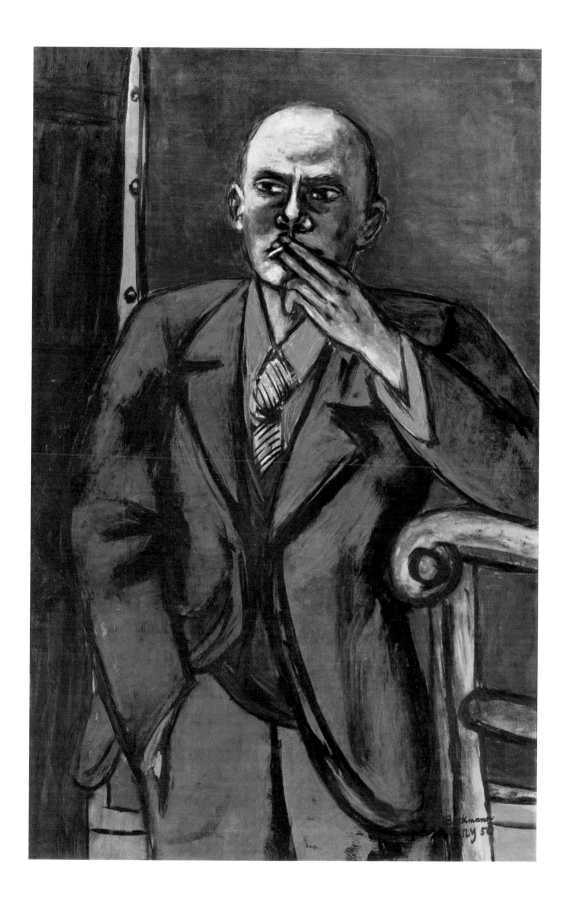

Max Beckmann: Life and Work

Max Beckmann at the time of his confirmation with sister Grethe and guardian in Braunschweig, c. 1898

Beckmann in 1906

Max Beckmann in Berlin, 1908
Photo: Leopold Thieme

1884 Max Beckmann born 12 February in Leipzig, the youngest of three children. His father, Carl Christian Heinrich Beckmann (1839–1895), son of an innkeeper, works as a grain merchant in Leipzig. His mother, Antoinette Henriette Bertha (née Düber, 1846–1906) comes from a farming family from Lower Saxony. Beckmann's brother Richard is ten years older, his sister Margarethe fifteen years older.

1892–1894 Extended stays in Falkenburg (Pomerania), where Beckmann's sister lives with chemist Carl Lüdecke. Beckmann's relationship with his sister is strained; he feels she is too attentive to his upbringing.

1895 Death of Beckmann's father. The family move to Braunschweig (Brunswick) where Beckmann first attends a school in the town, then later a boarding school near Gandersheim from which he runs away in the winter of 1899. His first watercolours are painted during the school years, and Beckmann requests "a big book on the history of art" and other art books from his mother.

1899 In spite of serious opposition from his family, Beckmann decides to become a painter. He takes the entrance exam for the Dresden Art Academy and is rejected.

Left:
Max Beckmann during a coffee break in his Amsterdam Studio, 1938

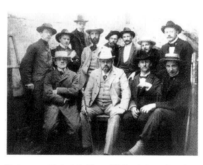

Beckmann with the Life Class of F. Smith (centre) at the Art Academy in Weimar, c. 1902

Minna and Max Beckmann in front of their house in Berlin-Hermsdorf, 1908. Photo: Leopold Thieme

1900 Acceptance at the Grand Ducal Art School in Weimar. Beckmann completes the compulsory year's study of classical antiquity.

1901 Changes to Life Class run by the Norwegian painter Frithjof Smith (1859–1917). Meets Ugi Battenberg in his class; start of lifelong friendship. First drypoint *Self-Portrait* (p. 10).

1902 At a carnival party Beckmann meets his future wife, Minna Tube (1881–1964). She is a clergyman's daughter, also studying at the Weimar Art School.

1903/04 Beckmann leaves the Weimar Art School and goes to Paris for six months, where he studies at the popular private Académie Colarossi. Beckmann later destroyed large canvases, referred to in letters, painted during his time in Paris. Returns to Germany via Geneva where he views the work of Ferdinand Hodler. Moves to Berlin, taking a studio in Schöneberg.

1905 Beckmann begins to keep an inventory of his work. No. 1 in this œuvre catalogue is the 1905 canvas *Young Men by the Sea* (p. 15). He also begins to sign his work HBSL ("Herr Beckmann seiner Liebsten" – "Mr. Beckmann to his Love"), a signature he uses until 1913.

1906 Takes part in the Berlin Secession Exhibition. Receives first prize from the German Society of Artists for *Young Men by the Sea* which is purchased by the Weimar Museum. The prize includes a scholarship to the Villa Romana in

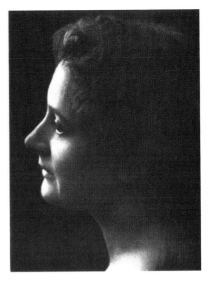

Beckmann on horseback in Hamburg, 1913
Photo: Jeanne Kaumann

Max Beckmann in Frankfurt am Main, c. 1917
Photo: Felicia Feith

Beckmann's wife, Minna Tube, in Dessau, c. 1917

Florence; he leaves in November. In the summer his mother dies of cancer, and Beckmann struggles to come to terms with this in his works *Drama*, *Large Death Scene* (p. 17) and *Small Death Scene*. Marries Minna Tube in September, honeymoon in Paris.

1907 Paints *Self-Portrait in Florence* (p. 6). After returning from Florence the Beckmanns move into a house and studio designed by Minna in Berlin-Hermsdorf, Ringstrasse 8. Exhibitions for the Berlin Secession and for Paul Cassirer.

1908 Son Peter Beckmann born 31 August (1908–1990). Beckmann becomes a member of the Berlin Secession, and meets painters Waldemar Rösler and Hans Meid, the sculptor Georg Kolbe and the writers Gustav Landauer and Mario Spiro. First plans for the founding of a "New Secession".

1909 Meets art critic Julius Meier-Graefe (1867–1935). Included for the first time in Paris exhibitions (Grand Palais, Salon d'Automne). Paints several important early works: *Double-Portrait of Max Beckmann and Minna Beckmann-Tube* (p. 19), *Scene from the Destruction of Messina* (p. 20), *The Crucifixion* (p. 22) and *Resurrection* (p. 29).

1910 Beckmann becomes the youngest ever elected member of the committee of the Berlin Secession. Visit to Wangerooge.

1912 Publishes a polemic against Franz Marc (1880–1916): *Gedanken über zeitgemäße und unzeitgemäße Kunst* (Reflections on fashionable and unfashionable Art). Beckmann takes a stand against the modern formalism of the group Der Blaue Reiter (Blue Rider).

1913 First Beckmann retrospective at the Cassirer Gallery in Berlin with 47 works. Hans Kaiser writes the first Beckmann monograph for

the occasion and well-known art critics such as Curt Glaser, Karl Scheffler and Max Osborn review Beckmann's work.

1914 As co-founder, Beckmann is elected to the committee of the Berlin Free Secession. After the outbreak of war he joins an aid mission to the East Prussian front where he remains for some time as voluntary medical attendant. Returns to Berlin in late autumn.

1915 Beckmann volunteers as medical orderly and is sent to the Belgian front where he first works in a typhoid ward and later in an operating theatre. Beckmann comes to terms with the horrific experiences of war almost exclusively in drawings and sketches; few paintings until 1917. Influenced by his impressions of war, Beckmann's style alters: de-formation and insecurity are mirrored in technique and materials. Beckmann's wartime letters to his wife Minna are published in the periodical *Kunst und Künstler* (Art and Artists). In the summer Beckmann suffers a complete physical and nervous breakdown, and is granted

Beckmann in Dr. Feith's house in Frankfurt, with Ugi and Fridel Battenberg and the Feith daughters Eva and Beate, c. 1916/17

sick leave. At the end of the year he moves to Frankfurt am Main where he is invited to stay with his Weimar artist friends, Ugi and Fridel Battenberg, in whose studio at Schweizerstrasse 3 he can also work. His wife Minna begins a career as an opera singer in Elberfeld under the conductor Hans Knappertsbusch (1888–1965).

1917 Finally released from military service. Important works in the new style: *Deposition* (p. 30), *Christ and the Woman Taken in Adultery* (p. 31), *Self-Portrait with Red Scarf* (p. 34), and *Portrait of Max Reger* (p. 36).

1918 Beckmann's *Bekenntnis* (Creative Credo) appears in a work with the title *Schöpferische Konfession* (Creative Confession) in a periodical published by Kasimir Edschmidt (1890–1966). The Marées Society publishes his portfolio *Faces* with 19 plates. Beckmann begins to explore arcane cults, gnosis and cabbala.

1919 Major works: *The Night* (p. 33), *Self-Portrait with Champagne Glass* (p. 35), *Synagogue* and the series of lithographs entitled *Hell* (pp. 43–49). First postwar museum purchases by Georg Swarzenski (1878–1957) for the Frankfurt Städel, and by Fritz Wichert for the Mannheim Kunsthalle.

1920 Beckmann writes two plays: *Ebbi* and *The Hotel*. Firm contract with Berlin gallery of Israel Ber Neumann becomes his agent; he meets a large number of important figures from public life: Henrich Simon, editor-in-chief of the *Frankfurter Zeitung*; Swarzenski, director of the Städel Museum in Frankfurt; Georg von Schnitzler, director of I.G. Farben, as well as his wife Lilly; the senior council official Ernst Levi; the writers Rudolph G. Binding (1867–1938) and Fritz von Unruh (1885–1970); and the actor Heinrich George (1893–1946).

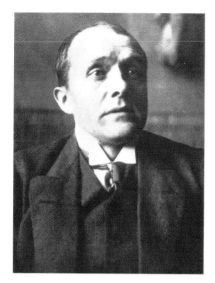

Beckmann c. 1923

1921 Meets art historian Wilhelm Hausenstein (1882–1957) and gallery owner Günther Franke. The Munich publisher Reinhard Piper (1879–1953) brings out a cycle of poems by Lili von Braunbehrens, entitled *Stadtnacht* (City Night) with illustrations by Beckmann. Paints *Self-Portrait as Clown* (p. 52).

1922 The Marées Society publishes a series of prints entitled *Der Jahrmarkt* (The Fair), and Neumann publishes *Die Berliner Reise* (Berlin Journey). Beckmann concentrates on graphic work. Numerous etchings, lithographs and woodcuts are made. He also paints *The Iron Footbridge* (p.63).

1923 Neumann moves to New York and becomes Beckmann's representative there. In Munich, Beckmann's graphics are taken on by the gallery owner Franke, who remains his foremost exhibitor to the end of his life. Stylistically Beckmann moves closer to New Objectivity. *Dance in Baden-Baden* (p. 54); *Double Portrait of Mrs. Swarzenski and Carola Netter* (p. 67); and *Self-Portrait with Cigarette on Yellow Ground* (p. 71).

1924 In Vienna Beckmann meets Mathilde "Quappi" von Kaulbach, daughter of painter Friedrich August von Kaulbach. Piper brings out a major Beckmann monograph with pieces by Hausenstein, Wilhelm Fraenger, Curt Glaser and Meier-Graefe. Solo exhibitions in Berlin and Frankfurt.

1925 Divorce from Minna Beckmann-Tube, who has achieved considerable success as an opera singer in Graz, Austria. On 1 September Beckmann marries Mathilde "Quappi" von Kaulbach, and they spend their honeymoon in Italy (Rome, Naples and Viareggio). Until moving into their newly-built flat at Steinhauserstrasse 7, the Beckmanns stay at the exclusive Frankfurt hotel Monopol-Metropol. Beckmann's most successful period begins. A contract with Neumann

guarantees him an annual income of 10,000 DM, and the City of Frankfurt invites him to head a master class and studio at the Städel Art School. His pupils include Marie-Louise von Motesiczky, Theo Garve, Walter Hergenhahn and others. Extensive representation at the Mannheim exhibition of New Objectivity and at international exhibitions in Zurich and London; solo exhibition at Alfred Flechtheim's gallery in Düsseldorf. Paints *Carnival Double-Portrait Max Beckmann and Quappi* (p. 77).

1926 Solo exhibitions in New York and with the Leipzig Art Society; exhibits also at the Biennale in Venice, as well as at various other shows in Berlin, Dresden, Berne and Paris. Journeys to Paris and Italy. Paints *Quappi in Blue in a Boat* (p. 162).

1927 Beckmann's essay *Der Künstler im Staat* (The Artist in the State) appears in the magazine *Europäische Revue*. Beckmann paints major works: *Self-Portrait in Tuxedo* (p. 74) and *Large Still-Life with Telescope* (p. 91). He donates his canvas *The Barque* (p. 57) to the Nationalgalerie in Berlin. Flechtheim is included in the contract with Neumann. Travels to Rimini during the summer.

1928 Gustav F. Hartlaub (1884–1963) mounts a major Beckmann retrospective at the Kunsthalle in Mannheim, showing 106 canvases and 110 lithographs, as well as watercolours and drawings. Beckmann is honoured with the 1000 DM Prize of Honour for German Art, and also receives the Gold Medal of the city of Düsseldorf for his painting *Large Still-Life with Telescope*. The Berlin Nationalgalerie purchases *Self-Portrait*

Beckmann with his publisher, Reinhard Piper, December 1922

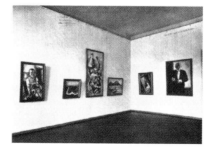

The Beckmann Room at the Berlin Nationalgalerie, in the former Crown Prince Palais, 1932/33. From left to right: "Self-Portrait as Clown", "The Barque", and "Self-Portrait in Tuxedo".

Beckmann's flat during his 1937–1947 exile in Amsterdam, Rokin 85. The apartment was on the first floor, his studio on the top floor.

in *Tuxedo*. Travels to the Dutch seaside town of Scheveningen in early summer, and also makes trips to Paris and St. Moritz.

1929 On the occasion of an exhibition at the Frankfurt Kunstverein (Art Association), Beckmann receives a Prize of Honour from the city of Frankfurt. Until 1932 Beckmann spends the winter months, from September to May, in a flat and studio he has rented in Paris. Once a month he commutes to Frankfurt to assess his students' work at the Städel Art Institute School. He is granted a professorship.

1930 His contract at the Städel Art Institute School is extended by another five years. Retrospectives are mounted in Basle (100 canvases) and Zurich (85 canvases), and Beckmann also contributes six pictures for the Biennale in Venice, and several more for other exhibitions. There are 13 Beckmann canvases to be seen at the Frankfurt Städel Art Institute at this time. Simon writes a short Beckmann monograph, while his subject travels to Bad Gastein, Cap Martin, Nice and Switzerland.

1931 Solo exhibition at the Galerie de la Renaissance in Paris, which is well received by the press. (*Le Figaro* writes: "Quelque chose comme un Picasso germanesque"). Pablo Picasso (1881–1973) and Ambroise Vollard (1865–1939) visit the exhibition. *Forest Landscape with Woodcutter* is bought by the Paris Musée du Luxembourg. Dispute with Fritz Wichert over Beckmann's lack of attendance at the Städel Art Institute School. Beckmann cancels his contract, but is persuaded to remain at the School by the head of the city's arts council. The National Socialist press attacks Beckmann for his Paris exhibition, and for the choice of work representing him at the Venice Biennale. Travels to the south of France, Bad Gastein and Vienna; skiing holiday in Garmisch-Partenkirchen in January.

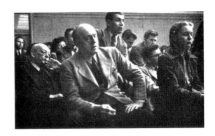

Max Beckmann with art historian Georg Swarzenski (left) during Quappi's reading from "Letters to a Woman Painter" at the Museum of Fine Arts in Boston, March 1948.

Beckmann lived on Millbrook Boulevard, Washington University campus, St. Louis, from 1947 to 1949. Photo: B. Göpel

1932 Ludwig Justi (1876–1957) sets up a Beckmann room in the Berlin Nationalgalerie, showing ten of the artist's canvases. For financial reasons, Beckmann gives up his flat in Paris. (It is the worst period of economic depression in the Weimar Republic). Meets Erhard Göpel, later one of Beckmann's most important publicists, and author of the catalogue raisonné of Beckmann's paintings.

1933 Repeated vitriolic attacks in the National Socialist press prompt Beckmann to move to Berlin (Graf-Spee-Strasse 3) in early January, where he hopes for more anonymity than in Frankfurt. Two months after Hitler comes to power Beckmann and several others are dismissed from the Städel Art School in Frankfurt. With Ludwig Justi's dismissal from his directorial post in July, the Beckmann Room at the Neue Nationalgalerie is also dismantled. An exhibition planned for the Erfurt Museum is prohibited. Stephan Lackner, later one of the most important collectors and patrons of Beckmann, saw the pictures in the cellar in Erfurt, and purchased *Man and Woman* (p. 97). Beckmann completes his first triptych: *Departure* (pp. 108/109) and paints *Brother and Sister* (p. 103). His themes show increasing reference to mythology.

1934 Journeys to Italy and Holland. Extended periods in Ohlstadt, where Beckmann works in his father-in-law's studio. On the occasion of his fiftieth birthday only one article appears: in the *Leipziger Neueste Nachrichten*, written by Erhard Göpel.

1936 Last Beckmann Exhibition in Germany until 1946, held at the Gurlitt gallery in Hamburg. Takes part in various exhibitions abroad. Investigates the possibility of emigrating to the USA with Lackner, who is living in Paris. First heart problems force Beckmann to take health-cure in Baden-Baden.

1937 Continued health-cure in Baden-Baden. Beckmann completes his second triptych, *Temptation* (pp. 112/113), which Lackner buys. During the Nazi campaign against "Degenerate Art", 28 paintings and some 560 watercolours, drawings and prints by Beckmann are confiscated from German museums. On 18 July Beckmann hears Hitler's radio speech for the opening of the inquisitorial exhibition of "Degenerate Art" in Munich, which includes 12 paintings by himself. The next day he decides to flee to Amsterdam with his wife, where they stay with Quappi's sister. After a short time they move into a small

apartment with studio, in a former tobacco warehouse, Rokin 85. Beckmann is never to return to Germany. His housekeeper, Mrs. Ruppelt, packs and sends household goods and paintings to Amsterdam before the Gestapo can intervene. In Amsterdam Beckmann paints self-portrait *Released* (p. 124).

1938 On the occasion of the London exhibition "20th Century German Art", Beckmann gives a lecture entitled *On my Painting*. His *Temptation* triptych, conceived as alternative view, defence and rehabilitation of the German artists who were hounded as "degenerate", is the centrepiece of this exhibition and is widely reproduced in the English press. Lackner promises to buy two of Beckmann's paintings each month, helping him over the worst of his financial difficulties. Paints *Self-Portrait with Horn* (p. 125) and *Death* (p. 129). Moves to Paris in October, but retains the Amsterdam flat.

1939 Beckmann receives his carte d'identité and decides to move to Paris entirely. However, the outbreak of war finally thwarts his plans to move. Beckmann is forced to give up his flat in Paris. Takes parts in a number of American exhibitions and is awarded first prize for his *Temptation* triptych at the San Francisco Golden Gate International Exhibition of Contemporary Art.

1940 Beckmann is offered a teaching post in Chicago, but fails to get a visa. After the invasion of Holland by the Germans, Beckmann destroys his diaries so as not to compromise himself or his wife. Once Lackner is unable to continue his payments, Beckmann's financial situation worsens.

1941 Georg Holzinger, director of the Frankfurt Städel Art Institute, brings Beckmann a contract from Georg Hartmann for the illustration of the *Apocalypse* (pp. 132/133). Visits by Franke, who buys some pictures; and also by son Peter Beckmann who, as a medical officer, succeeds in smuggling several pictures out of Germany in his ambulance. Among these pictures is the *Perseus* triptych (pp. 118/119). The Beckmanns undertake several bicycle tours around Holland, and make extended visits to Valkenburg and Zaandvoort. Paints *Double-Portrait of Max and Quappi Beckmann* (p. 139) and works on the triptych *The Actors* (pp. 130/131), which he completes in 1942.

1942 In spite of his serious heart condition Beckmann is called up for military service. He is declared unfit, however. The Museum of Modern Art in New York buys his *Departure* triptych, and he also has a solo exhibition in Chicago.

1943 Beckmann stores most of his studio contents with his friend Helmuth Lütjens since the German authorities are threatening to confiscate his work. Beckmann completes his sixth triptych, *Carnival* (pp. 136/137) as well as *Odysseus and Calypso* (p. 122). Hartmann commissions Beckmann to illustrate Goethe's *Faust II* and Franke buys the *Perseus* triptych.

1944 Beckmann contracts pneumonia and has serious heart problems. After a renewed call-up for military service he is once more declared unfit. Private exhibitions of his work take place in the homes of Franke and Lackner. Contact

with Germany is broken off at this stage in the war. The situation in Amsterdam becomes even more serious. Beckmann can no longer heat his studio and must work in his sitting-room. Paints *Self-Portrait in Black* (p. 127).

1945 The Allies enter Amsterdam on 4 May. Beckmann, as a German national, is threatened with the confiscation of all his assets, but succeeds in preventing this. His situation remains fraught with difficulties, however, as all Germans are under special surveillance and are not granted papers. Friends from the USA help him by sending care parcels. Beckmann receives news from Germany once more, both from Minna Beckmann-Tube and from his son Peter. Franke succeeds in saving his large Beckmann collection. The Stedelijk Museum in Amsterdam mounts a one-man show of Beckmann's work and purchases his *Double-Portrait of Max and Quappi Beckmann* (p. 139). Takes part in exhibitions in the USA and in Paris.

1946 Beckmann turns down teaching posts offered both by the Munich Academy and the Darmstadt Art School. Having been granted non-enemy status, he need no longer fear deportation to Germany. Beckmann is completely isolated in Amsterdam, however, and supply of basic provisions is still chaotic. Franke holds the first Beckmann retrospective after the Nazi era, at the Villa Stuck in Munich, and is responsible for his rehabilitation in Germany. During an exhibition mounted by his New York agent, Curt Valentin, almost all pictures are sold. Valentin publishes the series of lithographs entitled *Day and Dream* (p. 161) and sends Beckmann paint and canvas, as supplies in Amsterdam remain poor. The University of Iowa's Museum of Art purchases the *Carnival* triptych of 1942/43 (pp. 136/137).

1947 Beckmann travels abroad again for the first time, to Nice via Paris. Solo exhibitions are mounted at the Frankfurt Städel, the Hamburg Kunstverein, and the New York Museum of Modern Art. Beckmann turns down a teaching post offered at the Berlin School of Art, while accepting the professorship left vacant by Philip Guston at the University of Washington Art School. Valentin and Perry T. Rathbone, Director of the St. Louis Art Museum, visit the Beckmanns in Amsterdam and assist in preparations for their emigration to America. The Beckmanns board the "Westerdam" at Rotterdam on 29 August. Beckmann has many conversations with fellow passenger Thomas Mann. Arrival in New York

Beckmann's last apartment in New York, 38 West 69th Street (first house on the right)
Photo: B. Göpel

Quappi and Max Beckmann on the occasion of the honorary doctorate conferred by Washington University, St. Louis, 1950

Beckmann's New York studio, 38 West 69th Street, 1950

on 7 September, where they spend ten days touring the sights and museums and visiting friends such as Ludwig Mies van der Rohe. They then travel on to St. Louis, where Beckmann takes up his professorship. There he meets the newspaper publisher Joseph Pulitzer Jr., the art historian Horst W. Janson and many others.

1948 A major retrospective exhibition of Beckmann's work, including three of his triptychs, is held in St. Louis and is shown later in Detroit, Los Angeles, San Francisco, Chicago and Boston. Beckmann gives a lecture (*Three Letters to a Woman Painter*) at Stephens Art College, Columbia. His teaching contract in St. Louis is extended by one year. Beckmann travels to Amsterdam in June in order to give up his flat there. After a short visit to New York, Beckmann returns to St. Louis and applies for American citizenship. Meets the artists George Rickey and Rufino Tamayo. The Artist's Equity in New York holds a big party in honour of Beckmann on 30 December.

1949 Beckmann makes various trips around the USA and spends the summer teaching at the Boulder Art School in Colorado. Excursions into the Rocky Mountains. Beckmann travels to New York via Denver and Chicago. In September he takes up a professorial teaching post at the Brooklyn Art School in New York, and moves into an apartment near the Gramercy Park, at 234 East 19th Street. Receives first prize at the Pittsburgh exhibition "Painting in the United States Today" for his canvas *Fisherwomen* (p. 179). The Munich firm of Piper publishes a major Beckmann monograph by Hausenstein and Benno Reifenberg.

1950 Beckmann's contract at the Brooklyn Art School is extended by six years. He moves to 38 West 69th Street, near Central Park, on 1 May. At the Venice Biennale Beckmann is represented by 14 canvases, and is awarded the Conte Volpi Prize for foreign artists. He receives an honorary doctorate from Washington University in St. Louis, in June. Quappi reads his speech for

"Friends and the Faculty of Philosophy". Onward journey for holiday in Carmel, near San Francisco. Afterwards Beckmann spends July and August teaching a summer course at Mills College in Oakland, California. The Beckmanns travel by car to Las Vegas, Reno and the Nevada desert, before returning to New York. The Korean crisis puts paid to a planned journey to Europe. Beckmann turns down Ernst Holzinger's offer of a professorship at the Frankfurt Städel Art Institute, but offers to give summer courses there instead. Beckmann completes work on his triptych *The Argonauts* (pp. 190/191) on 26 December and dies of a heart attack near Central Park on 27 December while on his way to visit the exhibition "American Painting Today" where his final self-portrait, *Self-Portrait in Blue Jacket* (p. 193), is being shown.

Acknowledgements, Sources of Reproductions and Bibliography

Author and publisher wish to thank Maja and Mayen Beckmann for their active interest in this monograph and for their invaluable support and assistance throughout. We are grateful to Barbara Göpel and the Beckmann Archive in Munich for information and help. The author's personal gratitude is extended to Susanne Busch and Edgar Bierende for their part in discussions, for further suggestions and for reading the manuscript.

The publishers are grateful to the museums, private and public collections, galleries, archives and photographers who have made items in their possession available for reproduction. Owners of works reproduced are cited in the captions, except where they wished to remain anonymous or are not known. The publisher will be glad to receive additions or corrections.

Key to abbreviations: l = left, a = above, r = right, b = below.

Allschwil: Colorphoto Hans Hinz: 61. Berlin: Bildarchiv Preußischer Kulturbesitz: 129, 143; Rialto Film: 147 a; Sotheby's: 148 a; Villa Grisebach: 59. Cambridge: Perry T. Rathbone: 177. Chicago: The Art Institute of Chicago: 81. Darmstadt: Hessisches Landesmuseum: 173. Dortmund: Museum am Ostwall: 144 a, 156. Düsseldorf: Kunstmuseum Düsseldorf im Ehrenhof: 77; Kunstsammlung Nordrhein-Westfalen: 33, 63. Emden: Kunsthalle in Emden: 155. Essen: Museum Folkwang: 118/119, 160. Euerbach: Sammlung Georg Schäfer: 22 a. Frankfurt am Main: Städelsches Kunstinstitut und Städtische Galerie (Photo: Ursula Edelmann): 67, 157 b. Halle: Staatliche Galerie Moritzburg: 19. Hamburg: Hamburger Kunsthalle (Photo: Elke Walford): 65. Hanover: Sprengel Museum: 146, 180. Herford: Ahlers Collection: 117, 162. Iowa City: The University of Iowa Museum of Art: 136/137. Kaiserslautern: Pfalzgalerie: 95. Cologne: Rheinisches Bildarchiv: 21, 41 a. Lübeck: Museum für Kunst und Kulturgeschichte der Hansestadt Lübeck: 66. Ludwigshafen: Wilhelm-Hack-Museum: 154. Madrid: Fundación Colección Thyssen-Bornemisza: 149. Mannheim: Städtische Kunsthalle Mannheim: 39. Munich: Beckmann Archive: 10, 16, 23–27, 32, 35, 38, 40, 41 b, 43–49, 56 a, 57, 60, 70, 80 o, 92, 93, 101, 104, 107, 110, 128, 139, 145, 161, 167 a, 168, 179, 186 l, 188, 189; Sammlung Amélie Ziersch: 132/133. New York: Frumkin/Adams Gallery: 99; Lafayette Parke Gallery: 152 o; Richard L. Feigen Collection: 100; The Museum of Modern Art: 71. Peißenberg: Artothek: 30, 31 a r, 54, 55, 68, 73, 74, 79, 82, 86, 89, 91, 97 r, 98 a, 108/109, 112/113, 122, 126, 127, 130/131, 134, 140, 171, 181, 182 b. Saint Louis, The Saint Louis Art Museum: 20 b, 94, 147 b, 151, 159, 175, 183, 185, 193. Stuttgart: Staatsgalerie Stuttgart: 29 a, 141. Waltham: Rose Art Museum, Brandeis University: 62. Washington: National Gallery of Art: 178, 187, 190/191. Weimar: Kunstsammlungen Schloßmuseum: 15 b. Wichtrach, Galerie Henze & Ketterer AG: 148 b, 153. Wuppertal: Von der Heydt-Museum: 52, 144. All further reproductions are either taken from the archives belonging to Beckmann's heirs, to the Benedikt Taschen Verlag, or to Ingo F. Walther, or were provided by the author.

Writings by the Artist

Max Beckmann: Frühe Tagebücher. Ed. Doris Schmidt. With epilogue by Minna Beckmann-Tube. Munich, 1985

Max Beckmann: Leben in Berlin. Tagebücher 1908/1909, 1912/13. Ed. H. Kinkel. Munich, ²1983

Max Beckmann: Tagebücher 1940–1950. Ed. Mathilde Q. Beckmann, Erhard Göpel. Munich, 1955; Munich and Vienna, 1979; Munich, 1984

Max Beckmann: Briefe. Band I: 1899–1925. Ed. Klaus Gallwitz, Uwe M. Schneede, Stephan von Wiese assisted by Barbara Golz. Munich, 1993

Max Beckmann: Briefe im Kriege 1914/15. Collected by Minna Tube. Berlin, 1916; Munich, 1984

Max Beckmann: Die Realität der Träume in den Bildern. Schriften und Gespräche 1911–1950. Rudolf Pillep. Munich, 1990

Max Beckmann: Ebbi. Komödie. Vienna, 1924, Gerlingen, 1984

Max Beckmann: Das Hotel. Drama in vier Akten (Typescript, 1921). Gerlingen, 1984

Catalogue raisonnés

Göpel, Erhard and Barbara: Max Beckmann. Katalog der Gemälde. 2 Vols. Berne, 1976 (with bibliography up to 1970; bibliography 1971–1993 in Max Beckmann. Bibliographie 1971–1993, ed. F. Billeter, A. Dobrzecki, C. Lenz. Max Beckmann Archiv, Munich, 1994)

Hofmaier, James: Max Beckmann. Catalogue Raisonné of His Prints. 2 Vols. Berne, 1990

Wiese, Stephan von: Max Beckmanns zeichnerisches Werk 1903–1925. Düsseldorf, 1978

Max Beckmann. Aquarelle und Zeichnungen. Ed. Ulrich Weisner and Klaus Gallwitz. Kunsthalle Bielefeld; Kunsthalle Tübingen; Städtische Galerie im Städel, Frankfurt am Main; Bielefeld, 1977 (Exhibition Catalogue)

Memoirs/Biographical Records

Beckmann, Mathilde Quappi: Mein Leben mit Max Beckmann. Munich and Zurich, 1983

Beckmann, Peter and Joachim Schaffer: Die Bibliothek Max Beckmanns. Worms, 1992

Göpel, Erhard: Max Beckmann—Berichte eines Augenzeugen. Ed. Barbara Göpel. Frankfurt am Main, 1984

Lackner, Stephan: Ich erinnere mich gut an Max Beckmann. Mainz, 1967

Max Beckmann Colloqium 1984. Leipzig 1984

Piper, Reinhard: Mein Leben als Verleger. Munich, 1964; Munich and Zurich, 1991

Schmidt, Doris (Ed.): Briefe an Günther Franke. Porträt eines deutschen Kunsthändlers. Cologne, 1970

Monographs and Critical Studies

Beckmann, Peter: Die "Versuchung". Eine Interpretation des Triptychons von Max Beckmann. Heroldsberg (near Nuremberg), 1977

Beckmann, Peter: Max Beckmann. Leben und Werk. Stuttgart and Zurich, 1982

Belting, Hans: Max Beckmann. Die Tradition als Problem in der Kunst der Moderne. Munich, 1984

Buenger, Barbara C.: Max Beckmann's Artistic Sources. The Artist's Relation to Older and Modern Tradition. Phil. Diss. New York, 1979 (Typescript)

Busch, Günther: Max Beckmann. Eine Einführung. Munich, 1960; Munich and Zurich, 1989

Eberle, Mathias: Die Nacht. Passion ohne Erlösung. Frankfurt am Main, 1984

Erpel, Fritz: Max Beckmann Leben im Werk. Die Selbstbildnisse. Berlin, 1985

Fischer, Friedrich Wilhelm: Max Beckmann – Symbol und Weltbild. Grundriß zu einer Deutung des Gesamtwerkes. Munich, 1972

Franzke, Andreas: Max Beckmann – Skulpturen. Munich and Zurich, 1987

Gallwitz, Klaus: Max Beckmann in Frankfurt. Frankfurt am Main, 1984

Güse, Ernst-Gerhard: Das Frühwerk Max Beckmanns 1903–1917. Phil. Diss. Hamburg. Frankfurt am Main and Berne, 1977

Kessler, Charles: Max Beckmann's Triptychs. Cambridge (MA), 1970

Lackner, Stephan: Max Beckmann. New York, 1977

Lackner, Stephan: Max Beckmann – Die neun Triptychen. Berlin, 1965

Lenz, Christian: Max Beckmann und Italien. Frankfurt am Main, 1976

Peter, Nina: Max Beckmann: Landschaften der Zwanziger Jahre. Frankfurt am Main, 1993

Reifenberg, Benno and Wilhelm Hausenstein: Max Beckmann. Munich, 1949

Schneede, Uwe M.: Max Beckmann. Hamburg, 1993

Schubert, Dietrich: Auferstehung und Erscheinung der Toten. Heidelberg, 1984

Schulz-Hoffmann, Carla: Max Beckmann. "Der Maler". Munich, 1991

Exhibition Catalogues (chronological)

Max Beckmann. Die Druckgraphik – Radierungen, Lithographien, Holzschnitte. Ed. Klaus Gallwitz. Badischer Kunstverein, Karlsruhe, 1962

Max Beckmann – Das Porträt. Gemälde, Aquarelle, Zeichnungen. Ed. Klaus Gallwitz. Badischer Kunstverein, Karlsruhe, 1963

Max Beckmann. Die Triptychen im Städel. Ed. Klaus Gallwitz. Stedelijk Museum, Amsterdam; Whitechapel Art Gallery, London; Städtische Galerie im Städel, Frankfurt am Main; Frankfurt am Main, 1981

Max Beckmann. Die frühen Bilder. Ulrich Weisner. Kunsthalle, Bielefeld; Städtische Galerie im Städel, Frankfurt am Main; Bielefeld, 1982

Max Beckmann. Die Hölle, 1919. A. Dückers. Kupferstichkabinett, Berlin, 1983

Max Beckmann. Frankfurt 1915–1933. Ed. Klaus Gallwitz. Städtische Galerie im Städel, Frankfurt am Main, 1983

Max Beckmann. Retrospektive. Ed. Carla Schulz-Hoffmann and Judith C. Weiss. Haus der Kunst, Munich; Nationalgalerie, Berlin; The Saint Louis Art Museum, St. Louis; Los Angeles County Museum of Art, Los Angeles; Munich, 1984

Max Beckmann. Ed. Siegfried Gohr. Joseph-Haubrich-Kunsthalle, Cologne, 1984

Max Beckmann – Gemälde, Handzeichnungen, Druckgraphik. Ed. Günther Busch. Kunsthalle, Bremen, 1984

Max Beckmann. Graphik, Malerei, Zeichnung. Ed. Dieter Gleisberg. Museum der bildenden Künste, Leipzig, 1984

Max Beckmann Druckgraphik. Ed. Christian Lenz. Esslingen, 1984

Max Beckmann Gemälde 1905–1950. Ed. K. Gallwitz. Museum der bildenden Künste, Leipzig, 1990

Hinter der Bühne. Max Beckmann 1950. Ed. Martin Sonnabend and Margret Stuffmann. Städtische Galerie im Städel, Frankfurt am Main, 1990

Max Beckmann. The Self-Portraits. Peter Selz. Gagosian Gallery, New York, 1992

Max Beckmann. Graphic Works from the Metropolitan Museum of Art. New York, 1992

Max Beckmann Selbstbildnisse. Ed. Uwe M. Schneede and Carla Schulz-Hoffmann. Kunsthalle, Hamburg, 1993

Max Beckmann Welt-Theater. Das graphische Werk. Jo-Anne Birnie Danzker and Amélie Ziersch. Villa Stuck, Munich, 1993

Max Beckmann. Meisterwerke 1907–1950. Ed. Karin von Maur. Staatsgalerie Stuttgart, 1994

Jeff Koons

Featured Art Newspaper information on Jeff Koons

Representation
Gagosian Gallery
555 West 24th Street
USA – New York, NY 10111
tel +1 212-741-1111
fax +1 212-741-9611
www.gagosian.com

Galerie Max Hetzler
Zimmerstraße 90/91
D – 10117 Berlin
tel +49 (0)30 229-2437
fax +49 (0)30 229-2417
www.maxhetzler.com

Sonnabend Gallery
532 West 22nd Street
USA – New York, NY 10011
tel +1 212-627-1018
fax +1 212-627-0489

Collections
Baltimore Museum of Art, USA
capcMusee d'Art Contemporain, Bordeaux, France
Des Moines Art Center, USA
Deutsche Guggenheim Berlin, Germany
Groninger Museum, Groningen, The Netherlands
Guggenheim Museum, Bilbao, Spain
Hirschhorn Museum and Sculpture Garden, Washington D.C., USA
Kunstmuseum Wolfsburg, Germany

Metropolitan Museum, Tokyo, Japan
Milwaukee Art Museum, USA
Museum Boijmans Van Beuningen, Rotterdam, The Netherlands
Museum Ludwig, Cologne, Germany
Museum of Contemporary Art Chicago, USA
Nationalgalerie im Hamburger Bahnhof, Museum für Gegenwart, Berlin, Germany
San Francisco Museum of Modern Art, USA
Staatsgalerie Stuttgart, Germany
Stedelijk Museum, Amsterdam, The Netherlands
Tate Gallery, London, UK
The Museum of Contemporary Art, Los Angeles, USA
The Museum of Modern Art, New York, USA
The National Gallery, Washington D.C., USA
Whitney Museum of American Art, New York, USA
Wright State University Art Museum, Dayton, USA

Price Range
$10,000 (multiples); $150,000 – $3,000,000 (other works);
several million for monumental sculpture.

Auction Sales
Price: $5,100,000
Michael Jackson and Bubbles, 1988
porcelain ceramic blend; num. 3/3; 107 x 179 x 83 cm
Date Sold: 15-May-01
Auction House: Sotheby's, New York

Price: $2,600,000
Woman in tub, 1988
porcelain; num. 1/3;
62 x 91 x 69 cm
Date Sold: 17-May-01
Auction House: Christie's, Rockefeller NY

Price: $1,700,000
Ushering in banality
polychromed wood
num. 2 of 3; 96 x 157 x 76 cm
Date Sold: 14-Nov-01
Auction House: Sotheby's, New York

Price: $1,650,000
Pink Panther, 1988
porcelain; num. 3/3
104 x 52 x 48 cm
Date Sold: 16-Nov-99
Auction House: Christie's, Rockefeller NY

Price: $1,550,000
Woman in tub, 1988
Porcelain; num. 3/3;
157 x 23 x 175 cm
Date Sold: 16-May-00
Auction House: Christie's, Rockefeller NY

Martin Creed

Rineke Dijkstra

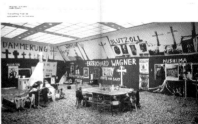

Keith Edmier

Who, what, when, where, and how much $$$

Contemporary art in a nutshell

"Buy this book by all means."
Contemporary Visual Arts, London, on *Art at the Turn of the Millennium*

ART NOW

137 Artists at the Rise of the New Millennium
137 Künstler zu Beginn des 21. Jahrhunderts — 137 Artistes au commencement du 21ème siècle
Servicepart on the international art market in collaboration with THE ART NEWSPAPER

Edited by Uta Grosenick & Burkhard Riemschneider

TASCHEN

Dear Taschen,
I love your book *Art at the Turn of the Millennium* but it's been a few years now and the art scene changes so fast these days. How about an updated and expanded version? I would like to learn not only who are the hottest artists working today, but also how to work the art scene like a pro, and how to shop for art without looking like a novice. Could you make a new book like this, just for me?
Thanks,
Harry L.

Dear Harry,
We've been working hard on your request and think you'll be pleased with the result. Enclosed is the spanking-new *Art Now*, in which you'll find the most recent work and updated biographical information for our revised selection of today's 150 most influential artists. *Art Now* also includes a completely new section—a sort of "service guide"—produced in collaboration with *The Art Newspaper* which lists museums, restaurants, and hotels we recommend you check out while you're cruising the global art scene, and even gives the scoop on how much one can expect to pay for a Damien Hirst or a Sharon Lockhart and whom to contact if you decide to buy. We also let you know useful details like how many prints Wolfgang Tillmans made for a certain edition and what sorts of sums big players like Koons, Sherman,

and Struth bring in at auction. **Think of it as an indispensable reference book, travel guide, and art market directory all rolled into one**
We hope you like it, and thanks for writing!
Love, TASCHEN

P.S. This book actually turned out quite good, so we've decided to publish it. We hope you don't mind.

Art Now Ed. Burkhard Riemschneider / Uta Grosenick
English/German/French edition / Japanese/English/French edition / Italian/Spanish/Portuguese edition / Flexi-cover, format: 19.6 x 24.9 cm (7.6 x 9.8 in.), 640 pp. / US$ 40 / £ 20 / € 32 / ¥ 4.500

Alchemy & Mysticism

Alexander Roob / Flexi-cover / ...

Art at the Turn of the Millennium

Ed. Burkhard Riemschneider, Uta Grosenick / Flexi-cover / ...

New!

Art Now

Ed. Burkhard Riemschneider, Uta Grosenick / Flexi-cover / 640 pp. / ...

New edition!

Beckmann

Reinhard Spieler / Flexi-cover / 200 pp. / ...

New edition!

Description de l'Egypte

New edition!

Dix

New edition!

Egypt

Codices illustres. The world's most famous illuminated manuscripts

Ingo F. Walther / Hardcover with mylar jacket, 504 pp. / ...

"The one book you want if you are interested in illuminated manuscripts —and once you open it, you will be. [An] exceptionally handsome book.... Run, don't walk."
—*The Wall Street Journal*, New York

Timetunnel to the 15th century:

1493's must-have history book and city guide

Chronicle of the World—1493
Hartmann Schedel

"... ist Schedels 'Weltchronik' gewiß das den heutigen Leser faszinierendste Buch vor 1500. Daß es nun wohlfeil unters Volk kommt (frühere Faksimile-Drucke kosteten noch um die 2000 Euro), ist eine bildungsgeschichtliche Sensation." —*Die Presse*, Wien

"... schon das Gefühl, die ... 3,5 kg schwere Neuausgabe der Schedel'schen Weltchronik im weichen braunen Samteinband in Händen zu halten, ist die wahre Freude —und die steigt beim Blättern in dem ehrwürdigen Zeugnis früher Druckkunst sogar noch an. Natürlich hat der TASCHEN-Verlag für sein Faksimile der berühmten 'Nürnberger Chronik' ... eine besonders schön kolorierte Vorlage gewählt. Freuen wir uns über den überaus hochwertigen und preiswerten Nachdruck!" —*Nordbayerischer Kurier*, Bayreuth

"An extraordinary facsimile at a remarkably reasonable price."
—*United Press International*, USA

H.R. Giger, Zurich, 2000

www HR Giger com

HR Giger / Hardcover, 240 pp. /
US$ 30 / £ 17 / € 20 / ¥ 3.800

Encyclopaedia Anatomica

Museo La Specola, Florence / M. von Düring, M. Poggesi,
G. Didi-Huberman / Flexi-cover, Klotz, 704 pp. /
US$ 30 / £ 17 / € 24 / ¥ 3.800

Art —all titles

French Impressionism

Peter H. Feist, Ed. Ingo F. Walther / Hardcover, 440 pp. /
US$ 40 / £ 25 / € 32 / ¥ 5.000

Highlights of Art

Thyssen-Bornemisza Museum, Madrid / Teresa Pérez-Jofre
Flexi-cover, Klotz, 768 pp. US$ 30 / £ 17 / € 24 / ¥ 3.800

 New edition!

Hopper

Ivo Kranzfelder / Flexi-cover, 200 pp. /
US$ 15 / £ 13 / € 16 / ¥ 3.000

 New edition!

Japanese Prints

Gabriele Fahr-Becker / Flexi-cover, 200 pp. /
US$ 15 / £ 13 / € 16 / ¥ 3.000

 New edition!

Matisse

Gilles Néret / Flexi-cover, 256 pp. /
US$ 15 / £ 13 / € 16 / ¥ 3.000

Hundertwasser Architecture

Ed. Angelika Taschen / Hardcover, 320 pp. /
US$ 40 / £ 25 / € 32 / ¥ 5.000

"Dear Philippi, thank you for the regards
and for the dummy. I'm working hard.
Now I'm already at number 400, with a lot of
fantastic little stories for the image captions."
—fax from Hundertwasser to TASCHEN vice
editor-in-chief Simone Philippi, 1998

Hundertwasser sent over 3.500 faxes during the
preparation of the book

Hundertwasser
–his complete works

This edition, the last book created by
Friedensreich Hundertwasser, includes:

* Two volumes in a slip case designed by Hundertwasser,
 lavishly printed in ten colors on rounded, black-edged pages
* Hundertwasser's original layout design
* 1.792 pages and over 2.000 illustrations, documenting
 Hundertwasser's life and œuvre from 1928 to 2000, with many
 personal notes and comments by the artist
* An original 24 x 20 cm color etching (9.4 x 7.9 in.),
 specially created for this edition, numbered and marked
 with the Hundertwasser estate stamp
* Limited edition of worldwide 10.000 copies
* US$ 750 / £ 500 / € 750 / ¥ 90.000

**Subscription price
until November 1, 2002:
£ 350 / € 500**

**Outside Europe until
January 1, 2002:
US$ 500 / ¥ 60.000**

The Lucky Seven: classic reference books, new size – small price!

"An extraordinary bargain"

—*The Sunday Times*, London

Art of the 20th Century

K. Ruhrberg, M. Schneckenburger, C. Fricke, K. Honnef /
Ed. Ingo F. Walther / Flexi-cover, 840 pp. /
US$ 40 / £ 20 / € 32 / ¥ 4.500

Dalí. The Paintings

Robert Descharnes, Gilles Néret / Flexi-cover, 780 pp. /
US$ 40 / £ 20 / € 32 / ¥ 4.500

"And while the end of the 20th century might not give us much occasion for celebration, in celebrating this book we can all agree." —*Süddeutsche Zeitung*, Munich, on *Art of the 20th Century*

"Bound to become the standard reference work."

—*Le Figaro*, Paris, on *Dalí*

Van Gogh – The Complete Paintings

Rainer Metzger, Ed. Ingo F. Walther / Flexi-cover, 740 pp. /
US$ 40 / £ 20 / € 32 / ¥ 4.500

New edition!

Impressionism 1860–1920

Ed. Ingo F. Walther / Flexi-cover, 712 pp. /
US$ 40 / £ 20 / € 32 / ¥ 4.500

New edition!

Picasso

Carsten-Peter Warncke / Ed. Ingo F. Walther / Flexi-cover, 740 pp. /
US$ 40 / £ 20 / € 32 / ¥ 4.500

New edition!

Sculpture

Georges Duby / Hardcover, 1.184 pp. /
US$ 39 / £ 17 / € 25 / ¥ 3.900

New edition!

Masterpieces of Western Art

Ed. Ingo F. Walther / Flexi-cover, 768 pp. /
US$ 40 / £ 20 / € 32 / ¥ 4.500

"... the definitive introduction to the scope and range of Picasso's work."

—*The Times*, London, on *Picasso*

"... nine expert writers present over 900 pictures analyses ranging from Giotto to Jean-Michel Basquiat, born 1960.
The period from Gothic to the present is divided into ten chapters with detailed introductions, directed at advanced museum-goers but also painless reading for lay readers ...
536 potted biographies in the appendix make a reference work of this fine compendium."

—*art*, Hamburg, on *Masterpieces of Western Art*

Monet or the Triumph of Impressionism
Daniel Wildenstein / Ed. Gilles Néret / Hardcover, 480 pp. /
US$ 40 / £ 25 / € 32 / ¥ 6.500

Piranesi. The Complete Etchings
Luigi Ficacci / Flexi-cover, 800 pp. /
US$ 40 / £ 20 / € 32 / ¥ 4.500

The Portrait
Norbert Schneider / Flexi-cover, 192 pp. /
US$ 15 / £ 13 / € 16 / ¥ 3.000

New edition!

Art—all titles

Renoir. Painter of Happiness
Gilles Néret / Hardcover, 440 pp. /
US$ 40 / £ 25 / € 32 / ¥ 5.000

Soutine – Catalogue Raisonné
M. Tuchman, E. Dunow, K. Perls / Ed. Ingo F. Walther /
Hardcover, 780 pp. / US$ 50 / £ 30 / € 32 / ¥ 6.500

What Great Paintings Say
Rose-Marie & Rainer Hagen / Hardcover, 500 pp. /
US$ 40 / £ 20 / € 32 / ¥ 5.000

Women Artists
Ed. Uta Grosenick / Flexi-cover, 576 pp. /
US$ 40 / £ 20 / € 32 / ¥ 4.500

"... Ce superbe ouvrage présente les artistes les plus marquantes du XX et du XXI siècle par le biais de leurs œuvres, souvent surprenantes. A découvrir."
—*Le Vif / L'express*, Bruxelles

"Perhaps this year's most unusual book"
—*Town & Country*, USA, on *Cabinet of Natural Curiosities*

"A vast and beguiling tome... Any one of the reproductions... could be framed as a picture in its own right." —*The Times*, London, on *Cabinet of Natural Curiosities*

ALBERTUS SEBA

CABINET OF NATURAL CURIOSITIES

THE COMPLETE REPRINTS

TASCHEN

New price: January 1, 2003: US$ 200 / £ 135 / € 200 / ¥ 25.000

"This is an extraordinary and beautiful book, stuffed with information. TASCHEN has reproduced the entire set of plates—449 in all—from a hand-coloured Dutch edition. The price is high, but the alternative is to save up for a plate or two and chase round the auction rooms (...). There's no question that people will want it. While it sat on my desk at *New Scientist*, everyone who spotted it offered to give it a home."
—*The New Scientist*, London, on *Cabinet of Natural Curiosities*

Albertus Seba. Cabinet of Natural Curiosities
Irmgard Musch, Jes Rust, Rainer Willmann / Hardcover, 588 pp. /
US$ 150 / £ 100 / € 150 / ¥ 20.000

"This is a massive book. It is also, probably, one of the most beautiful you are ever likely to see... Fortean Times verdict: Academic Publishing at its glorious best. 10 out of 10."
—*Fortean Times*, London, on *Cabinet of Natural Curiosities*